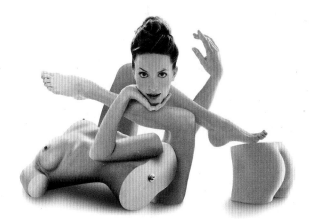

surreal
digital photography

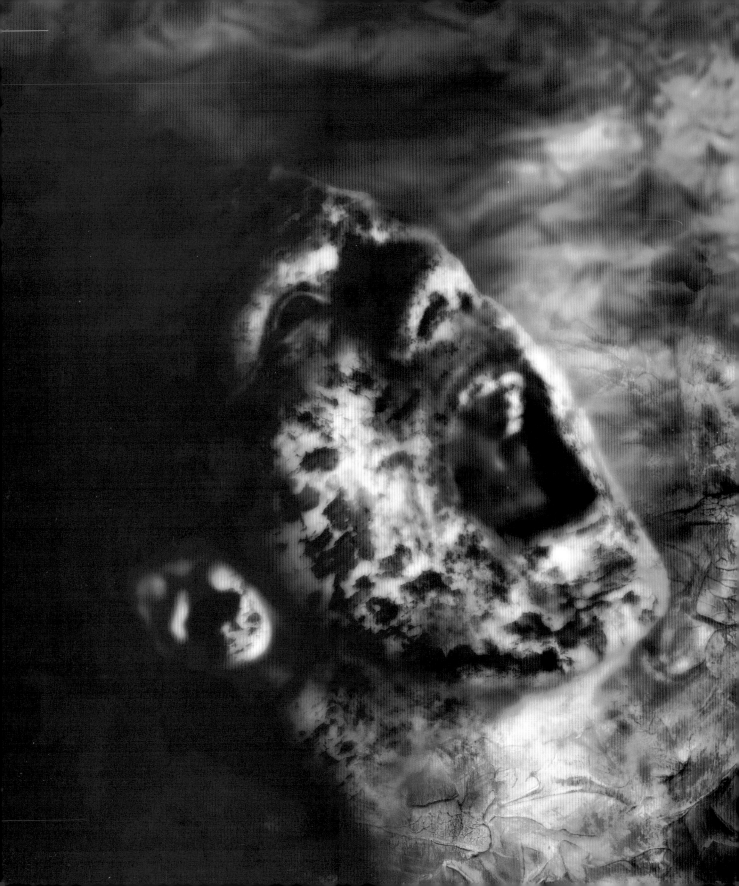

surreal
digital photography

Barry Huggins and Ian Probert

THOMSON

COURSE TECHNOLOGY

Professional ■ Trade ■ Reference

First published in the United States in 2004 by
Course PTR, a division of Thomson Course
Technology.

For Course PTR
Publisher: Stacy L. Hiquet
Senior Marketing Manager: Sarah O'Donnell
Marketing Manager: Heather Hurley
Associate Marketing Managers:
 Kristin Eisenzopf, Sarah Dubois
Associate Acquisitions Editor: Megan Belanger
Manager of Editorial Services: Heather Talbot
Market Coordinator: Amanda Weaver

ISBN: 1-59200-389-3

5 4 3 2

Library of Congress Catalog Card number:
2004106448

COURSE PTR,
A Division of Thomson Course Technology
(www.courseptr.com)
25 Thomson Place
Boston, MA 02210

This book was conceived, designed, and
produced by
The Ilex Press Limited
Cambridge
England

Publisher: Alastair Campbell
Executive Publisher: Sophie Collins
Creative Director: Peter Bridgewater
Design Manager: Tony Seddon
Editor: Stuart Andrews
Designer: Alistair Plumb
Artwork Administrator: Joanna Clinch
Development Art Director: Graham Davis
Technical Art Editor: Nicholas Rowland

Printed in China

For more information on this title please visit:
www.dphtus.web-linked.com

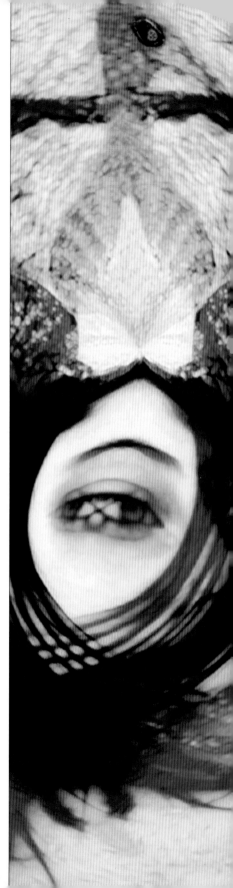

CONTENTS

INTRODUCTION

The flexibility and endless possibilities of digital photography make the medium ideally suited to surreal photography. Using Adobe Photoshop, along with other powerful image-editing programs, photographs can be edited, recolored, and re-arranged in any way you can imagine. With a digital camera, home computer, and image-editing software there is simply no limit to what you can achieve.

It's probably a safe bet to assume that somewhere up there, people such as Salvador Dalí, Luis Buñuel, and Man Ray are looking down on us all with more than a little envy. These three renowned pioneers of surrealist painting, movie-making, and photography would, no doubt, have been blown away by the sheer range of image making possibilities that are available to modern artists. As the spiritual father of surreal photography, Man Ray in particular would have revelled in the freedom, flexibility, and limitless potential that comes so easily to the digital artist. And yet nowadays we take this power for granted.

New Methods

In Man Ray's day, of course, it was all so different. The surreal images that he created were the result of a superb artistic eye and a brilliant mind, which sought to liberate the fantastic from the mundane. They were also the result of hard work. Back in the 1920s, the working photographer had to roll up his sleeves and get his hands dirty, preparing his own chemicals, composing his prints on a primitive enlarger, hanging them up to dry, and waiting for hours to view the results. Yet, despite the limitations of archaic equipment and the inconvenience of the printing process, Man Ray's photographs were quite brilliant.

Right **Digital image manipulation can easily distort the reality of the photo. Whether disturbing or wittily cartoon-like, the results can be stunningly effective.**

The images that Man Ray produced helped to define the term 'surreal', a word that has since been absorbed into the language to describe any picture or object that has bizarre or unreal qualities. Indeed, these days we can see echoes of the surrealist movement in almost every walk of life: in TV adverts, movies, product packaging, and of course, photography. In fact, surreal imagery is so much part of our lives that we almost take it as the norm. Many of the surreal images we see on an almost daily basis will have been created using digital technology.

Along with the digital camera and its ability to produce images in fractions of a second, software packages such as Photoshop have revolutionized the way in which photographs are created. Instead of colored dots printed on to paper or film, the modern digital photograph has become a flexible entity, capable of infinite adjustment and transformation, a multi-colored canvas on which the artist is free to imprint his vision. This made it almost inevitable that digital photography would lend itself so well to surreal imagery. After all, even if you've only used image-editing software to lighten the skies or correct color casts in your photographs, you can't help but be aware of its enormous creative potential. This was something that the early digital photographers instantly recognized and exploited. As a result, the first attempts at artistic digital photography were characterized by an extreme distortion of subject matter and a tendency to throw in everything and the kitchen sink.

Thankfully, these early excesses have since become cliché. Those modern digital photographers who work in the field of surreal imagery are an altogether subtler breed. *Surreal Digital Photography* features some of the world's leading exponents. In reproducing the finest examples of their work we explore many of the techniques that they use to create award-winning images. This book is not a manual, nor is it something to place on your coffee table. Rather, it is a journey inside the minds of the people who are at the cutting edge of artistic digital photography.

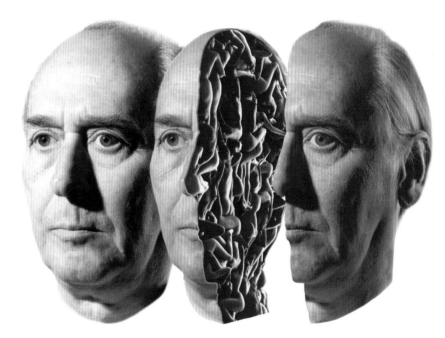

Above **Colin Thomas's portrait of J.G. Ballard brings one of the author's many preoccupations (human sexuality) to surreal visual life.**

Below **Using image-editing software, photographic images can be turned into something painterly. The photo is no longer a literal recording.**

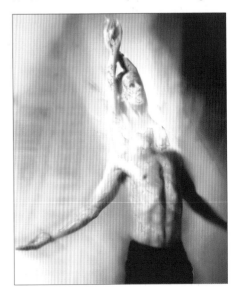

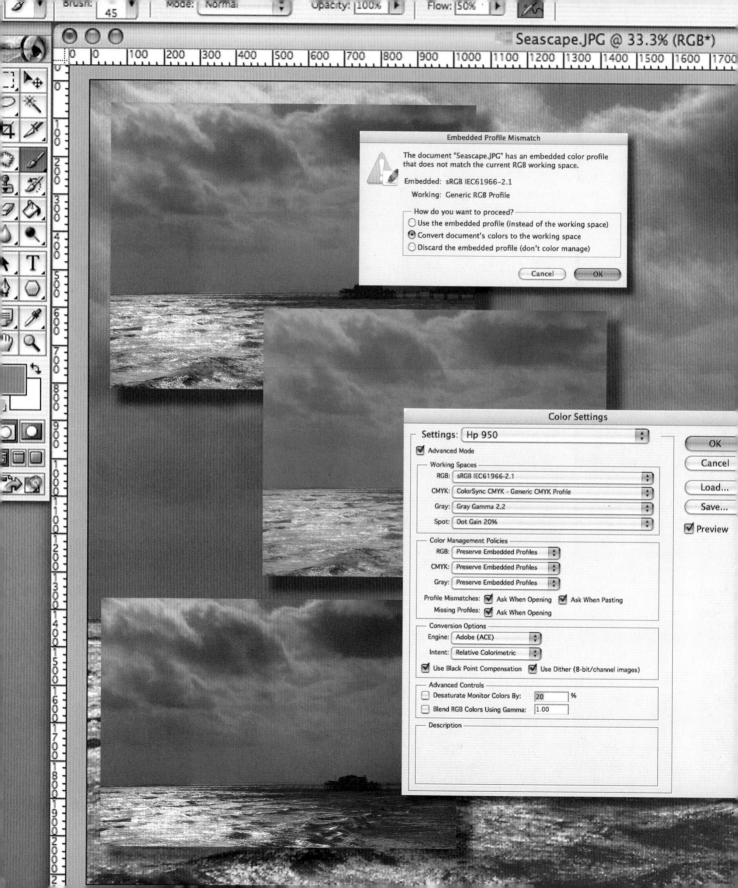

1

Naturally, before you can begin to explore the tools and techniques of the masters, you need the right equipment. Luckily, while it's possible to pour vast amounts of cash into your digital toolbox, you don't have to spend a fortune to produce images of professional quality. Follow our guide to cameras, computers, software, and peripherals, then choose equipment that comfortably fits within your budget. As pioneers such as Man Ray demonstrated, in surreal photography the equipment you use to create your images is not as important as what you choose to do with it.

the digital toolbox

DIGITAL CAMERAS

It's easy to become bewildered with the sheer variety of digital cameras on the market, as every manufacturer offers many variations of megapixel rating, zoom lens, and form-factor. If you intend to produce images for print, you need a camera with a high resolution, but megapixels don't tell the whole story. To produce high-quality images that can be later manipulated in an image-editing program, you need a flexible lens system and plenty of control, which often means a professional or a prosumer model.

At the low end of the digital camera spectrum are compact digital cameras. These are affordable, easy to use, and ideal for beginners or as a second camera for the serious photographer. If you wish to create images that will look professional when printed out, however, you will need to look further up the price chain.

Prosumer Cameras

At first glance it's very difficult to spot any difference between prosumer digital cameras and professional models. Both types of camera usually have the lens mounted at the center of the camera, giving the impression that they are Single Lens Reflex cameras.

This isn't actually the case. Prosumer cameras take their pictures in a similar way to the smaller compact digital cameras: the viewfinder is a separate optical system, usually situated beneath the viewfinder. This results in images where the composition may differ slightly from what you see. Using the LCD screen will give you a more accurate picture, but will also drain the battery faster, and the screen might not be visible in all light conditions.

Apart from this minor issue, prosumer cameras offer a range of features that rival more expensive professional models. Most prosumer digital cameras, for example, come equipped with a respectable optical zoom, enabling you to pick out detail from a distance or include depth-of-field effects in your photographs. Prosumer cameras also come equipped with a choice of automatic exposure controls that are designed to assist you when shooting in specific situations such as night-time, studio, or when capturing motion. And most prosumer cameras also include a good built-in flash, a hot-shoe for an external flash, and a full range of standard controls including automatic timer, macro function, and LCD view screen with image-editing functions.

If you decide to invest in a prosumer camera, there is one feature that is a must-have. The camera should offer a full manual mode that allows you to adjust exposure settings and aperture. Without this feature, your prosumer camera will be no more useful than a cheaper compact camera.

All of this control means that you can shoot images that are often indistinguishable from images taken with a professional camera, and recent models from Canon,

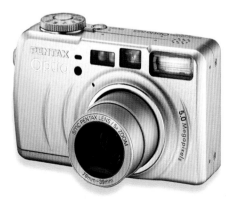

Left **A good compact digital camera can produce fantastic results, thanks to high resolutions and cutting-edge lens technology, but can't match the flexibility and fine control of prosumer and digital SLR models.**

Right **With an 8-megapixel CCD, a 7x optical zoom lens, and a comprehensive selection of manual and autofocus and exposure controls, the Sony DSC-F828 is an advanced prosumer digital camera.**

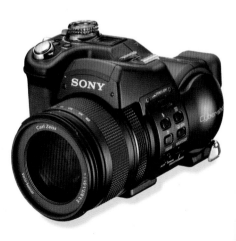

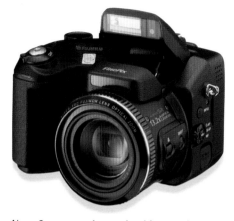

Above **Cameras such as the Fuji S20-Pro offer professional-** **level features in a more convenient all-in-one form.**

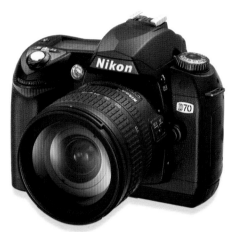

Above **Nikon's D70 is one of several digital SLRs that, by lowering** **the price, are able to take the technology to the enthusiast market.**

Sony, Fuji, Konica-Minolta, and Nikon offer resolutions beyond 6 megapixels, meaning they are capable of producing images that will print out at larger-than US Letter sizes.

Professional Digital Cameras

Professional digital cameras offer all of the functions of prosumer cameras and more. The extensive range of features and build quality more than reflect the expensive price tag. As well as providing the user with full manual control over almost every aspect of the camera, professional digital cameras also offer true SLR functionality.

For the photographer this has two advantages: firstly, because you are looking through the actual lens when you shoot, you can be sure that every image you take will be exactly what you saw. Secondly, SLR cameras allow you to use other types of lens; this means that you can purchase extra lenses

such as fisheye or wide-angle and fit them to the camera. This is ideal for traditional film photographers moving over to digital, as it gives them the option of using old lenses on their new camera, provided the mounting system is compatible.

It's worth mentioning that this facility comes with a slight disadvantage. Every time you fit a new lens to a professional digital camera, its CCD sensor is exposed to the elements. CCDs are susceptible to dust and this can have an impact on image quality. As such, it is wise to swap lenses away from the elements and regularly clean the sensor with a blow brush.

As mentioned earlier, professional digital cameras offer enormous capacities of up to 14 megapixels. This allows you to shoot images that can be printed out to poster size, and the ability to capture such great detail is also ideal when editing images later. In addition, you should be able to save at 16 bits per channel in the high-quality RAW file format (*see page 22*).

MEGAPIXELS

The term "megapixels" is used to measure the amount of detail that a digital camera is able to record and store when taking a photograph. While there won't seem much difference between a 4-megapixel shot and a 6-megapixel shot if printed at 8 x 10 photo size, the difference becomes more apparent during image editing. To print out an image at true photographic quality, it needs to be the size you want it printed when the resolution is set to 300 pixels per inch (300ppi). The 4-megapixel model captures enough pixels to do this at 8 x 10 photo size, but having 50% more pixels to play with, the 6-megapixel shot gives you more freedom. You can zoom in on portions of the image, expand them, or manipulate the image in other ways without having to worry about jagged digital artifacts appearing. If you're unhappy with a composition, you can crop your shot quite fiercely, knowing that you'll still have enough pixel information remaining to create a decent print.

The Digital Toolbox

SCANNERS

Not so long ago a scanner was a major investment, particularly if you needed to scan in transparencies. Nowadays, prices have fallen and perfectly acceptable scanners are available at bargain-basement prices. If you plan to use a scanner to produce high-quality images, however, it is sensible to look at what's available at the higher end of the market.

Generally speaking, there are three types of scanner available. At the top end of the spectrum is the drum scanner, an expensive option that works by taping film on to a rotating drum and shining a narrow beam of light on to it, which is then converted to digital information. At the bottom end is the flatbed scanner, which operates by moving a CCD array across a glass plate. These can be purchased for less than $150. Most photographers, however, should opt for something more capable if they want to work with transparencies, and that could mean a specialist film scanner.

Costing more than the flatbed, the film scanner uses a row of sensors known as a linear array, moving a light source slowly across a film transparency and focusing this on to the array. Most are built to handle 35mm film, and adaptors are available for APS cartridges as well.

If you are a traditional film photographer moving over to digital—or even someone who wishes to work in film, then digitize your images—a film scanner is indispensable when converting film transparencies into editable digital files. If this is not a prime consideration, however, you may decide that a less expensive flatbed scanner is ideal for your purposes (in fact, many modern flatbed scanners include transparency adapters that are capable of producing respectable results).

In either case, there are a number of features to look out for when selecting a scanner that is right for you. Probably the most important feature of a scanner is its optical resolution. This term relates to the amount of pixels that the scanner is able to capture, and is measured in dots per inch, or dpi. In general, a maximum resolution of 300dpi is more than good enough for most digital photographers. When buying a scanner, do not confuse resolution with "interpolated resolution"—this refers to a method used by some scanners to effectively "guess" the colors of extra pixels to increase resolution, which should really be avoided.

Color depth is measured in "bits" and is another important feature to be aware of. This term refers to the units of information that a computer uses to store color. Most scanners and digital cameras work in 24-bit color, with each pixel assigned 8 bits of data per red, green, and blue color channel for a total of 16.8 million colors. More high-end software such as Adobe Photoshop is able to work in 48-bit color, for 16 bits for each of the RGB color channels and billions of colors. This may seem excessive, but it actually helps keep colors accurate during manipulation. However, if your image-editing software is limited to 24 bits, there's little point in purchasing a 48-bit scanner.

Above and right
Film scanners are capable of scanning 35mm negatives and transparencies at very high resolutions.

Above **Scanners aren't limited to photos, illustrations, and transparencies. They can also be employed to scan in materials and textures for use in photomontage.**

Right **Many high-end flatbed scanners now include a built-in transparency adaptor, enabling the user to scan negatives and transparencies at very workable resolutions.**

QUALITY AND RESOLUTION

Resolution is probably one of the most misunderstood aspects of scanning, partly because the issue isn't so much what you need to scan in as what you need to print out. If you're creating images for use on screen, say, to put on a web page or use in a slideshow, then your image only needs to be large enough to show at 72 pixels per inch on a 17-inch monitor. For print, however, your image needs to reproduce at 300ppi. Thus a standard 8 x 10 print at 300dpi requires that your image be 2,400 x 3000 pixels. Similarly, an 11 x 17 print at 300dpi requires that your image be 3,508 x 4961 pixels. If you scan an 8 x 10 print and intend to print it out at 8 x 10 inches, then it's easy: you just scan at 300dpi. If you scan a 4 x 6 image, however, and want it to print out at the same size, then you would need to scan at 400dpi. If you want to check that you're scanning to the correct resolution, create an empty image at the file size and resolution you require in your image-editing software. This gives you the precise size that you should be scanning to. The other main problem with scanners is their tendency to produce interference patterns (or moiré). This usually only happens if you scan in printed material from a book or magazine, and even then it can usually be fixed in the scanner software or your image-editing application.

Remember that a scanner is not only limited to scanning in photographs and transparencies. Many photographers scan in objects such as fabric for use as backgrounds in their photographs or for advanced texture mapping in a program such as Adobe Photoshop.

COMPUTERS

Digital image editing can be an intensive task, particularly when you're working with high-resolution digital photographs. Your computer needs a fast processor, a large hard disk, and plenty of RAM. It's also sensible to have something to back up your valuable images should disaster strike.

Home Computers

Many graphics professionals favor an Apple Mac computer, while others use a PC, but either is capable of producing high-quality results. PCs have an advantage in that they are more common and produced by many manufacturers in competition, which means they are cheaper and have a wider range of available software. Macs, on the other hand, feature a more attractive interface that can be easier to learn and use, and come with Apple's own suite of creative applications—iPhoto, iMovie, iTunes, and GarageBand—built in. Both PCs and Macs are able to run Photoshop, and the two versions are practically identical in use except for the keyboard shortcuts.

Nowadays, it is quite possible to purchase a home computer with everything you need for digital editing right out of the box. You may, however, prefer a computer system that suits your own specifications. This means ensuring that the computer's processor is fast enough to handle image manipulation, that there is enough RAM fitted to run powerful programs such as Photoshop, and that there is enough hard disk space to accommodate the enormous file sizes that digital image editing produces.

Generally speaking, an ideal configuration for a PC would comprise a minimum 60GB hard drive, with 512MB of RAM, and a 2GHz Pentium 4 processor. Macintosh users should aim for a similar configuration, ensuring that the processor is

Right **Large PC manufacturers, such as Dell, produce desktop machines that are more than capable enough for photographic work. You don't need to pay out for a specialist workstation to work with digital images.**

a 1Ghz G4 processor or any G5 processor. These specifications will ensure that you are able to run almost any image-editing program without spending too much time watching activity bars edge slowly forward.

One other consideration should be the graphics card or graphics chipset used by your computer. Ten years ago these did little more than provide an interface between your computer and your monitor screen, but nowadays they include their own speedy processors that accelerate 2D and–especially–3D graphics. If you intend to use 3D applications as well as a 2D image-editor, a fast graphics card with support for OpenGL (a set of instructions for 3D graphics) is essential. Nearly any new PC or Mac will come with some form of OpenGL-supporting hardware included, but the performance can differ massively, so do your homework before buying.

Right **Apple's G4 Powerbooks put image-editing power in a portable package, with large screens and excellent graphics capabilities.**

Monitors

Monitors also come in two distinct types. Some still use CRT (Cathode Ray Tube) screens–a technology similar to that used in most TV sets. These offer a high-quality display at the disadvantage of being big and bulky. If you have limited desk space, you might want to look at an LCD monitor instead. These are more expensive than CRT monitors but take up much less room. Although there is some debate as to which of the two types of screen offers the best picture, both have advantages. A CRT is usually brighter, but a good LCD screen offers better definition. When purchasing a monitor, try to get one with the largest screen you can afford–it will make your image-editing work that much easier.

Storage

No matter how big your hard drive is, it's likely that you'll manage to fill it up sooner or later. This–and the need to back up your precious data–is a good reason to invest in some form of external storage device. There are a number of options available to you, including external hard disks that range in capacity from 20GB all the way up to 800GB. An external hard drive connects to your computer and enables you to back up thousands of digital photographs. If you are on a budget, however, you might want to consider CD or DVD burners. Compact disks can store a maximum of 800MB of data, while DVDs can store 4.7GB of data. For many people this is plenty enough capacity for archiving and distribution.

The Digital Toolbox

PRINTERS

The digital photographer's third and final piece of essential equipment is the printer. Top of the range laser printers produce consistently excellent results at high speeds, but the cost of buying one is prohibitive for nonprofessionals. Meanwhile, an inexpensive inkjet printer allows you to output prints of photographic quality, but this approach has its own hidden costs—inks and papers don't come cheap!

Inkjet Printers

Nowadays, even the cheapest inkjet printers are capable of producing prints that can pass for photo-quality, and more expensive models can produce gallery-standard output. Like digital cameras, there are dozens of different models available, and for this reason there are a few important features that you need to be aware of.

As always, resolution is a prime consideration, but once again this isn't a clear-cut issue. While an image destined for printing should have a resolution of 300ppi, most inkjets now offer a resolution of at least 1,200dpi, and sometimes up to 2,800dpi. Inkjet printers work by squirting microscopic dots of three, four, or six colors on to paper, and these colors are layered or dithered into patterns to create an impression of the other colors in the image. This makes the size of the dot a significant factor: the smaller it is, the better the image quality. Good printers use up to three-dozen dots per pixel, but. cheaper models may not even offer half this number, and print quality will inevitably suffer as a result. For this reason, a 2,800dpi model is a wise investment if you want to hang your work on the wall.

However, resolution doesn't tell the whole story. Most inkjet printers use four different colors of ink to produce their prints—cyan, magenta, yellow, and black—while some use six colors, adding a lighter cyan and magenta. This results in more realistic-looking photo prints, but has another downside. Inkjet printers have a tendency to use up inks very quickly and replacement cartridges can be expensive—sometimes a single cartridge can cost a quarter of the price of the printer! For this reason, try to minimize your ink usage by ensuring that the printer you purchase allows you to buy replacement cartridges for each individual color. Some cheaper models demand that you replace all colors when only one color has run out—an expensive business.

Dye-Sub Printers

As an alternative, some printer and camera manufacturers now produce smaller dye-sub printers specifically for photo printing. These work by vaporizing solid dye on to paper, so producing true continuous tone images that closely match the quality and look of conventional photographs. Unfortunately, these printers only produce prints of a limited size (usually 6 x 4), and while larger dye-sub printers are available for professional print and graphics work, the cost of purchasing and maintaining such a system is prohibitive.

Right **For printing purposes, the resolution of an image needs to be as close to 300ppi as possible. At 11 x17 size, this would mean a ludicrous 15-megapixel image—one reason why most professional photographers need all the megapixels they can get.**

New

Name: Untitled–1 OK

Image Size: 49.8M Cancel

Preset Sizes: A3

Width: 3508 pixels

Height: 4961 pixels

Resolution: 300 pixels/inch

Mode: RGB Color

Contents
- ● White
- ○ Background Color
- ○ Transparent

Below **Epson's Stylus Photo R800 is a good photo-quality inkjet printer, with archive-standard inks and a 5,760 x 1,440 dpi resolution.**

Above **Canon's i905d combines a 4,800 x 1,200dpi resolution with the ability to print images direct from a memory card. The LCD screen means you can review and print images without ever using a computer.**

PAPER PRIORITY

High-resolution inkjet technology and photo-quality inks won't produce good prints unless you're also prepared to splash out on paper. This is another hidden cost of inkjet printing. If you have ever tried to print a photo on standard copier paper, you will probably have got a poor result with dull colors and a serious lack of detail. This is because the small drops of ink hit the paper but sink into the surface and flow into the coarse grain of the sheet. Specialist photo papers use a matte or glossy coating to keep the ink on top of the paper, while a specially prepared or textured surface keeps the ink from spreading. Most inkjet manufacturers will advise you to use their own paper. On the one hand, this will be designed to work with their inks and their printer technology, but on the other hand, it's often an expensive option. In many cases, a third-party photo paper will provide excellent results.

Laser Printers

A third option is the laser printer. These are becoming more affordable, and are able to produce photographic prints that easily match the quality of ink jets without using special paper or inks. For this reason, they can be a cost-effective option if you intend to output your images in the larger format, but you would have to be doing a lot of printing to really make a color laser printer a worthwhile option. As a result, only print and graphics professionals will have access to this sort of technology.

IMAGE-MANIPULATION SOFTWARE

There is an amazing wealth of software available for the digital photographer, including image-editing software, 3D landscape generators, cataloging software, and special-effects plug-ins. At the least, most digital photographers will be familiar with Adobe Photoshop or its accomplished junior version, Photoshop Elements.

Surreal digital photography is all about image manipulation. While cheap or free packages such as iPhoto, Graphic Converter, or PictureIt! offer basic correction features, manipulation requires something more heavy-duty. There are several applications that can do the job, but the big daddy of all image-editing packages is undoubtedly Adobe Photoshop.

From its birth in the late 1980s, Adobe Photoshop has developed into the de facto standard in image editing on both the PC and Macintosh platforms. Now at version 8, Photoshop gives you absolute control over the photographs that you take—there is literally nothing that you cannot do with an image. Unfortunately, there are a few drawbacks to all this power. Firstly, Photoshop is not an easy piece of software to master; its learning curve is steep and has spawned a whole cottage industry of off-the-shelf manuals and tutorials to help you get to grips with it. Secondly, it has a price tag that is likely to deter all but the professional digital photographer.

Fortunately, Adobe also offers a cut-down version of Photoshop, Photoshop Elements, which offers most of the features of its elder brother at a more affordable price. For most people cutting their teeth in the world of digital imaging, Elements will provide more than enough power to get you started. Indeed, its simpler interface can provide an ideal introduction to Photoshop. By the time you have used Elements and become comfortable with its features, you will be ready to upgrade to the real thing.

On the PC, it is also worth taking a look at Paint Shop Pro. This cut-price rival to Photoshop has many of the same features and, despite a sometimes clunky interface, some extremely powerful tools all of its own.

Adobe Photoshop

Photoshop offers such an abundance of capabilities that it's difficult to know where to start, but there are some key features that you will keep returning to time and again. First among these is Photoshop's extensive color controls, including adjustments that give you control over color channels, color curves, brightness and contrast, hue and saturation, and tonal levels. These features allow you to fine-tune the colors in your images by making adjustments to the whole image or to individual color channels.

Another important feature for the digital photographer is layers. Layers are rather like pieces of translucent tracing paper laid over your image. You can select and copy elements from within your image, place them within their own layer, and work on them independently, or you can control the opacity of layers and how they interact with

Right **The complexity of the Photoshop interface may initially be a little off-putting. Once you use the program for a short time, however, you become accustomed to its huge range of powerful controls.**

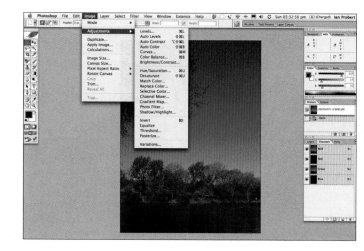

other layers using a range of preset blend modes. You can also create adjustment layers, enabling you to control how changes to color and tone affect your image with a greater precision. When editing an image, layers give you tremendous flexibility, as you will see later on in this book.

No discussion of Photoshop is complete without mentioning its filters. There are dozens available, all offering different functions—some useful, some not so useful. Filters are used to transform the look of an image or part of an image. This can mean blurring or sharpening the focus of a picture, distorting components of the picture, or even turning it into a digital watercolor painting or chalk drawing. The possibilities are limitless. Remember—this is only the start of what Photoshop can do.

GRAPHICS TABLETS

For the digital photographer, the graphics tablet is an interesting alternative to the mouse. Graphics tablets are pressure sensitive and come equipped with a special pen. They are particularly useful when using the drawing and painting tools in programs such as Photoshop or Painter. Pressing down harder with the pen on the tablet increases the flow of ink; pressing softly decreases the flow. Graphics tablets come in a variety of sizes, from 4 x 5 up to 12 x 18 inches.

Left **The Photoshop Elements interface shares many similarities with its elder brother, Photoshop. Elements is still a very powerful program in its own right, and a great introduction to digital image editing.**

Elements

It's hard to launch Photoshop Elements without being struck by its similarity to Photoshop proper. Both programs' interfaces look more or less the same, with tools available at the sides and top of the screen, plus pull-down menu commands and floating palettes. Indeed, feature-wise there are few major differences between the two programs, and both offer extensive color adjustments, layers, and filters. In fact, the only significant differences between the two programs is that Photoshop offers more

complex color adjustment features and the ability to work with CMYK images—essential features if you're involved in professional publishing, but not so essential if you're printing to a standard inkjet printer. This makes Elements a fine image-editing package and the ideal entry-level program.

Paint Shop Pro

For PC users, Paint Shop Pro is a very commendable alternative to Photoshop. All the standard image-editing tools are built into the program, as well as advanced

batch-editing features and a useful image browser. At less than $100, it's far cheaper than Photoshop, too.

Painter

Another alternative to Photoshop is Painter. Although not strictly a dedicated image-editing package, Painter offers many of the features of Photoshop—including advanced color controls, layers, and filters. Where Painter differs from Photoshop, however, is in its use of real media tools. Painter offers digital re-creations of almost any kind of

IMAGE-MANIPULATION SOFTWARE

Right **Although not a dedicated image-editing program, Corel Painter offers some interesting effects, including the ability to add textured backgrounds to your images.**

Right **Apple's iPhoto is bundled free with every new Macintosh computer and is a very useful image-editing program. Not only does it include rudimentary brightness, contrast, red eye, and correction tools, the program is also adept at cataloging photographs.**

painting or drawing medium, including oil, watercolor, chalk, pencil, and even Magic Markers. This is particularly useful for digital photographers who wish to add painterly effects to images.

Corel Photo-Paint

Part of Corel's CorelDRAW graphics suite, Photo-Paint offers a similar feature-set to Photoshop with a slick professional interface, plus powerful tools to extract

foreground selections from backgrounds and additional creative features. Earlier versions are also available in inexpensive bundles, meaning you can pick up a professional-level photo-editing package at a bargain price.

iPhoto

Available for purchase as part of Apple's iLife 04 or bundled free with any new Macintosh computer, iPhoto offers limited

image-editing features. Of more use, however, is iPhoto's image browser, which offers useful cataloging facilities and "smart" slideshows. Not really a professional tool, iPhoto is still an excellent means of organizing your digital photographs.

PLUG-INS

Plug-ins are small "applets" that are added to host programs to extend their features or functionality. There is a wide range of plug-ins available for Photoshop, and most other programs, including Photoshop Elements, Paint Shop Pro, and Photo-Paint, will support Photoshop compatible plug-ins, although it's always wise to check first.

KPT Effects

KPT, or Kai's Power Tools, is long established as one of the premier suites of plug-ins for Adobe Photoshop. Consisting of a set of different plug-ins that allow you to create textures, gradients, and diverse effects such as lightning and fractal patterns, KPT Effects is aimed at the digital photographer with an equally diverse imagination. KPT has an unusual interface that many find difficult to master. In terms of what you can do to an image, however, the suite of filters has no peer. Where KPT really excels is in its ability to generate unique backgrounds and textures—ideal when working with photomontages.

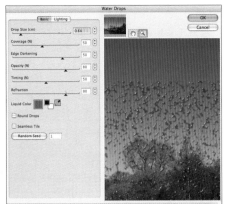

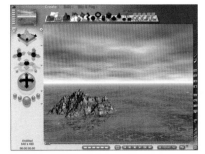

Above **KPT's unique interface is an ideal aid to creativity. Here lightning effects are added to a seascape.**

Above right **The Eye Candy plug-in offers a host of special effects, including the ability to add water drops to your photographs.**

Above **With Bryce you can "shoot" your own exotic landscapes without ever having to leave the house. You** **can then import the file into Photoshop and use it as an exotic background in your photomontages.**

Eye Candy 4000

The Eye Candy suite of plug-ins is another eclectic set of effects. It's useful for adding effects such as fur, fire, shadows, and bevels to selections, and is particularly well-suited to adding special effects to type. Note that, with a little knowledge, many of Eye Candy's effects can be created using Photoshop's standard toolset.

3D LANDSCAPE CREATION

Adventurous digital photographers might also consider a 3D landscape generator, such as Bryce or Vue D'Esprit. These allow you to create photorealistic landscapes with complete control over terrain, oceans, trees, skies, and weather. Using them takes some technical skill and practice, but they do have advantages for surrealist photography, as you can create your own world, then place photographed figures or objects within it.

Bryce

Bryce is the most famous 3D landscape generator, but has suffered from a lack of support in recent years. At its highest render settings you can create 3D scenes that are scarcely discernible from the real thing. The program features a unique "organic" interface that is designed to speed up your workflow. Landscapes are created as polygons that can be edited and positioned anywhere within the picture frame. Bryce also gives you control over the weather and time of day; the program even includes a Tree Room, in which you can generate naturalistic-looking trees.

You can import 3D models from other programs, or use your own photos as backdrops in the image. The results can be output to a variety of formats, including layered TIFF files that allow you to store channels and masks for use in Photoshop.

Vue D'Esprit

Vue D'Esprit is available on both the PC and Macintosh platforms and is another powerful 3D landscape creator. Originally developed as a plug-in, the program is now stand-alone and shares many of the features of Bryce. Vue D'Esprit is currently considered top-of-the range in this field and integrates very well with Photoshop.

CATALOGING SOFTWARE

Although Photoshop now includes its own image browser, it's useful to have a means of organizing and cataloging photographs. Programs such as Extensis Portfolio (available from **www.extensis.com**) and iView MediaPro (available from **www.iview-multimedia.com**) can help. These enable you to label, organize, archive, and search through your photos in an easy-to-understand manner.

COLOR MANAGEMENT

One of the best things about image-editing's move into the mainstream is that you don't really need much technical know-how to get on with it. However, if you want to do justice to your art, then you need to understand something about color management. Getting your printed color to match what you see on screen is a science, and it helps if you know a few basics.

FILE TYPES

Most digital cameras are capable of storing images in a variety of formats.

JPEG

The most common format, and the standard format in most digital cameras. JPEG uses sophisticated compression methods to produce high-quality prints while keeping file sizes to a minimum. At the lowest-compression/highest-quality setting, a JPEG file can be output at photographic quality. At higher compression settings, however, detail might be lost and imperfections known as artifacts could appear. If your camera only stores its images in JPEG format, it is advisable to convert them into the generic Photoshop (PSD) format before editing.

TIFF

Some cameras allow you to save your images as TIFF files. These are uncompressed files that support 24-bit color, allowing for very high-quality photographic output. TIFF files also include lossless LZW compression, which can reduce file sizes by up to 50%. Use TIFF files if you want to print photo-quality images with full detail and no risk of artifacts appearing.

RAW files

High-end professional digital cameras may allow you to store files in the RAW format—which now acts like a widely supported "digital negative." This format stores the same level of detail as a TIFF but with more color information (RAW files can store 16 bits per channel if your camera will support it) and with extra information, such as camera focus and exposure settings, stored as part of the file. Naturally there are drawbacks: RAW files can be up to eight times the size of a JPEG file, which means that a digital camera memory card can fill up very quickly, and many image-editing programs need a special plug-in before they can open RAW images.

One of the biggest problems that you will encounter when using a computer to edit photographs is the tendency for colors to appear differently on screen to how they appear when printed out. The rich blue of a sky, for example, may look perfect on screen. When printed out, however, it may lose its proper hue—the difference might be subtle, but it will have an impact on your image. This partly occurs because your monitor might not be set correctly, with the colors too dim or the contrast too high or low. To make things more complicated, the colors on a computer monitor are described in terms of how much red, green and blue (RGB) light is present in a pixel, while colors on the printed page are described in terms of cyan, magenta, and yellow ink. Getting one to match the other isn't always as straightforward as you might think.

To combat these color discrepancies it is necessary to calibrate your screen. This isn't as difficult as it sounds—you just need to use a Color Management System or CMS for short. The easiest way to do this is to use ICC profiles. Developed by the International Color Consortium, ICC profiles change the colors on your screen so that they match the color profile of the device to which you are outputting your image.

Many output devices such as inkjet printers include software-install disks that contain an ICC color profile of the device. In

Color Management in Adobe Photoshop

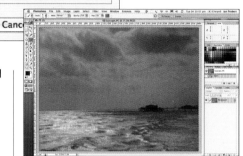

Mismatch
Opening any digital photograph in Photoshop brings up a range of options designed to assist with the color-management process.

Custom Settings
A better option is to load settings that you have already fine-tuned to suit your

output device. In this case, I'm using a Hewlett Packard 950 inkjet printer.

the Windows or Macintosh Displays control panel, all you need to do is select your printer's ICC profile and the colors on your screen adjust to match it. For this reason, it is best to decide how you intend to output your images—if you intend to send your image to a printing bureau, ask them for a copy of their ICC profile.

Color calibration is a good idea if you're printing on an inkjet at home, but essential if you're sending images out to print elsewhere. Even if you use an ICC profile, it is good practice to test the results by comparing prints that include neutral tones such as flesh or skies with those seen on screen. This should be an ongoing process of refinement until you finally achieve printed results that you are happy with. When you do so, be sure to save a copy of your settings, which can be loaded into your image-editing software whenever you open a new image.

No Conversion
Selecting the *Use the embedded profile* option leaves the image with the color profile assigned to it by the digital camera

that produced the image. In this case, the end results are unsatisfactory, leaving the overall colors muted and the blues in the sky washed out.

Converted
An alternative is to select the *Convert document's colors to the working space* option. This converts

the file's colors to the same profile that is currently in use by Photoshop. Again, the results are far from perfect.

Print Settings
With these settings loaded, the image is converted to your printer's working color space. This increases the contrast and strengthens the blues

in the image. More importantly, because these settings are adjusted to match your specific printer, the image will print out exactly as it appears on screen.

2

Before we embark on our voyage into digital surrealism, we need to prepare with some basic image-editing techniques. If you're already involved in digital photography, you will already be familiar with color correction and retouching tools, but you may not be so experienced with selections and compositing, the brush tools, or digital filters and effects. If that's the case, this chapter will help you on your way. As Adobe Photoshop is the most popular image-editing package around, we're going to concentrate on using its features, but many of the methods shown can be replicated using Paint Shop Pro or Corel Photo-Paint instead.

special effects workshop

Special Effects Workshop

SELECTIONS, PATHS, MASKS, AND CHANNELS

Montage is key to surreal digital imagery, and the first task of montage is being able to separate digital photos into discrete elements. Once you have these elements—your raw material—they can be combined and manipulated at will. This will require a deft hand with Photoshop's basic selection tools, not to mention its paths, masks, and channels facilities, but there are good working methods that can help you get the best from the Photoshop toolbox.

Working With Selections And Masks

Making good selections is the bread and butter of Photoshop. Making a selection of an element within an image is often the starting point for many special effects projects. Without clean selections, no amount of special effects wizardry will make your artwork believable.

The basic Marquee selection tools and the Magic Wand tool are among the oldest of Photoshop's selection tools and are as valid today as they ever were. However, like all tools they have their limitations and they may need some assistance to generate professional and credible works of art.

Speed and ease of work are important factors to take into account. There are many different ways to make any given selection

and, with experience, you soon learn which will be the most effective for the task in hand. While the automated selection tools are always tempting, in some cases the Magic Wand or a simple Elliptical Marquee selection may be a better starting point.

I am adopting this strategy in the selection of the girl. I want to cut out the girl and the orange cushion on her lap. The girl's hair color, flesh tone, different-coloured clothes, and cushion make it too complex for a simple selection, but the plain white background is crying out to be made use of. There are times when it is easier to select the subject's background rather than the subject itself and this is particularly true in this case.

3 With half a dozen clicks I've managed to make a fast, automated selection of the majority of the girl. Not bad for 10 seconds work.

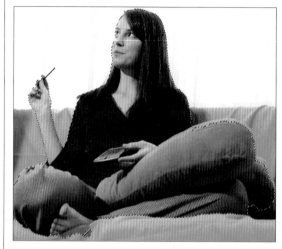

4 However, there are a couple of problem areas. The orange cushion is very similar to the color of the sofa at the edges, as is the girl's foot. Even adjusting the Magic Wand tool's Tolerance can't overcome this problem, but all is not lost because we have a nifty feature called the Quick Mask which will make a great job of finishing off our selection.

1 Using the Magic Wand tool, I click on the white background and I have an instant clean selection of the upper part of the girl.

Now if I invert the image (Ctrl/Cmd + I), I have selected the subject rather than the background.

2 I will stay with the Magic Wand tool and use the Add To mode to click on other areas of the girl to build up the selection.

5 The Quick Mask is ideal for making selections where there is little contrast or, as in this case, finishing off an okay selection. The Quick Mask is accessed by pressing Q on the keyboard or clicking the Quick Mask mode icon in the Toolbox.

6 Now in *Quick Mask* mode I can use a paintbrush and paint with black to add to the mask. Painting with white does the reverse and removes the mask, so you can switch back and forth, fine-tuning as desired.

7 The default color of the *Quick Mask* is red, but if red conflicts with the image, as it does in this case, you can change the color by double clicking the *Quick Mask* icon in the *Toolbox* and changing the color from the options dialog box that opens.

Here I'm using a purple color that contrasts well with the image and makes my task easier.

The Color Range Selector

The Magic Wand *tool worked well in the last example, but you would need to set a limit on how many multiple clicks of the tool you are prepared to carry out, for the sake of your index finger if nothing else.*

The Color Range *selector gives us a variety of options that extend the capabilities of the* Magic Wand *tool.*

1 I want to make a selection of the yellow areas of the birds only.

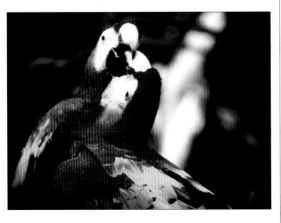

2 Going to *Select >* **Color Range** I use the central + *Eyedropper* and drag through the yellows to select them. The yellows do not have to be contiguous in the image in order for them to be selected. The selection is based on the color value. The *Fuzziness* slider works in a similar way to the *Magic Wand* tool's tolerance value in that moving it increases or reduces the range of colors within the selection.

3 The *Color Range* selector is also ideal for more nebulous selections. In the next image I want to select the smoke and tint its color.

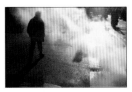

4 Rather than thinking about which colors I am trying to select, I can look at the brightness values in the image and use those as the basis for my selection. The smoke is definitely the lightest part of the image, so I can use the *Color Range* selector to select just the highlights.

5 This gives me a perfect feathered selection of an area that would be difficult to define with sufficient subtlety.

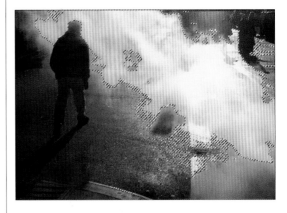

Special Effects Workshop

SELECTIONS, PATHS, MASKS, AND CHANNELS

The Extract Tool

A more recent addition to the Photoshop arsenal of selection tools is the Extract tool. While this tool can be used in more general situations, it is ideally suited to making selections of subjects with fine hair or fur–in fact, any task where more conventional tools may struggle.

The close-up of the heron's head is a likely candidate for the Extract tool. Its outline has a number of fine hairs or feathers that would cause problems for other tools.

1 The Extract tool is accessed from the Filter menu. Using a small brush, I have carefully traced around the outline.

2 Filling the outline with a contrasting color using the Extract tool's paint bucket completes the operation.

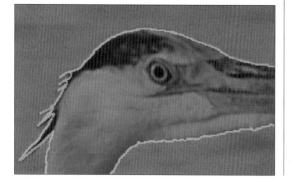

Paths

Paths are created using the Pen tool, although they can also be created from converted selections. A common use of paths is when very accurate lines are required and the image offers no color or brightness contrast from which to make a selection.

The black automobile is an example of this. Beneath the front right wheel arch, the distinction between the vehicle and the ground disappears.

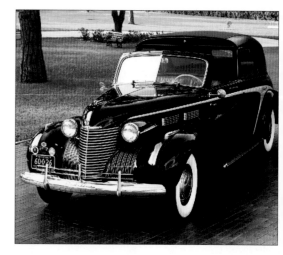

1 Using the Pen tool, I have created a path around the outline of the automobile. Of course, if you cannot see the outline of the subject, as in this case, you will need to exercise a little artistic license.

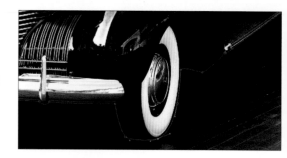

2 Paths are enormously flexible. If there are elements you're not happy with once a path is finished, you can simply edit the anchor points with the Direct Selection tool and fine-tune the entire path until it is perfect.

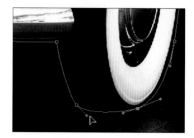

3 When the path is perfected, it can be converted to a selection and used as any normal selection would be used. To convert the path to a selection, press Cmd + Return (Mac); Ctrl + Return (Win).

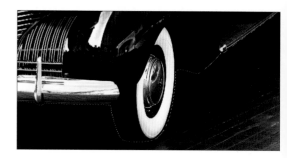

Channels

Even though you may never use or even look at the channels, they are always in residence in Photoshop anytime you open a document. The channels store the color information of an image, with each category of color being stored separately. For instance, in an RGB image you will see 4 channels. The Composite RGB *channel shows all the colors combined as well as a* Red, *a* Green, *and a* Blue *channel.*

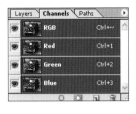

Each channel can be viewed separately by clicking the relevant channel in the *Channels* palette. Depending on how the preferences have been set up, you will see either a grayscale image or a blanket color cast relative to the channel chosen, i.e. the *Red* channel will appear with a red cast and so on.

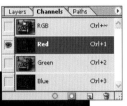

As well as storing the image in separate color channels, the *Channels* palette also stores alpha channels. This is the name given to a selection after you have saved it. The selection is saved as a grayscale in the *Channels* palette. This is the selection of the car after it has been saved and stored as an alpha channel.

▶ In some cases, the channels can be used as a method of making the selection itself. This is a technique most commonly employed when the image offers little or no color contrast for making a selection. In the next image, I want to cut the girl out from the background.

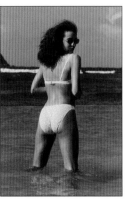

1 With the *Red* channel selected, I go to *Image > Calculations*. Using the settings shown in the next image, Photoshop creates another channel which is the result of the *Red* channel duplicated using the *Add* blend mode.

2 Looking in the channels, I click through each of the *Red*, *Green,* and *Blue* and find the *Red* channel offers the greatest contrast between the girl and the background in this case.

3 This has effectively increased the contrast further between the girl and the background. Now I can paint with white on the new channel to complete the alpha channel.

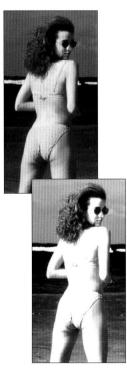

MASKS, ADJUSTMENT LAYERS, AND BLEND MODES

The introduction of layers into Photoshop some years ago signaled the advent of a new era in digital-image manipulation and from that moment onward life for many digital artists, image manipulators, and photographers would never be the same again. Suddenly, a world of possibilities opened up. The seemingly impossible was now a reality. A creative's mental vision could be rendered on screen with ease and the closed world that was the art of illusion opened its doors to a whole new breed of digital innovators.

To create images without layers today would be unthinkable, but the power of digital special effects lies in going beyond the basic layers to utilizes Photoshop's enhanced layer facilities.

Clipping Masks

The simplest way of describing a Clipping Mask (previously called clipping groups prior to Photoshop CS) is to think in terms of putting something inside something else. For instance, think of putting a person in a cage or some jelly in a jar. A Clipping Mask allows you to fit the pixels on the top layer into the pixels on the bottom layer in one easy move.

In the next example, I want to create the illusion of a view of some open grassland with deer grazing. The viewer is looking through some binoculars and sees one deer in close-up through the typical twin circles of a pair of binoculars. This is a perfect illusion for a Clipping Mask.

3 The resulting image allows me to move the close-up deer image so I can position it anywhere I wish within the binocular-shaped pixels.

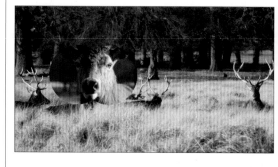

4 To make the binocular illusion stand out more, I have added a *Stroke* layer style to the binoculars layer.

Solid Color...
Gradient...
Pattern...

Levels...
Curves...
Color Balance...

1 First, I need to set up the layer order. The bottom layer holds the deer in open grassland. A simple pair of overlapping circles are on the next layer and the top layer has the close-up version of a deer.

2 Ignore the bottom layer. It's the top two layers that do all the work. These are the two that will become the *Clipping Mask*.

One very simple way to make the *Clipping Mask* is to hover the cursor on the border between the two relevant layers, hold down the Alt key, and click.

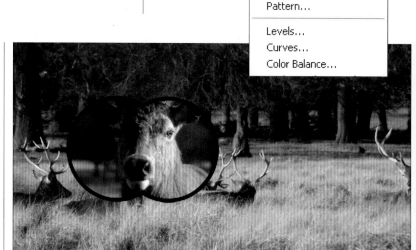

Layer Masks

Layer Masks *are the big daddy of photo compositing. They have replaced the valuable function performed by airbrush artists who spent thousands of hours working to create ethereal illusions, scenarios that never existed, and put the super into supermodel (yes, even the famous and beautiful need the help of Photoshop sometimes).*

Scan through any magazine and you're bound to see the result of a Layer Mask. *But above all else,* Layer Masks *remain the style of choice for movie producers and paperback book publishers. There is no better way to sell a book or a movie than to composite some choice imagery at different proportions in one neat package.*

For this romantic novel paperback cover, I want the heroine to be gazing dreamily into space as her face fades out from blue sky across a tropical paradise.

1 First, I combine the two layers with the tropical island as the bottom layer.

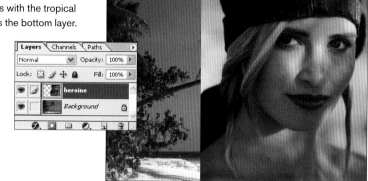

2 Then I add a *Layer Mask* to the heroine layer by clicking the icon at the bottom of the *Layers* palette.

3 The principle is now the same as with the *Quick Mask*. If I want to hide the heroine image, I paint with black. If I paint with white, I will reveal the image. In either case, it's important to make sure the thumbnail on the right is the active one. This way I am painting on the mask, and using black and white paint will simply hide or reveal the image.

4 I have used a large soft-edged brush at low *Opacity* to create the effect shown here. Unless you are trying to achieve crisp edges you will find low *Opacity* soft-edged brushes render more pleasing results.

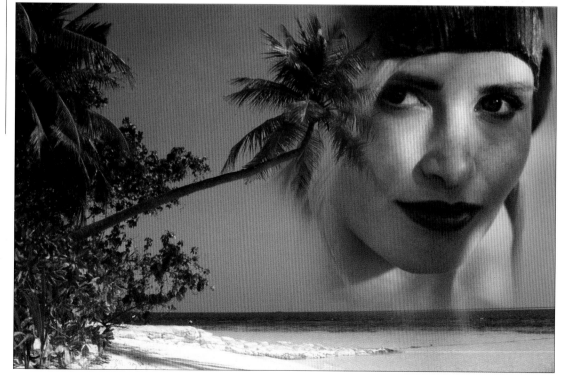

MASKS, ADJUSTMENT LAYERS, AND BLEND MODES

Adjustment Layers

Rather than being an aid to special effects, adjustment layers offer greater functionality with the tools and commands at your disposal. As an example, if you wanted to make a color change using the Hue/Saturation command, once you had made the edit, it would be permanent unless you used the History Palette to go back or saved additional copies. Adjustment layers

remove this permanence and save you the trouble of making additional copies. The Hue/Saturation command is just one of a number of edit capabilities that can be applied as an adjustment layer for greater flexibility.

I'm going to stay with my romantic book cover to demonstrate adjustment layers. I've decided to make the heroine an overall blue color.

1 With the heroine layer selected, I click the Adjustment Layer icon at the bottom of the layers palette and choose Hue/Saturation for the drop-down box. This also reveals all the options applicable to adjustment layers.

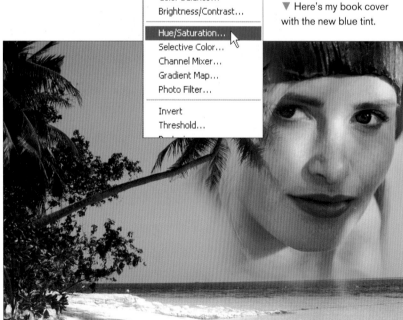

▼ Here's my book cover with the new blue tint.

2 Now that I've selected the shade of blue, if I don't like it either now or at some future time, all I need to do is double click the left thumbnail in the adjustment layer to access the settings I applied previously.

3 You may have noticed that I only wanted the girl to turn blue, not the whole scene. But adjustment layers affect every layer below them. This isn't a problem, however, as I can call on a trick we know from a previous step. By making a Clipping Mask of the adjustment layer, and the heroine layer I can get the adjustment layer to affect only the layer immediately below it.

4 If you know you want to clip an adjustment layer and another layer together before even creating the adjustment layer, you can do this by pressing and holding the Alt key as you click the New Adjustment Layer icon in the Layers palette. By doing this, you will cause the New Layer dialog box to open. Check the box labeled "Use previous layer to create clipping mask" and the Clipping Mask will be automatically created.

Blend Modes

Blend modes offer a powerful way of applying special effects between pairs of layers. The variety of effects is broad and warrants experimentation to get the best out of them, but here's a brief rundown of the most useful modes.

Layer blend modes are accessed from the drop-down box at the top of the layer palette.

1 For changing colors while keeping the shadow, highlights, and textures intact, use either *Hue* or *Color*. In this example, the top layer has a selection of the car with a solid green fill. The bottom layer is the original car.

2 This is the image with the top layer blend mode changed to *Hue*.

3 And now changed to *Color* mode.

4 Similar effects are achieved with *Overlay* mode.

5 And *Soft Light* mode.

6 *Screen* mode is useful anytime you want to hide a dark background but keep any lighter elements on the layer visible. A good example is when applying the *Lens Flare* filter. In the next image, a *Lens Flare* has been applied to a solid black layer which is above the car layer.

7 By changing the *Lens Flare* layer's blend mode to *Screen*, the black is no longer visible which means I can now reposition the flare at will. This would not normally be possible. Additionally, the layer *Opacity* can now be brought into play to control the degree of flare.

8 *Multiply* mode is an old favorite for drop shadows. Using this mode at a reduced layer *Opacity* allows the textures of the lower layer to show through, making for a convincing shadow.

Special Effects Workshop

BRUSH AND AIRBRUSH TECHNIQUES

The Photoshop paintbrush engine underwent some startling transformations when version 7 was introduced, and these have carried through into Photoshop CS. From a relatively humble tool, it is now a powerful creative feature capable of simulating real-world painting media.

For photographic special effects purposes, the paintbrush is important. Thus is not so much for its ability to mimic oil paint and watercolor, as for the way it makes techniques possible that can enhance an illusion. These effects would be difficult to carry off with other, more conventional methods.

▶ *To demonstrate an important paintbrush technique, I'd like to place the exploding firework image on top of the sunset image.*

All I want is the explosive light of the firework, not the background sky or the city, and of course I want the fine threadlike sparks at the outer perimeter. A Layer Mask *is the method I've chosen to combine the two images, but I don't want to spend*

time meticulously painting around every spark. So I will create my own custom brush shape with as much intricacy as I wish.

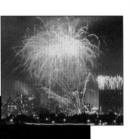

1 First, I make a selection with the *Magic Wand* tool of a suitable area. I've gone into *Quick Mask* mode just to aid clarity.

2 To make the selection into a brush, I go to *Edit > Define Brush Shape* and give the brush a name.

3 This new brush appears in the *Brush* palette as the last entry.

4 Before I use it, I'm going to set up some random functions so the brush twists and turns as I paint, avoiding any obvious repeated patterns.

First, I select the *Shape Dynamics* option within the *Brush* palette and apply settings to the *Size Jitter*, *Minimum Diameter*, and *Angle Jitter*. This will randomize the size and angle of the brush. The *Minimum Diameter* ensures the brush will not shrink below the size I have specified.

5 Next, I go to the *Scattering* option and apply a scatter of 128% to both axes and set the count to 5. This has the effect of bulking up the brush as each brush mark scatters away from the path I paint. The *Count* defines the number of individual brush marks that are generated.

Special Effects Workshop

6 All that remains is for me to paint. I am painting on a *Layer Mask*, as we saw in the previous section. I can now quite effortlessly paint on the mask with my custom brush and reveal the firework in all its intricate detail—I don't even have to zoom in.

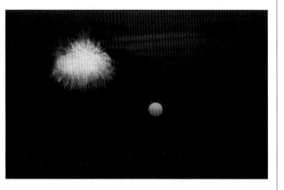

▼ I've used this work-through to demonstrate how you can make your own complex brushes and apply what would seem to be a difficult effect with ease. However, to move away from brushes just for one brief moment, we could also achieve the task of merging these two images using the same Layer Mask and blend modes that you learned about in the last section. I've used

Hard Light *mode here and painted out the background of the firework scene using the same layer mask and an ordinary soft brush. The* Hard Light *blend mode has successfully hidden the dark sky around the firework but still reveals the bright sparks.*

Okay, back to brushes.

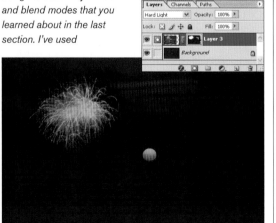

The Airbrush

The tool of choice in pre-computer days for fine post-photographic enhancement. But its digital namesake still has a role to play. Creating or accentuating highlights is an ideal task for the airbrush. I have boosted the highlight on the chrome edge in the second of the next two images by adding a couple of bursts of white paint on a new layer. The airbrush will respond with greater subtlety when used at lower Opacity *and* Flow *settings.*

The airbrush generates a uniform flow of paint. There are times when this may not be practical. Perhaps you want a soft edge on one side of the brush stroke and a hard edge on the other. This would be a typical scenario if you were using the airbrush to define highlight and shadow. Traditional airbrush artists used a stencil principle to achieve this effect so hard or soft edges could be controlled. The same principle can be applied to Photoshop, but with much less trouble.

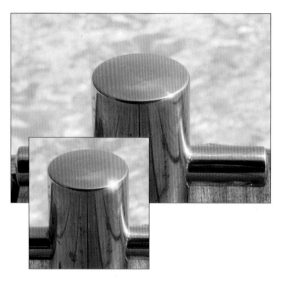

1 I am using this method on the image of the wood carving. I want to bolster the highlights and shadows, so first I make a selection of the area I want to protect.

2 Now I run the airbrush at a low setting over the relevant image area so that the brush actually overlaps the protected area.

3 Deselecting the selection reveals the result. I now have a hard edge on the left and a soft edge on the right. Perfect for the illusion of manually molding the carving and enhancing a lifelike highlight.

LEVELS, CURVES, AND COLORIZING

Tone and color correction are important parts of any image-editing process, but even more so in surrealist montage, where color matching and manipulation are needed for a believable result.

Levels

The Levels *tool is a fundamental feature of Photoshop. A large proportion of all images will always benefit from some form of adjustment to their tonal levels.*

▶ If we look at the histogram for the shower image, it tells us this image would be described as an average key image. That is to say, the bulk of the pixels that make up the image are distributed within the mid-gray range. Fewer pixels make up the shadow and highlight areas, so we see an almost symmetrical mountain peak.

▶ If we were to criticize the image, we could say it's a little lackluster. The image looks rather flat and lacks definition. This is where levels can help us. By dragging the *White* slider to the left and the *Black* slider to the right, I will increase contrast. The closer the sliders come together, the greater the contrast.

▶ Here's the result of the levels change. A more punchy image that comes alive.

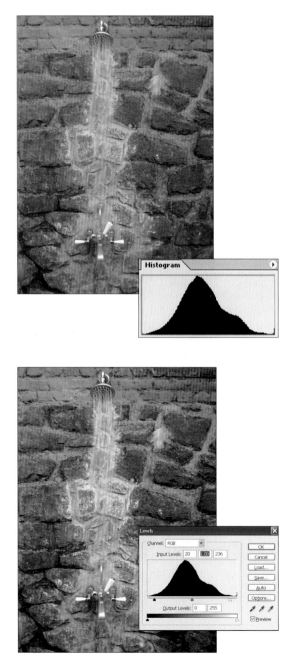

▶ *Levels* is indispensable when it comes to black and white photography. In this example, a dull cloudscape is seriously suffering from a lack of contrast.

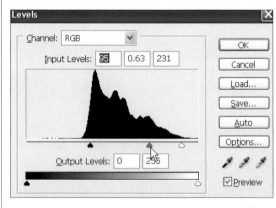

▼ A good helping of *Levels* adjustment makes for a dramatic cloud scene. This time, as well as bringing the *White* and *Black* sliders closer together, I have also dragged the middle *Gray* slider to the right, which adjusts the gamma of the image. This shifts the intensity values of the middle gray tones without dramatically changing the values of the highlights and shadows.

▶ *Levels* can also be used for the removal of color casts. But as we are chiefly concerned with creative special effects in this book, perhaps we should talk about introducing color casts instead.

This lazy equatorial scene is a little too blue, and would benefit from warmer colors to make it look typically tropical.

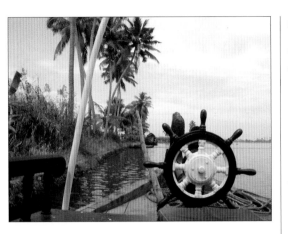

▶ This time I am only editing the *Blue* channel, which I access from the drop-down box at the top of the levels box. Dragging the *Black* and *Gray* sliders to the right results in a warmer image.

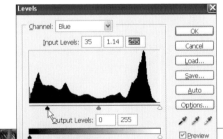

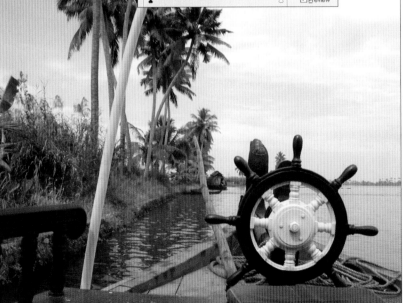

Curves

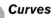

Whereas Levels *allows me to edit the black, white, and gray points,* Curves *allows me to edit up to 14 different points from shadows through to highlights.*

1 In the next image, the scene was lit by a very strong directional sunlight with heavy shadows to the left and right of the image. I want to balance the image a little by bringing out some of the detail in the heavy shadow areas but without overexposing the current highlights in the middle of the image.

Using the *Eyedropper* from within the *Curves* dialog box, I first take a sample of the darkest highlight area I want to preserve.

A corresponding circle appears on the diagonal curve in the *Curves* dialog box.

LEVELS, CURVES, AND COLORIZING

2 I click that point on the diagonal line to fix it in place. Any adjustments I now carry out to the curve will have no effect on that point. It's locked in place.

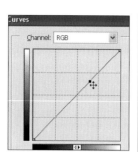

3 Using the *Curves Eyedropper* again, I now assess which part of the curve I should edit by placing the *Eyedropper* cursor in the shadow area of the image that I wish to lighten. The corresponding circle that pops up on the line in the *Curves* dialog box shows me where I need to make adjustments.

Curves have another more exciting role to play when it comes to special effects, which we'll come to shortly when we look at textures and embossing.

4 I now click on the diagonal line at the shadow point and gradually drag upwards, to lighten the shadow areas. Use very slight adjustments as the effect is very strong.

The finished result has successfully brought out some detail from the shadows without affecting the highlights.

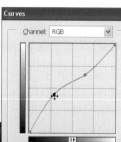

Colorizing

Colorizing can be used to add color to a grayscale image, to create a minimal color effect on color or grayscale images, or to generally change the color effect for creative purposes.

A broad range of options exists for colorizing—here's a couple of the best ones.

1 Making a sepia tint is very easy to do. The color image of the tall ship has been treated with the *Hue/Saturation* command. I have clicked the *Colorize* checkbox, then dragged the *Hue* slider until I arrived at the desired color. The *Saturation* control allows me to control the degree of color.

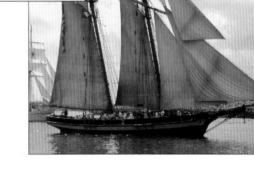

2 If that's not automated enough, there is also a pre-made style in the *Styles* palette which is designed for this very purpose. It uses a layer style to achieve the same result.

3 This is how it appears in the *Layers* palette.

4 Clicking the *Color* chip opens up the *Color Picker* where I can choose a color.

5 If I decide I want to colorize the image with another color, I just double click the *Color Overlay* sub layer to reveal the *Layer Style* dialog box.

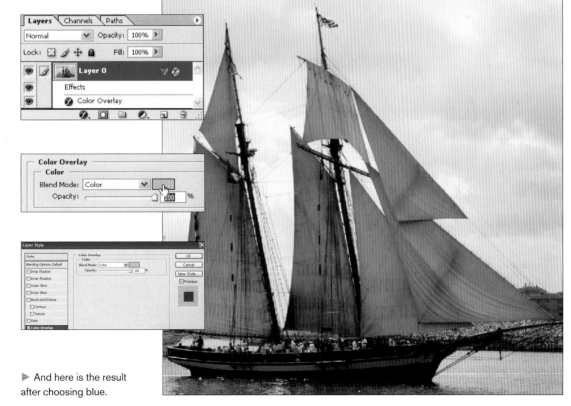

▶ And here is the result after choosing blue.

TEXTURES, EMBOSSING, AND BUMP MAPS

Special Effects Workshop

Introducing textures can be another way of adding a surreal element to an otherwise straight digital photo—you will see some good examples later on.

Applying Textures

As with so many of Photoshop's tasks, there are many ways to apply texture to an image. The texture can come from an existing image or it can be entirely created from scratch.

2 After making a selection of the strawberry, I used it to cut out the shape from the earth image.

1 For the strawberry image, I am using an image of a dry, sun-baked earth as the texture.

3 Next, I changed the earth layer's blend mode to *Linear Burn*.

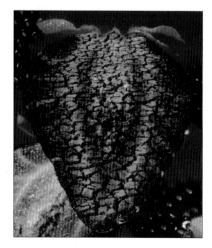

4 For minimal effort the filters offer a range of texture options. This image shows the result of going to *Filter > Texture > Craquelure*.

Embossing

There are quick and easy automated functions for embossing. Under the Filter > Stylize menu you will find the Emboss command. Alternatively, from the Layer Styles menu, the Bevel and Emboss command offers an enormous range of customization.

On a more advanced note I'm using a combination of alpha channels, curves and the lighting effects filter to produce an embossed 3D object and a chrome texture at the same time.

3 I apply 4 spotlights using the settings shown. The result is an embossed shape which has been defined by the amount and type of lights as well as the degree of blurring in the alpha channel. So experiment with the settings to get the kind of embossing you are looking for.

4 For the chrome texture, I am going to call up the *Curves* that we looked at earlier for more mundane purposes. Applying a curve similar to the one shown allows me to create the extreme contrasts of highlight and shadow so typical of highly reflective surfaces.

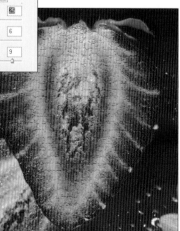

1 I start with a slightly blurred white on black artwork created in a new channel.

2 On a white filled layer, I go to the *Lighting Effects* filter (*Filter > Render > Lighting Effects*) and call up the alpha channel from the *Texture* drop-down box.

Bump Maps

A Bump Map is a grayscale document that is used to distort another image. They are commonly used with 3D programs for making textures, but can also be invaluable when making realistic distortions to photographic images.

▼ I am going to use the image of the banknote as the model in this demonstration. I want to apply a subtle wave to the note with smooth distortions so it looks as if it was photographed that way.

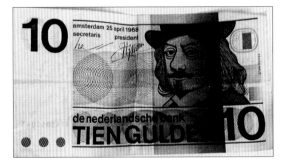

1 First, I create the *Bump Map* (also known as a displacement map). This is a simple PSD document with the same dimensions as the document that it will be used to distort. I have applied a black and white gradient to the document. Smoother gradations of color result in smoother distortions.

2 With the banknote file active, I go to *Filter > Distort > Displace*, applying the settings shown to make the distortion. I am now prompted to select the file that will be used as the displacement map.

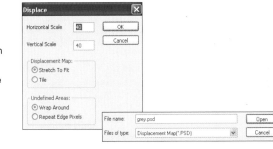

▶ And the result is a wavy banknote.

LIQUIFYING AND DISTORTING

The most famous surrealist, Salvador Dali, frequently distorted landscapes, architecture, and the human body. Photoshop's tools make it easy to warp images in equally bizarre ways.

When the Liquify *filter first entered service in Photoshop, there were those who said it's very clever but what do you do with it apart from make funny faces. Well, you'll find a host of real-world examples of how you can use it within the pages of this book and I'm sure you'll find many more once you are inspired. Simply put, the* Liquify *tool allows you to distort pixels, but by how much is up to you. In terms of a human face, anything is possible. Here, we'll do nothing more than give this girl a hint of a smile.*

▲ The original photo of a girl with neutral expression, has been transformed using a slight adjustment via the *Liquify Warp* tool.

▼ A flat, calm ocean makes an ideal canvas for us to put Photoshop's *Liquify* tool through its paces.

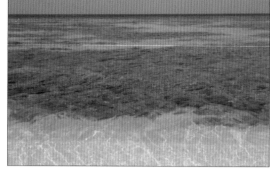

1 Using the *Liquify Push Left* tool, I have been able to create a turbulent wavy ocean.

2 Anyone familiar with the movie *The Abyss* will remember the wonderful effect where the being uses the water as a vehicle to manifest itself. Try using the same *Push Left* tool and increasing the settings. Now I can drag over the water to create a similar effect.

Tool Options
Brush Size: 202
Brush Density: 69
Brush Pressure: 82

The *Liquify* tool is not the only distortion tool for achieving similar effects. *Under Filter > **Distortion***, a whole collection of distortion filters exist, including the displacement map that we looked at in the last section.

Many of the *Distortion* filters can be applied using an automated process, unlike the manual "drawing" required with the *Liquify* tool.

▶ The distortion witnessed by looking through frosted glass or glass tile blocks can be easily simulated using a specific set of distortion filters under the category of glass. I am going to apply one of these filters on the fish image.

▼ I go to *Filter > Distort > **Glass*** and choose *Blocks* from the *Texture* drop-down menu. I have complete control over the amount of clarity that remains in the image. I want to keep the fish very distinct, so I am using low to medium levels of *Distortion*.

▲ If I were required to add a desert mirage to the following scene, the *Liquify* tool would certainly be capable, but it may not be the most efficient way of applying the effect. Let's look at a different way of doing it.

1 First, I create a feathered selection describing the area of the mirage and press Ctrl/Cmd + J to copy and paste the selection to a new layer.

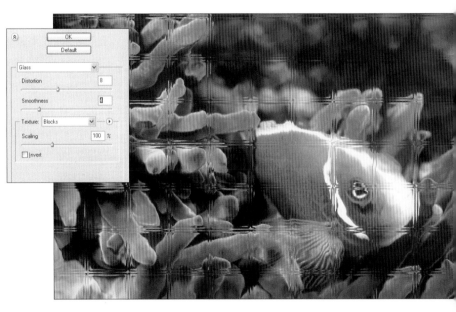

2 With the new layer active, I go to *Filter > Distort > **Ocean Ripple,*** applying relatively high settings, as shown.

3 The effect itself is not subtle enough.

4 So I change the layer blend mode to *Darken* for the finished effect.

THE RENDER FILTERS

The range of filters under the render category are a powerhouse in themselves. All the filters in this group either possess or can be manipulated to have a strong photographic quality about them.

Clouds

You may have utilized this one for the obvious purpose of creating a cloud scene, but it has a multitude of other uses. As with so many of Photoshop's filters, they come into their own when combined with other filters and effects so that they cease to be recognizable in their own right.

▼ This rather dull-looking foliage image needs some atmospheric lighting to lift it.

▶ I've applied the *Clouds* filter to a layer above the foliage layer using some warm, earthy colors. Next, I reduce the cloud layer's *Opacity* to 65% and change the blend mode to *Vivid Light* to create a dappled sunlight effect typical of the light type I would expect to see in a heavily wooded forest.

Difference Clouds

Difference Clouds *works in a similar way to* Clouds *except that it applies its clouds effect to the existing pixels on the layer in the same way that the* Difference *layer blend mode works between a pair of layers. So the effect is one of an inverted image. Applying the filter multiple times results in fibrous vein like effects.*

I am going to use this technique for a different play on the lighthouse theme. Rather than an ordinary ray of light being beamed from the lighthouse, it will appear to emit ethereal strands of charged light energy (think of those old Frankenstein movies).

1 I start by applying the *Clouds* filter to a layer.

2 Next, I apply *Difference Clouds* to the same layer, then to emphasize the veins further I use *Levels* to increase contrast.

3 And now once again I apply *Difference Clouds*. I now drag the clouds layer into the lighthouse image, positioning the clouds layer above the lighthouse and changing the blend mode to *Linear Dodge*.

4 And finally, I apply a *Layer Mask* to the clouds layer and paint out everything apart from the strands of light emitted.

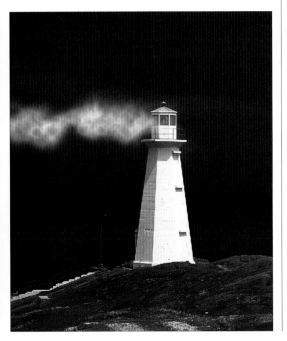

 Lighting Effects

The Lighting Effects *filter, as we saw earlier in the section on embossing, has other uses beyond lighting a scene. Its capacity for rendering 3D objects is a valuable asset in the digital artist's toolbox. In a more conventional sense, the* Lighting Effects *filter can be used to lift a drab image by creating more dynamic or atmospheric lighting.*

2 The settings used have given a strong impression of a directional single-source light. Although it provides good atmosphere, it has also created heavy dark areas in the top-right and bottom-left corners.

1 The image of the door could use some light enhancement. I have

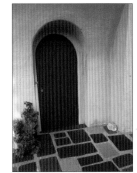

applied a single spotlight from the top-left corner of the image.

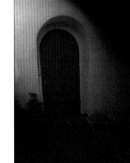

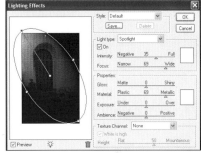

3 For a more evenly lit scene but with the same single-source light, I'll apply the *Lighting Effects* filter to the original scene again. This time I increase the *Ambience*, dragging the slider toward *Positive*. This adjustment has the effect of adding more overall light to the scene. The result maintains the strong sense of a spotlight but avoids the high-contrast shadow areas.

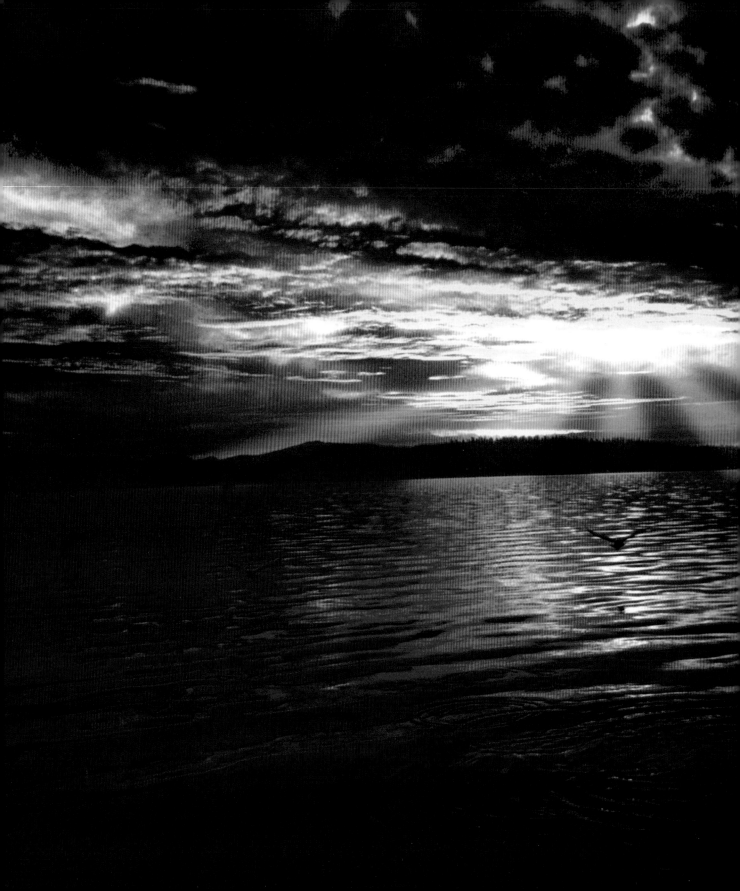

3

Strange landscapes, alien landscapes, incongruous or impossible landscapes—surrealism has embraced them all. And just as surrealism took the conventions of the landscape painting and twisted them to create something new, so digital imaging can take landscape photography and, by changing colors or creating weird juxtapositions, produce equally weird, humorous, or thought-provoking results. The images and workthroughs on the following pages all fit loosely within the landscape genre, and show that an unnatural world can have a beauty all its own.

landscapes

FANTASY LANDSCAPE SHOTS

 Some landscape images look so good they leave you wondering what you can possibly do to improve them. The fact is perhaps they don't need any improvement at all. That doesn't mean that you have to leave them alone, however. Why not take your best images and use them to make new ones that could never be taken in real life. Imagine, for example, the warmth of a tropical ocean, but with icebergs and penguins for company. That's what we're going to attempt right now.

1 Sometimes the choice of images to montage can be perfect in all but one or two details, but this should not necessarily prevent them from being used. The base image being used for this montage has direct sunlight shining from the right. This will contradict the light direction in the other images that will be used. The most obvious problem area is the shadow of the leaves on the tree on the left. We will soften this shadow so that it is not so pronounced.

2 Using the *Patch* tool set to *Source*, make a selection of the shadowed area of the tree trunk.

Patch: ● Source ○ Destination

3 Place the cursor inside the selected area and drag it to the lower part of the tree trunk where no shadow exists. The result is a softened area with no obvious direction of light.

4 The foreground will contain a bank of snow taken from another image. In the snow image, make a selection of the foreground and drag the selection into the tropical image.

5 Name the layer "foreground" and position the snow at the bottom of the canvas after flipping it horizontally. > *Edit* > *Transform* > **Flip Horizontal**.

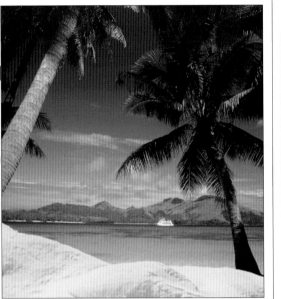

7 To strengthen the powerful juxtaposition of hot and cold, we are going to add an iceberg to the warm tropical ocean. Select the iceberg including its reflection and some of the water. We don't have to use all of the ice on the surface, but having more to work with gives us greater flexibility.

8 Drag the selection into the main working image and name its layer "iceberg."

9 Position the iceberg, scaling it as necessary using the *Transform* > **Scale** command.

6 The realism of the composited image is only as good as the original selection, but even with a perfect textbook selection, a hard edge can sometimes give the game away. To minimize this effect, use the *Blur* tool at default settings and run the tool over the edge of the snow. This will help to blend the snow into its new background.

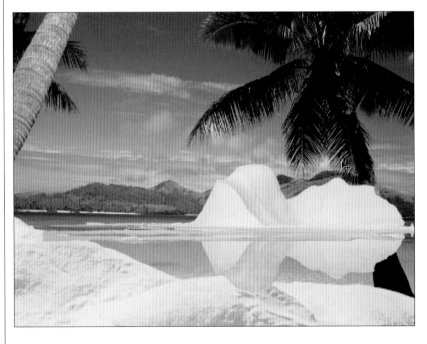

FANTASY LANDSCAPE SHOTS

10 Clearly, the iceberg needs to be sandwiched between the palm tree and the hills. We are going to use a layer mask to achieve this effect which will also allow us to make the water reflection look realistic.

First, reduce the *Opacity* of the iceberg layer and make a selection of the part of the tree and leaves that would be visible in front of the iceberg. Reducing the layer *Opacity* allows us to see how much of a selection needs to be created.

13 The ice sheet on the water's surface and the reflection can now be worked on using the same *Layer Mask*. Use a large soft-edged brush at a reduced *Opacity* and fade out some of the ice and the lower part of the reflection.

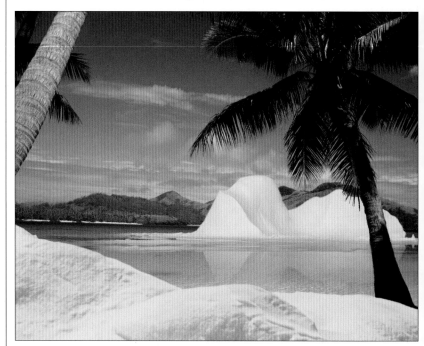

11 Invert the selection. (Ctrl/Cmd + I). Return the iceberg layer to full *Opacity* and then add a *Layer Mask* by clicking the icon at the bottom of the *Layer* palette.

12 If required, the mask can now be painted on to clean up any rough edges where the tree lies in front of the iceberg.

14 The penguin is the final element to be brought into the scene.
After making a selection of the penguin, drag it into the working image and name the layer "Penguin". The layers need to be positioned as follows from top to bottom:
- foreground
- penguin
- iceberg

15 Scale the penguin and position it as shown so that its feet are hidden by the foreground snow. If required, run the *Blur* around the edge of the penguin to blend it in with the background.

Landscapes

16 There is one last problem with the image. The foreground snow has a strong blue/purple color cast that doesn't sit comfortably with the rest of the scene, which is leaning toward the cyan end of the blue range. There are a number of ways to fix this. The method we are going to use is by way of a *Curves* adjustment layer. As well as providing us with a great degree of control, it is also enormously flexible in allowing us to edit the image without ever committing to a final setting.

▲ Apply a *Curves* adjustment layer to the foreground layer. Hold down the Alt key while clicking the *Adjustment Layer* icon.

17 Holding down the *Alt* key allows you to make a *Clipping Mask* between the adjustment layer and the foreground layer. Tick the box labeled "use previous layer to make *Clipping Mask*" in the dialog box that opens and click OK.

18 Apply fine adjustments to the red, green, and blue *Curves* as shown.

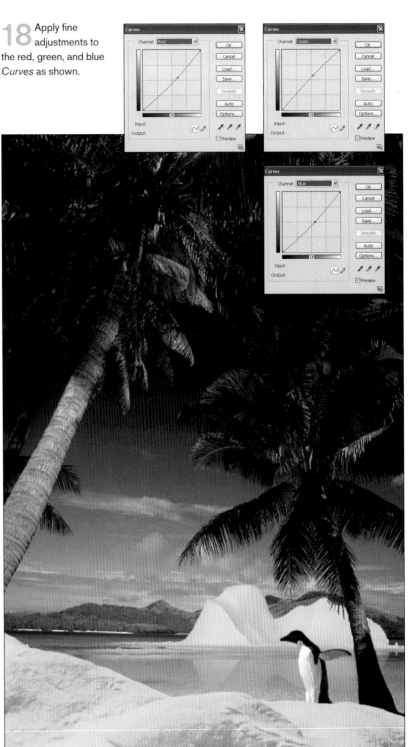

Landscapes

SPECIAL EFFECTS WITH SKIES

Skies are often seen as a backdrop to the main subject, but with a little inspiration they can make an excellent focus of attention. We're going to turn one of those most common of phrases of the television weather forecaster, "isolated showers," into a reality.

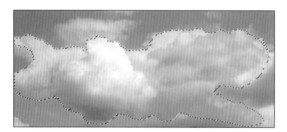

1 Finding the right kind of clouds is the first problem in this kind of project. It may be necessary to use clouds from several images, or even duplicate one cloud as we are going to do here. Well-defined fluffy clouds work best. Typical cotton wool balls appear much more tangible and help the effect. Make a selection with a small feather of an area of cloud you wish to use and drag it into the working file of the ocean.

2 Duplicate and arrange the clouds to give an even spread. The example shows four different layers. Don't worry too much about neatness and clean edges for the moment, as there will be a certain amount of editing to do.

3 Select the hands and arms and drag them into the main file. Arrange the layer order so that the hands are in the middle of the two cloud layers. This will allow for lots of overlapping to help the realism.

4 Add *Layer Masks* to each layer, and start painting on the masks with black to reveal the hands, then continue to blend any clouds together that require it. Use soft brushes at low *Opacity*, changing to a harder edge when working around the hands.

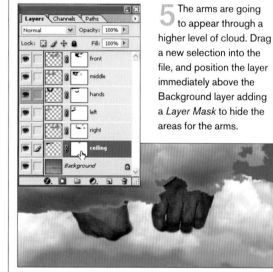

5 The arms are going to appear through a higher level of cloud. Drag a new selection into the file, and position the layer immediately above the Background layer adding a *Layer Mask* to hide the areas for the arms.

6 Drag the wave image in and rotate it clockwise about 45 degrees, then add a *Layer Mask* and paint in black, until just part of the wave is visible.

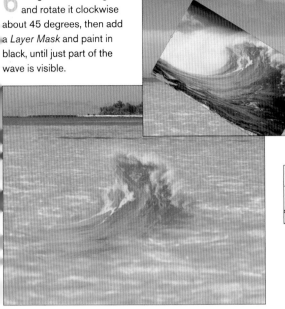

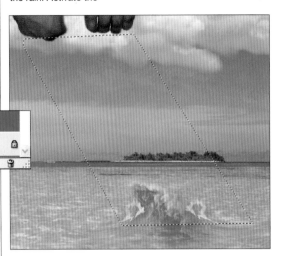

8 To make the isolated rain storm, make a feathered selection outlining the shape of the rain. Activate the Background layer and press Ctrl/Cmd + J to copy and paste the selection on to a new layer.

7 Duplicate the wave layer, flip it horizontally, and position them back to back. Here, we've placed the waves further apart than they need to be for clarity. Now bring the two waves together and paint on the *Layer Masks* to merge them until they appear to form one unified crest.

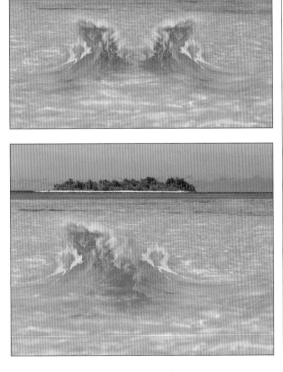

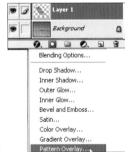

9 Apply a *Pattern Overlay* layer style to the new layer. Choose any style and click *OK*. We are going to apply a ready-made style from the *Styles* palette. Load the *Image Effects* styles if they are not already in the *Styles* palette.

SPECIAL EFFECTS WITH SKIES

Landscapes

10 With the pattern layer still active, click the rain style swatch from the *Styles* palette to apply the effect, then double click the *Pattern Overlay* sub layer in the *Layers* palette to access the pattern settings. Change the *Scale* to 360% to make the rain larger and more visible.

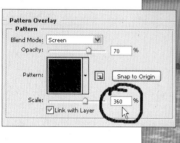

11 Add a *Layer Mask* to the pattern layer to control how much of the rainfall is visible.

12 The hands need a slight adjustment, as they should be lighter to match the amount of light in the clouds. Add a *Curves* adjustment layer to the hands layer, making sure it is clipped to the hands layer. Adjust the lightness on the RGB curve and the blue curve as shown.

13 The clouds need to appear as if they are being squeezed close to the hands. The *Liquify* filter is the perfect tool for this. Identify the area that needs to be squeezed, then go to *Filter > Liquify*. Use the *Pucker* tool and press in short bursts to achieve the effect. Repeat the process on various parts of the cloud where the clouds and hands meet.

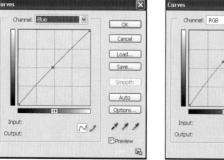

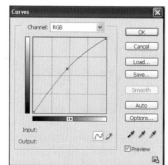

14 Finally, the hands are mingling with a lot of cloud of different densities, so we would expect to see various patterns of light and shadow over the hands. Add a *Pattern Overlay* layer style to the hands layer, and from within the default pattern set, choose the clouds swatch. Apply the settings displayed.

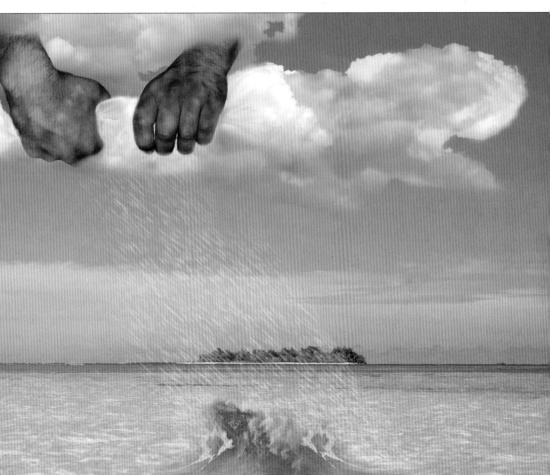

TRICKS WITH NATURAL LIGHT

The majority of photos are taken with nothing more than natural light. Natural light is a wonderful light source of course, but is often difficult to control and adjust to your needs. So here are some techniques that harness only the natural light as used at the time of the original photograph.

1 In the first example, the image of the girl on the beach is suffering from a cold blue cast. There are a variety of reasons for a color cast such as this, as well as a variety of solutions to the problem, such as *Curves* and the *Color Balance* command to name just two. We are going to use a more traditional photographic technique to add a warm tint using one of the new innovations built into Photoshop CS, the *Photo* filter command. Traditional photo filters placed over the camera lens can be used to warm up colors as well as cool them down. They are also used with black and white photography to control levels of gray. Beyond these very common applications, they also cover a wide gamut of uses, from simple color adjustments to special effects.

2 Apply a *Photo* filter adjustment layer using the icon at the bottom of the layer palette. Choose the *Warming* filter (85) from the drop-down box. Use 25% as the *Density* setting. This can be increased for a more pronounced effect. The result is a much more pleasing image with colors more appropriate to the scene. The *Photo* filter command can also be applied from the *Image> Adjust* menu, but applying it as an adjustment layer gives you greater flexibility for further editing.

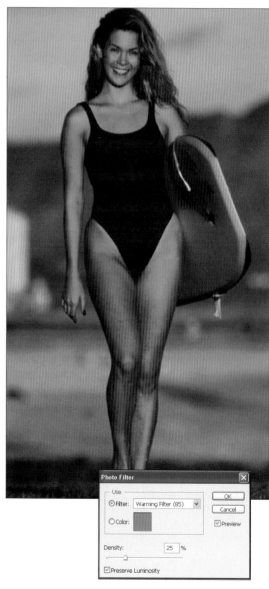

Changing The Quality Of Natural Light

1 Natural light comes in a variety of flavors, from direct sunlight or moonlight through to diffused light on an overcast day. Each type of natural light has its own unique qualities that lends its characteristics to the finished image. The mood created therefore is largely dependent upon the quality of the light at the time the image was taken.

The image of the arched window was taken in the late afternoon with strong directional sunlight casting long shadows on the floor. If we want to radically change the sunny mood of this image to a more somber moonlit scene, we can use some very quick and convincing techniques to achieve the goal.

3 Change the duplicated layer blend mode to *Hue*.

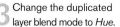
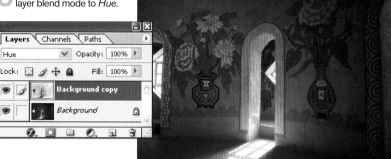

4 We now need to control the amount of ambient "moonlight" that floods into the room. Add a *Curves* adjustment layer to the original background layer. Create a curve as shown to darken the overall image. Adjust the curve as necessary to achieve the right degree of ambient light.

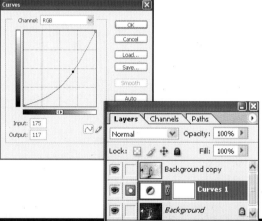

2 Duplicate the background layer then, with the new duplicate layer active, press Ctrl/Cmd + I to invert the image.

TRICKS WITH NATURAL LIGHT

Creating Dynamic Effects With Natural Light

1 For really striking effects, natural light sometimes needs a little help. Obstacles to the light such as broken clouds, bars at a window, or heavy foliage can create sharp, penetrating rays of light where the sun is partially blocked. A sunburst is one of the most popular examples of this phenomenon where the direct sunlight is filtered by a broken line of cloud. To stay within the theme of this section, we are going to create a sunburst effect but without using any special effects. We will only harness the natural light in the image with a little adjustment.

3 We need to make the original background layer light and the duplicated layer dark. Work on the original background layer first, but hide the duplicate layer so that the adjustment can be seen. The setting shown lightens the original layer. Now reveal the duplicate layer and edit its adjustment layer to make the layer darker.

2 Duplicate the background layer, then add *Curves* adjustment layers to each of the layers. Make sure the *Background Copy* layer and its adjustment layer are clipped together as a clipping group.

4 Using the *Polygon Marquee* selection tool, create some independent selections that describe the rays of sunlight. Feather the selections to give a soft edge.

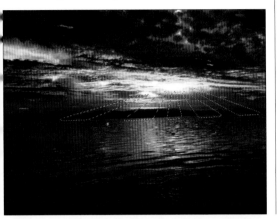

5 Now apply the rays of light. Make sure the duplicate *Layer Mask* thumbnail is active. With the sunray selections still active, fill the selections with black.

6 The final result can now be fine-tuned if required by adjusting the lightness and darkness of the respective *Curves* adjustment layers.

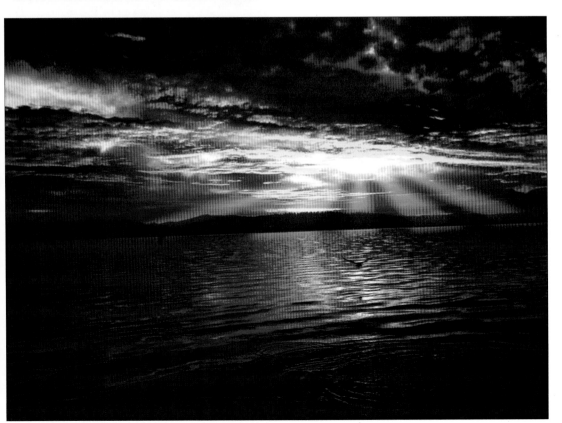

WEATHER EFFECTS: STORM IN A TEACUP

The weather offers an almost infinite variety of imagery to generate any mood imaginable, from dynamic, breathtaking storms to serene misty moments of silence. Capturing the elements can be challenging in itself, but the fun really begins when you start to combine them in the most outlandish of ways. By way of an example, let's take a literal approach to a storm in teacup.

1 We are using a full teacup with a broad area of canvas above it. This space will be used to add clouds and lightning. The teacup has been cut out and placed on a separate layer.

2 The tea will be turned into a turbulent mass, depicting a storm at sea. Take a selection from a suitable image. It's better to select a larger area than will actually be needed. Now drag the selection into the teacup file and rename its layer to "rough water."

3 Add a *Layer Mask* to the rough water layer and paint on the mask with black paint to blend the water into the tea. Use a low *Opacity* brush, changing the size for different areas. Try to reveal some of the water splashes above the level of the tea. This creates greater depth and unifies the elements.

4 Make a selection of the lightning, again selecting a little more than you plan to use. Drag the lightning into the working image and name its layer before adding a *Layer Mask*.

5 We'll create the final background layer now as it's impossible to judge the effectiveness against the current white background. Use the *Eyedropper* to sample a dark and a pale color from the lightning layer to act as the foreground and background colors. Activate the bottom white layer in the *Layers* palette and select *Filter > Render > **Clouds*** from the menu.

6 Change the lightning layer blend mode to *Lighten*. This will save us all the hard work of having to select the original blue sky around the lightning and deleting it.

7 The *Lighten* blend mode has also taken away some of the glow around the lightning, so we'll reintroduce it using a fast method. Add a *Levels* adjustment layer to the lightning layer. Make sure the two layers are grouped as a *Clipping Mask*. The easy way to do this is to hold the *Alt* key as you click the adjustment layer icon at the bottom of the *Layers* palette, then enable the checkbox labeled "Use Previous Layer to create Clipping Mask." Make small adjustments to the white and gray points as shown.

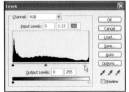

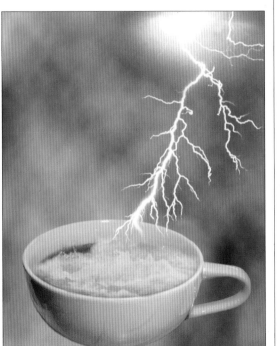

8 This may make some sharp edges visible again, but these can be removed by using the lightning layers *Layer Mask* that was created earlier.

9 We'll now add a photographic cloud, which will add another dimension to the image.

Make a selection of the cloud. Drag it into the working file to the top of the *Layers* palette and add a *Layers Mask*. Position the cloud on the top left of the cup and use the *Layer Mask* to soften the edges.

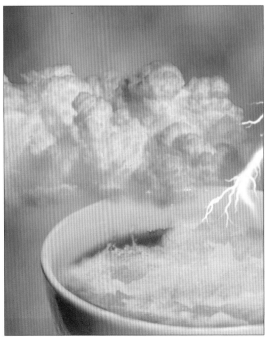

WEATHER EFFECTS: STORM IN A TEACUP

10 We can really add some depth to this image by casting a shadow from the cloud partially over the cup, just as a cloud would do in real life as it passes over a hill.

Create a new layer called "shadow" above the cup layer, then create a

high- feathered selection overlapping the cup just beneath the cloud. Fill the selection with a deep blue color.

11 Now deselect, then load the cups selection by pressing Ctrl/Cmd + clicking the cup layer in the *Layers* palette. Activate the shadow layer. Invert the selection (*Select > Inverse*) and press delete to remove the shadow from outside the cup. Reduce the shadow layer *Opacity* to about 50%.

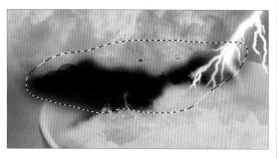

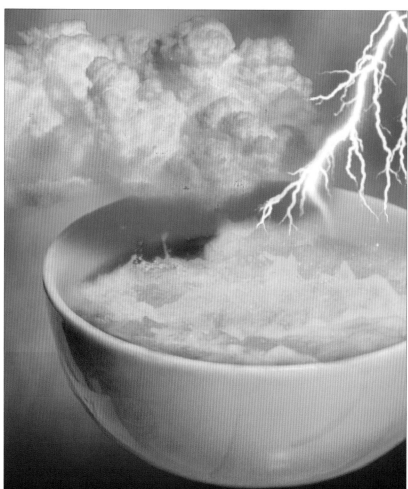

12 In the next stage, I am duplicating the cloud layer, increasing the scale, and positioning it at the top of the document to add a little more depth. To suggest distance, I am also adding some blue using color balance (*Image > Adjustments > **Color Balance***) and slightly reducing the layer *Opacity*.

13 As a final touch, I want to bring out more red and yellow in the lightning to aid contrast. Add a *Color Balance* adjustment layer to the lightning layer, applying the settings shown to the *Highlights* and *Midtones*.

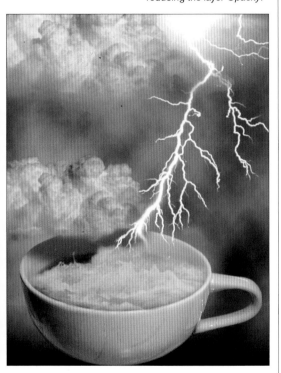

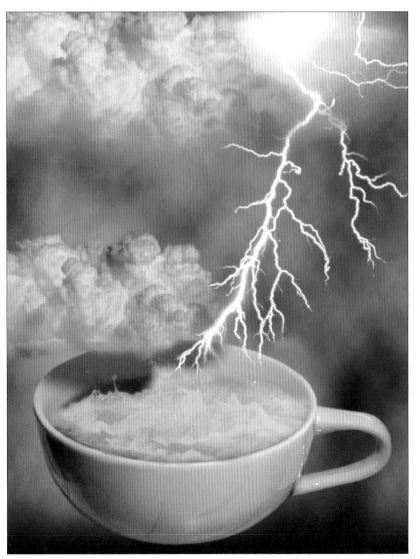

Landscapes

THE END OF THE RAINBOW

Thanks to *The Wizard of Oz*, the myth of the Leprechaun's gold, and a hundred other childhood tales, the rainbow is a powerful image in all our dream landscapes. This image is the answer to a question on every child's lips at some stage of their development—where do rainbows start or end?

1 The whirlpool effect will be built up in two stages. First, create a feathered elliptical selection on the surface of the water. Press Ctrl/Cmd + J to copy and paste the selection to a new layer. Name the new layer "whirlpool." Now make another feathered elliptical selection smaller than the first one but with matching center points. Hiding the background layer will allow you to gauge the size as you draw.

2 Activate the *Background* layer Ctrl/Cmd + J again. Name the new layer "spout" and drag it to the top of the *Layers* palette.

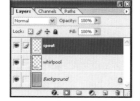

3 For the moment hide the spout layer and activate the whirlpool layer. We need to load the selection of the whirlpool layer prior to applying the *Twirl* filter. To load the layers selection, press Ctrl/Cmd and click the whirlpool layer in the *Layers* palette. Now go to *Filter > Distort > Twirl*. Apply just enough twirl to create the idea of a whirlpool.

4 Activate the spout layer and then go to *Filter > Liquify*. Using the *Liquify Warp* tool, choose a large brush size, then click and drag from the center of the artwork in a gentle curve toward the upper right. Once you're finished warping, click *OK* to close the *Liquify* dialog.

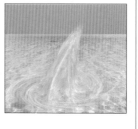

5 Add a *Layer Mask* to the spout layer and use this to blend any edges that might need fine-tuning. The spout itself can be repositioned if necessary. Ultimately, we are going to blend the rainbow into the top of the spout, so use the *Layer Mask* to hide the top of the spout.

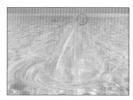

6 Now for the rainbow itself. Create a new layer at the top of the *Layers* palette called rainbow. Note that if you haven't used the *Rainbow* gradient before, it will need to be loaded into the gradients swatches. Click the gradient drop-down box button on the tool options bar, then click the pop-up menu button in the top-right corner of the palette. Choose *Special Effects*.

7 When the special effects set has loaded choose the one called "Russels Rainbow" and select the *Radial Gradient* option. Using the *Gradient* tool, drag the gradient into the curve shown, then press Ctrl/Cmd + t to bring up the *Free Transform* tool and scale and rotate the gradient until it matches the example.

8 Rainbows are generally quite subtle by nature, so some blending may be required as well as the removal of any unwanted areas. Add a *Layer Mask* to the rainbow layer. Paint on the mask to hide the bottom part of the rainbow, molding it so that it appears to emanate from the top of the water spout.

9 For added subtlety, change the rainbow layer's blend mode to *Screen* and reduce the *Opacity* to about 67%.

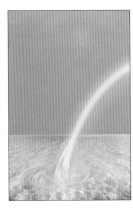

10 The rainbow still looks a little computer-generated. The colors are too well defined. To fix this we are going to use the *Hue/Saturation* command to take control over the distribution of color. Add a *Hue/Saturation* layer that is clipped to the rainbow layer. The quickest way to do this is to hold the *Alt* key while clicking the *Adjustment Layer* icon at the bottom of the *Layers* palette. When the dialog box opens, be sure to check the box labeled *Use Previous Layer to Create Clipping Mask.*

11 The main problem with the rainbow is the sharp division between the red and yellow. In the *Hue/Saturation* dialog box, select yellows from the edit drop-down and change the *Hue* setting as shown. Then select the greens and make the change as in the example. The result is a much more lifelike rainbow.

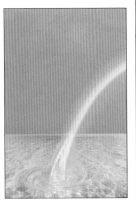

12 Finally, the idea is to create an underwater source for the root of the rainbow. This is going to be a nebulous area where the rainbow's base colors lie just below the surface. On a new layer, create a high-value feathered selection describing the underwater colors' overall shape. Drag the *Gradient* called *Spectrum* through the selection from the center to the outside using the *Conical* option.

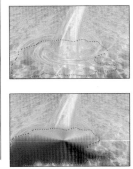

13 Deselect the selection and change the layer blend mode to *Hue* and the *Opacity* to 90% for the final result.

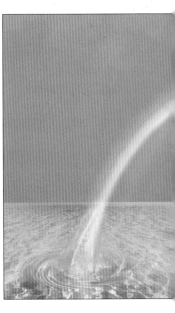

THE UNDERWORLD

What better way could there be to enhance a landscape than with an insight into a world that we could never see. This merging of reality and fantasy uses several different images to offer us a tantalizing glimpse into the underworld.

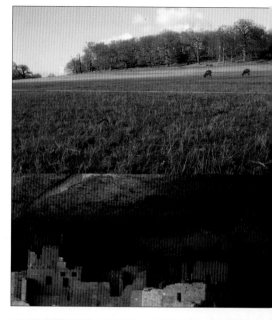

1 In the surface image, add extra canvas to the bottom of the document to make room for the other images (*Image* > **Canvas Size**). Make sure that the bottom of the image is transparent, then drag the image of the underworld into the working file.

2 Ultimately, we are going to fill the underworld with fire, which will reflect a warm glow throughout the lower half of the scene. As it is underground, we need to darken the area and disguise any traces of natural daylight. Add a *Curves* adjustment layer to the underworld layer and make changes to the RGB composite and the *Red* and *Blue* channels as shown.

3 Drag the soil image into the working image, positioning the layer at the top of the *Layers* palette.

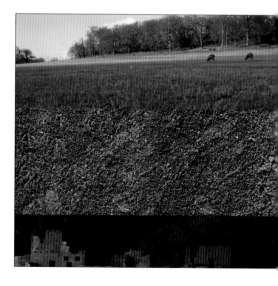

4 Now we need to blend the three elements together. Add a *Layer Mask* to the soil layer and use a large, soft-edged brush at low opacity to paint on the mask with black paint. Also experiment with a textured brush to create variation and a more seamless join.

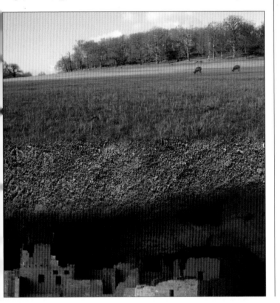

6 In order to draw all the elements together, we'll add a ladder that extends from the underworld through the earth and appears at the top of the hole. Select and drag the ladder selection into the working file at the top of the *Layers* palette. Add a *Layer Mask* to the ladder layer and hide the part that would be hidden by the earth as well as the bottom of the ladder.

5 To make the connection between the underworld and the surface, we'll dig a digital hole in the grass. Make a selection of the hole and drag it into the working document. Place the layer at the top of the *Layers* palette and add a *Layer Mask* to blend the hole into the grass.

7 The metal ladder should be reflecting the glow of the fire, so add a *Color Balance* adjustment layer above the ladder layer, combining them into a *Clipping Mask*. Make the changes shown to the *Midtones* and *Highlights*.

THE UNDERWORLD

Landscapes

8 We are now ready to add the fire. Make a feathered selection of the fire and drag it into the working file. Place the fire layer at the top of the *Layers* palette, adding a *Layer Mask,* then if necessary blend the edges using the mask so no joins are visible.

9 The feel I want to create is of a raging inferno, but the fire is currently a bit lame in terms of color depth. Add a *Curves* adjustment layer to the fire layer, clipping them together as a *Clipping Mask,* then make the adjustments shown to the *RGB,* the *Red,* and the *Blue* curve.

10 Repeat the process with either different fire images or duplicates of the first fire image, using different scales and transformations to avoid a repeated pattern effect.

Use the *Layer Masks* to make it seem as if some of the fire is behind elements of the existing picture. This promotes a much stronger 3D impression.

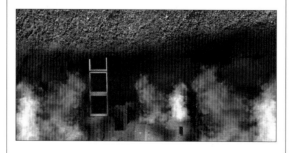

11 The more visual clues you can provide to suggest all the elements were originally photographed as seen, the greater the cohesiveness and credibility of the final image. Components that appear to overlap two or more montaged areas are excellent vehicles for this purpose. The ladder is one example of this. We'll now strengthen this further by generating a burst of flame that ascends from below ground and appears through the hole at the surface.

Position some fire on a layer below the fire layer with its own *Layer Mask.* Use the *Layer Mask* to hide parts of the fire so that it appears to disappear through the "ceiling" of the underworld.

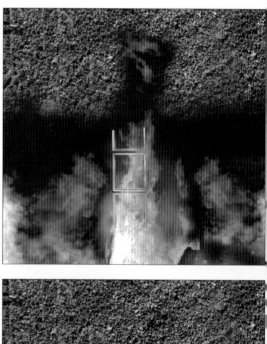

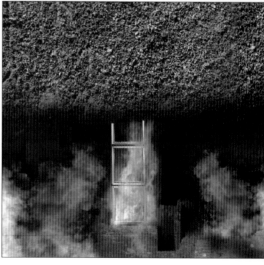

12 Position another layer of fire that appears to emanate from the top of the hole. Add a *Layer Mask* to this layer. The layer should be above the ladder layer and its *Color Balance* layer. Use the *Layer Mask* to remove the bulk of the dark areas around the fire image.

13 For added realism it would be nice to be able to see some of the trees slightly visible through the fire. Change the layer's blend mode to *Screen* to achieve this. This process also saves the trouble of having to blend away the remaining dark edges of the fire image.

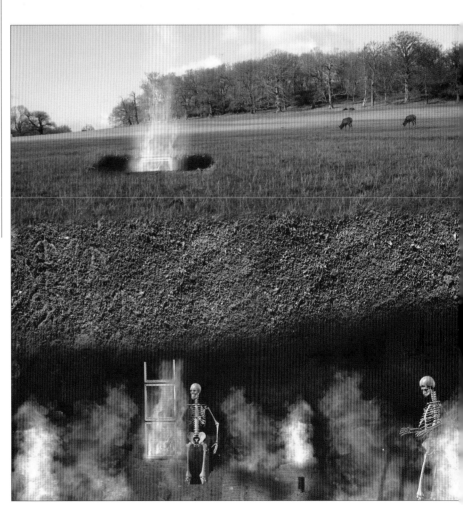

14 To finish the image, a couple of typical underworld characters have been added, each using a *Curves* adjustment layer to match the light to their surroundings. The great thing about adjustment layers is they can all be fine-tuned in relation to each other within the final context of the image. A cast shadow from one of the skeletons adds a final touch.

MOON AND STARS

Juxtaposition and role reversal are powerful tools in the hands of the advertising companies. Taking well-established scenes and clichés and turning them upside down makes for an eye-catching visual statement. Let's take a leaf out of the advertisers' book and turn around that favorite photographers' image of the moon's reflection on the sea.

1 First, select the moon and drag it into the star document. The color of the moon needs a very slight correction to sit comfortably with its new background. Add a *Color Balance* adjustment layer to the moon layer and add a small amount of cyan and blue to the *Midtones*. Make a *Clipping Mask* between the moon layer and the *Color Balance* adjustment layer so that the star layer isn't affected by it.

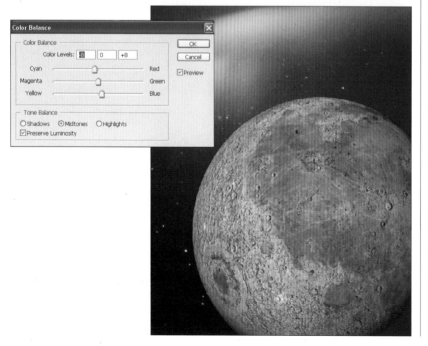

2 We are going to adopt a literal approach to the moon's seas by actually giving one of them some water. Create a new layer called "water" and draw a selection that describes the outline of the sea.

3 Fill the selection with white and deselect.

4 Duplicate the background and drag the duplicate above the sea layer. Now hover the cursor over the border between the two layers, hold down the Alt key, and click to make a *Clipping Mask* between the pair. That leaves us free to move the stars image around within the sea image to get the right feel for a reflection in water.

5 To help bolster the water-reflection idea, we'll get the water to pick up some of the vague cosmic gas clouds from deep space. Add a *Pattern Overlay* layer style to the water layer. When the *Layer Style* dialog box opens, choose the *Clouds* style from the default pattern set as illustrated.

6 Apply the settings shown to create a subtle effect.

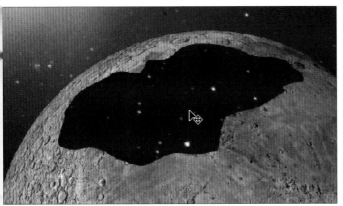

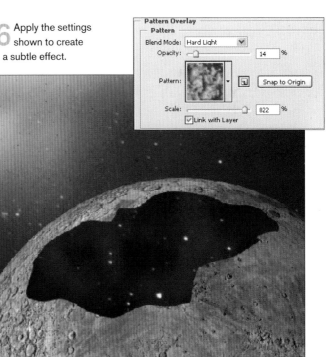

MOON AND STARS

7 Although the shape of the sea follows the curvature of the moon, it still looks like a cut-out that sits on top of the surface. To remedy this, we are going to create a recess for the water to rest in.

Add a *Bevel and Emboss* layer style to the sea layer. The settings shown will create the desired sunken effect.

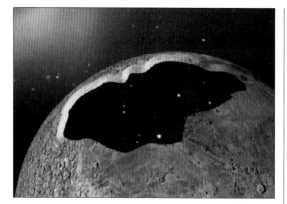

9 To make the earth reflect in the water, duplicate the earth layer, dragging the duplicate above the background copy layer. Make a *Clipping Mask* between the earth copy and the Background copy layer, using the same method used in step 4.

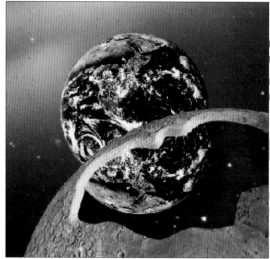

10 Now position the earth in the water and reduce the layer's *Opacity* to about 30%.

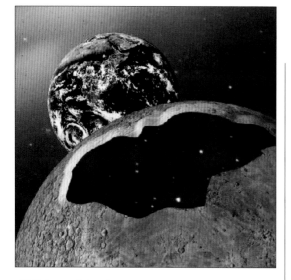

8 Select and drag the earth shot into the working image, positioning its layer in the slot below the moon layer.

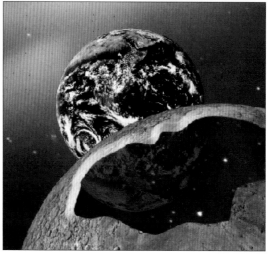

11 Finally, we'll add one more element to bind the whole image together. A scattering of cosmic gases will help to unify everything. Make a new layer at the top of the *Layers* palette, then sample a dark and a light blue from within the star background.

Go to *Filter > Render > **Clouds***. Change the layer's blend mode to *Soft Light* and reduce the *Opacity* to 48%.

12 Just as a footnote, the layer styles we have used in this tutorial offer enormous flexibility even when you think you may be committed to a certain stage of your work. I felt that the *Bevel* applied to the sea looked a little flat on the lower side. But this wasn't to prove a problem as I simply double clicked the relevant layer style in the *Layers* palette and adjusted the *Light Direction* and *Shadow* to completely change the effect.

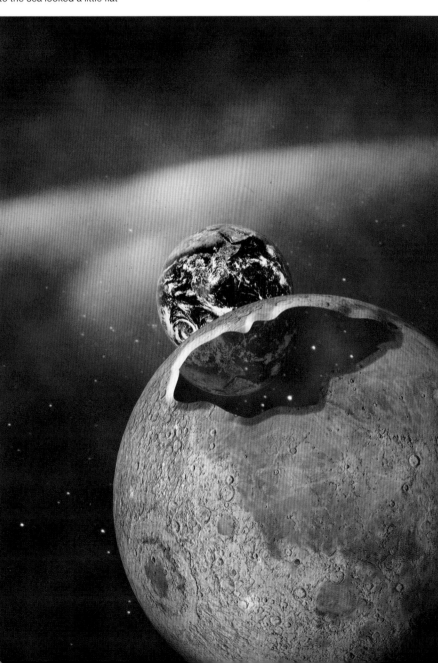

FANTASY LANDSCAPES

Canadian Shield #3 by Laurence Acland

This piece of work combines two separate landscape photographs to form one image. In order to do this, the artist makes extensive use of *Layer Masks* and uses the *Marquee* tool to create a simple but effective "portal" effect.

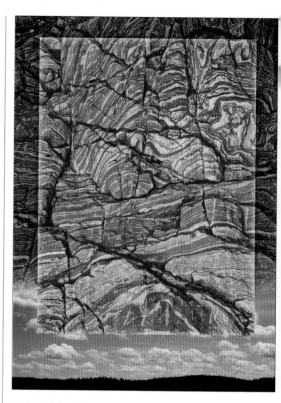

Preparing The Background

This landscape montage is part of a series exploring the beauty of Georgian Bay and Lake Superior in Canada. I have chosen the "portal" approach to landscape so that I can mix foreground and background in evocative ways not possible in a "straight" photograph. The work was begun by scanning three Ektachrome 35mm transparencies. A Nikon 8000 with the highest-resolution settings was used for this since I wanted to print the final image out via a specialized art printing process, ready for gallery presentation.

Filtering Away Detail

To prepare them for assembly, I ran several Photoshop filters over the images to introduce a more painterly feel and also to break up some of the photographic detail, which I find distracting. The sunset and the forest shoreline shots were both filtered using the buZZ filter (available from www.fo2pix.com). This filter simplifies detail but retains edge fidelity and is an extremely valuable plug-in for anyone wishing to give their photographs an "arty" look. I then filtered the rock close-up with Photoshop's *Cut-out* filter, which reduces images to simplified geometrical forms, and I ran *Poster Edges* over the resulting image to amplify the edges and give them a linear punchiness.

Using Alpha Channels As Masks

To begin the collage, I pasted the filtered rocks on to a blue background, aiming to use a block of blue at the bottom as an abstract shape (this was later obscured by a better solution). To begin building my "portals," I created a rectangular marquee on the rocks and saved this selection as an alpha channel so I could use it to create *Layer Masks* later.

Inverting the selection, I then darkened the selected outer rocks to create the first "portal." I then pasted the shoreline with trees and clouds to create layer 1. To get it to blend evenly with the rock background, I created a *Layer Mask* and filled it with a narrow gradient running from white to black. I then loaded the selection from Alpha 1 that I had saved and filled that selection with black, thereby revealing the central "portal" of rocks once again. It is important to note here that *Layer Masks* can be manipulated in many ways to facilitate the blending of layers.

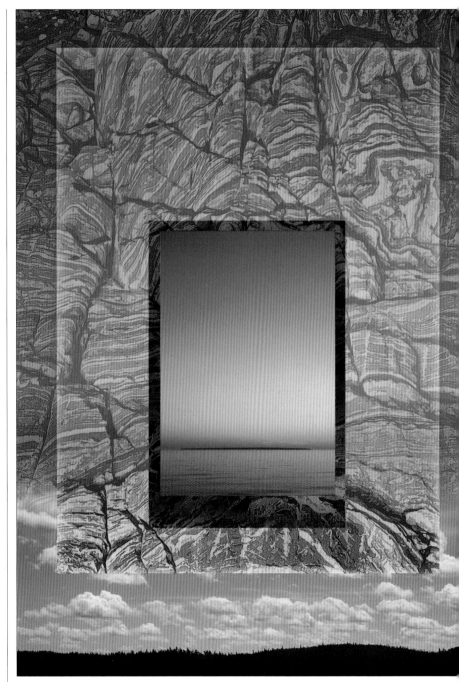

Creating The Frame

To complete the composition, I pasted the central landscape image, resizing it and positioning to taste (layer 2). To create a "frame" around this central image, I duplicated layer 2, resized it, and positioned it behind layer 2 using *Difference* as the blend mode to make the colors stand out (layer 3). Finally, I duplicated this image again as layer 4, resizing it to cover the width of the whole image and using *Vivid Light* as my blend mode with an *Opacity* of 50%. This warmed up the colors of the rocks around the central image. A *Layer Mask* was added to this layer to block its effect on the bottom area of the whole image. The final image was printed on heavy Arches watercolor paper and shadow box-framed for exhibition.

PAINTED LANDSCAPES

Shinzen Garden by Susan Thompson
This stylized "digital painting" uses an unusual technique whereby the artist manipulates a Polaroid image while it is still wet. When combined with image-editing software, this transforms the photograph and gives it a hand-painted appearance.

The Background Layer
First, I placed the original scan as the background layer of the image.

Using Adjustment Layers
Creating a *Selective Color* adjustment layer, I gradually enhanced the colors one at a time with the sliders of each color. I painted black on the mask to reduce the darkness at the top of the sky.

Retouching
Then I duplicated the background layer, removing any spots and blemishes with the *Healing* tool.

Adjusting The Tree

In a new layer, I began hand-painting in the trees. I duplicated layer 7 and changed the mode to *Color Dodge* mode with the *Opacity* set at 70%. I then created further layers set to *Color* mode and adjusted the *Opacity* to please my eye. Using the *Eraser* tool, I cleaned up the over-painted areas of the image.

Lightening The Sky

After selecting the sky area, I created another *Selective Color* adjustment layer to further lighten and blend tones. This layer was set to the *Screen* blend mode with the adjusted *Fill* slider set to 40. Next, the colors were gradually deepened in a *Hue/Saturation* layer.

The Finishing Touches

Finally, I filled another new layer with 50% gray and set the mode to *Vivid Light*. Using a soft-edged brush at very low *Opacity*, I burned in the details with black and dodged the details with white.

STRANGE CITYSCAPES

Cradle Of Man by Gregory Stewart

Layer Masks are an excellent means of fading parts of an image in or out. In his bold, stylized cityscape, *Cradle Of Man*, Gregory Stewart uses a number of *Layer Masks* to enable different picture elements to seamlessly interact with one another and create strong contrast between colors.

The Background Layers

This piece is a statement about the mechanical nature of life today as it consumes us. By distorting the mechanical elements of the image, they become animated in an unmechanical way. The colors lead the eye from background to foreground with the burning house as the focus.

Cradle of Man is a true composite Photoshop painting, consisting of many images in the finished piece. The background is a landscape of skyscrapers with adjusted *Opacity* on top of a stone wall. The snake figure is a single image of a gear, rotated and distorted. With controlled ripples, each appears as a different yet connected element of the body. Wind and motion *Blur* added to the snake's sense of depth as it moves into space.

Adding Filter Effects

The central image, a house being consumed by flames, began as a normal image with the effects of the flames built up layer by layer. Adjusting the color to the orange hue, a *Watercolor* filter was applied with *Median Noise* to soften and blend the color together. Once achieved, multiple layers of the house were distorted with *Ripples* and *Wave* filters to produce the look of moving flames, with masked gradients blending them together.

Adding Contrast

A strong contrast of blue sky works to contrast with the orange flames, pushing the house further into the foreground.

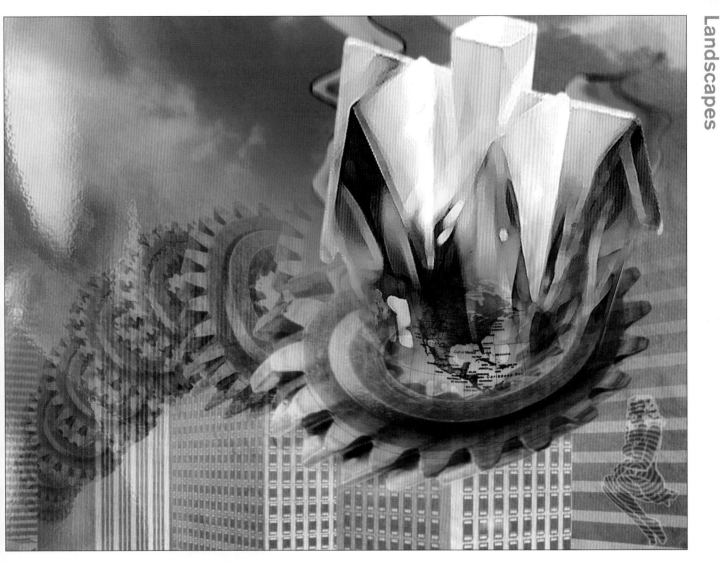

Adding The Final Picture Elements

Additional elements of the finished piece include a female form on the left, with a *Gradient Mask* applied over a distorted ocean ripple, and an inverted black and white pin up girl in the lower-right corner to offset the linear motion with a circle halftone.

DISTORTION EFFECTS

Handle With Care by Richard Ainslie

Adobe Photoshop is a vast program with myriad ways of achieving remarkable special effects. Sometimes, however, the simplest tools can be the best ones to use. In *Handle With Care*, by Richard Ainslie, effective use of the *Transform* command has produced a haunting and memorable image.

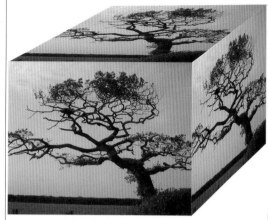

Creating The Box Shape

Next, the *Transform* command was used to skew the new layer to the right and pull it flatter, to achieve the illusion of depth. There are more precise ways of doing this, but here it was done by eye. When I was happy with the results, a third layer was added and skewed so that its left and top sides lay alongside the right edge of the first and second layer respectively. This created the box shape, which was then flattened and saved.

Conceiving The Image

The image *Handle With Care* was unusual for me in that I had an idea to start with and the result didn't differ greatly from that original conception. It came out pretty well as I'd intended.

It started with the tree itself. It's an old oak that stands on the border between the counties of Devon and Cornwall in England. Driving past it most days I became aware that it was a strikingly beautiful shape and was attractive in a way that our society does not venerate. For one thing, our language is inadequate when describing the sublime, the ineffable. The way that most of us live requires no need for such language.

Cropping The Tree

Having photographed the tree with my entry-level Kodak DX3500, the step from a flat image to a box shape seemed natural. The process was less difficult than I'd feared. Using Adobe Photoshop, I cropped and selected the oak. I copied it into a new document with a transparent background roughly twice the size of the cropped original. Next, I pasted it again and moved the new layer until its lower edge rested along the top edge of the first layer.

Adding The Background

The background is a beach in Westward Ho! in North Devon. I pasted my box on to it and then repeated the exercise five more times, moving and transforming the size and rotating each one until it looked right. Once I'd adjusted the *Opacity* of each layer and added a little shadow I flattened the image and added some *Unsharp Mask* to sharpen it up a little.

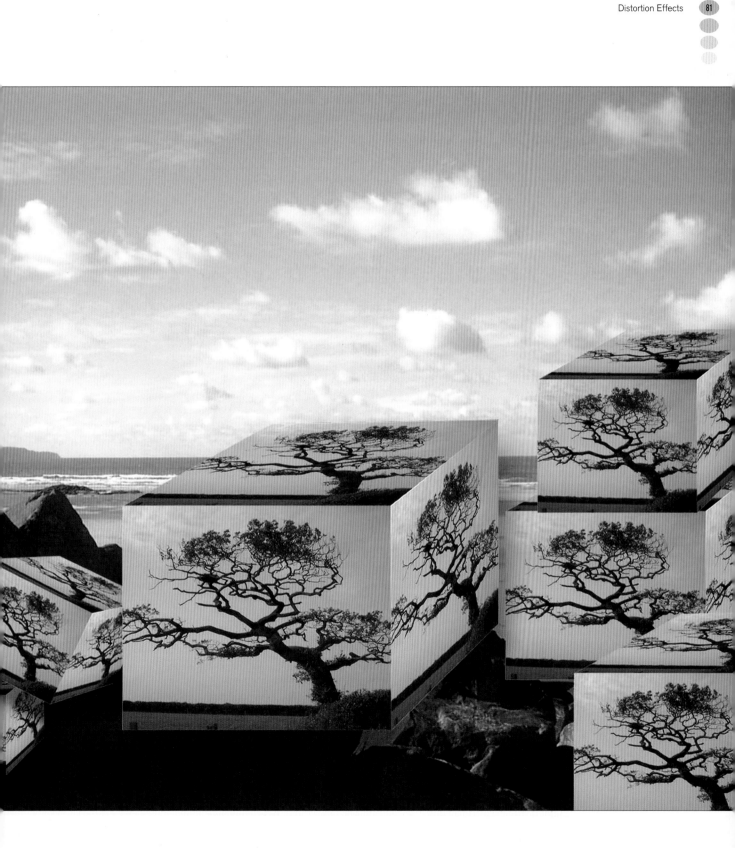

Landscapes

COMPOSITE LANDSCAPES

Beaming By Todd Pierson

Beaming, by Todd Pierson, demonstrates the importance of pre-planning. Because care was taken to ensure that all the picture elements were taken in identical lighting conditions, the whole image fits seamlessly together with only the minimum of adjustment in Adobe Photoshop.

The Concept

This image was constructed in Photoshop with many more shots than I expected it would take. The idea was to have a very dreamlike image of a gymnast shot on location. The challenge was to make it look as though it was shot in a field of flowers.

Shooting The Subject

The gymnast was photographed in a hall with directional lighting. I had the girls do several moves because I wasn't sure what would work best. The camera was on the ground to ensure I was looking up at them. Next, the beam was photographed with the same directional lighting at different angles. I also took a lot of field shots for the background. The sun and the sky shot were taken in my backyard.

Adding The Flowers

Next, I photographed bunches of flowers at different views and distances. These were taken at sunset, so I had the same strong directional lighting. All of the elements were stripped together in Adobe Photoshop, but I immediately hit problems. I was unable to get the gymnast in exactly the right position, so I had to move her legs into a more dramatic "splits" position. Also, it was difficult to make the field of flowers in the far distance look realistic, so I colored a field shot of tall grass. It was so far away from the camera, it did not matter that it was not really made out of flowers.

Putting It All Together

The hills were made using the *Liquify* tool. The flowers in the foreground had to be placed in at different heights and I had to ensure that a repeating pattern was not detectable. If you look closely, however, you may be able to see where some of the flowers were repeated. The final steps included checking edges and making sure they blended together well.

The key to assembling this surreal image was to make sure that all of the parts were photographed in the same light from a similar perspective. If care is taken at the planning stage, the imaging should be a lot easier and more believable.

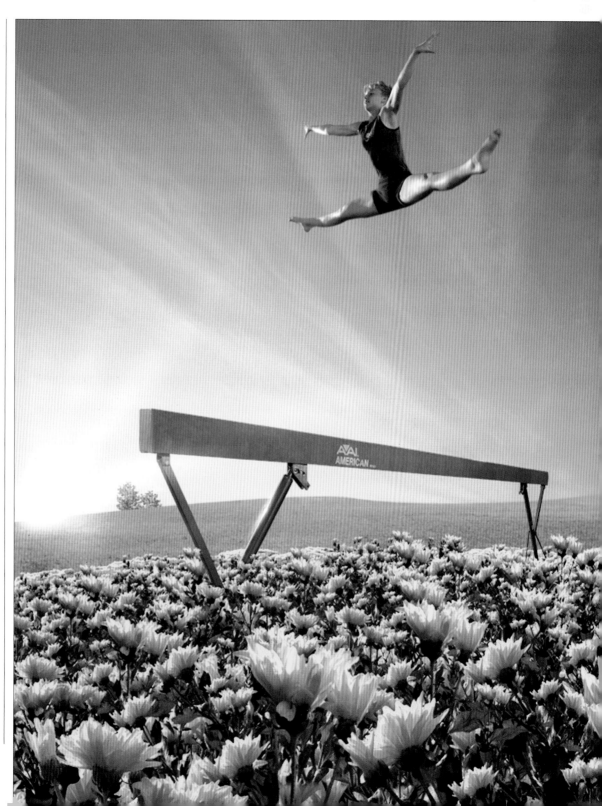

USING SCANNED IMAGES

Grinding Teeth And Land by Bob Bennett

This decidedly surreal landscape makes use of a scanned image to introduce an unexpected element into the picture frame. Scanners are an excellent means of bringing unusual pictorial elements into a composition.

The Location
The basic background is a picture taken at Limantour Spit, Pt Reyes, California; it's about an hour's drive north of San Francisco. I have been lucky enough to visit many times and one thing that always fascinates me is the interplay between land, sky, and sea in both momentary and geologic timeframes. The sky has been the major factor in shaping the land, and vice versa–the land can create the weather. As air masses hit the sudden elevations at the coast they get compressed, causing clouds to form in the sky above. This background layer is of land that has been sculpted over tens of thousands of years, dappled with shadows from the quickly moving clouds.

The Background Layer
Layer 1 is simply a gradient of blue, set on *Overlay* mode at 20%–just to beef up the sky a bit. Hold down the shift key while making the gradient, so that it is perfectly even and level.

Adding The Bone Fragments
Layer 2 is a scan of several small fragments of jawbone. I simply placed these on to the scanner and covered them with a black cloth. This is the raw scan, without any adjustments. I duplicated this and turned off the visibility so that I still had a copy of the original. Then I selected the teeth and positioned them opposing each other.

The Second Layer
Next, I erased the background around the bones and erased the bones themselves to make smooth blends with the background. This was set to *Screen* mode at 44%. After resizing and repositioning the bones, I duplicated this layer. I set the blend mode to *Normal* at 44% and erased more of the teeth to fine-tune the blend.

Working Quickly
The remnants of the black background around the bones did not concern me, but I did feel that the image still needed more contrast; I used a *Levels* adjustment layer to accomplish this. I usually work quickly on digital images, in much the same way as I do in the darkroom. Primarily, I am looking for some kind of combination of images that "works." I won't spend time doing a lot of tricks or making huge alterations and I rarely use any filters except for *Sharpen*.

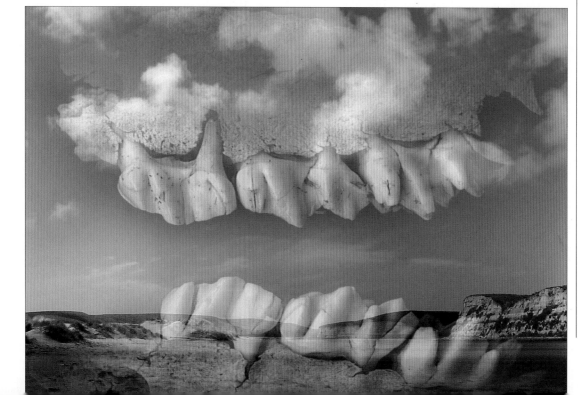

COMBINING LOCATIONS

Battery View by Bob Bennett

This view-within-a-view mixes together two landscape photographs taken on the same day, focusing upon different elements from each to create a seamless whole. The result is a haunting picture, in which reflections from the sky are clearly seen in the manipulated foreground.

Adding Another Image
Layer 3 is another image that was taken on the same day so that it has the same coloration and "feel." It is also looking at the hills from roughly the same angle on the compass, so that the lighting feels right. This layer is set on *Screen* at 65%, so that the blend is smooth. This accomplishes the blend with the elements below very well, but the top of the image still feels dark and muddy. To solve this problem, I duplicated the layer, erased some of the lower part of it, and set it on *Normal* mode at 78%.

The Background
The background layer is my basic starting point. The image was taken with a Canon Powershot A40, set on automatic, in the Marin Headlands, just north of San Francisco. All around the Headlands, there are defenses and gun batteries of various kinds. They were built to protect the harbor from a foreign threat that never materialized, and are now long abandoned.

Some are built into a hillside and resemble tunnels. The end of a tunnel facing the ocean is where the gun was situated; the other end served as access. This shot is looking out of the backside of one of those gun batteries toward the Marin hills. I was attracted by the reflections in the collected rainwater.

Manipulating A Duplicate Layer
Layer 2 is a duplicate of part of the background layer containing the reflections in the water. I have erased a lot of the image, feathering the edges with the *Eraser* tool and enlarging the selection. I like to experiment with all the various layer options. This layer is set to *Screen* at 60%.

Adjusting The Hills
The next layer is a *Levels* adjustment to the distant hills, and serves to balance the values between exterior and interior. It only affects the areas I want to adjust. I usually make a relatively crude selection, do the levels adjustments, and then airbrush to soften and feather the edges. I prefer to set both the *Eraser* and *Airbrush* tools to a relatively large size with a low value, and only use the outer edges of the brush, so that the gradations are very smooth.

DISTORTING WORLDS

Unavoidable Involvement by Paul Maple

Sometimes a little can go a long way when you are creating images. *Unavoidable Involvement*, by Paul Maple, uses a combination of clever layer work and minimal special effects to take an everyday image and add a surreal quality to it.

Masking The Subject

The main idea of the image is to depict the relationship between humanity and nature—how we affect and distort our environment. A ripple effect was chosen to emphasize this idea. To begin with, the subject is selected and copied on to a new layer, then enlarged slightly.

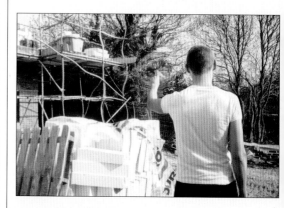

Applying The ZigZag Filter

The rulers and guides were made visible and two new guides were placed at the center of the subject's out-pointed finger. The canvas was then enlarged to add white space to the top and right of the image. To ensure accuracy, two new guides were carefully positioned at the top and right of the screen. Next, the *ZigZag* filter was then applied to the background layer—with the *Style* setting set to "Out from center." The excess white space was then cropped.

Cloning The Subject

The *ZigZag* filter affected the entire picture, creating a distortion effect on the subject as well as the background. To remove the distortion effect from the subject, a new layer was created for the purpose of cloning and positioned between the background layer and the "Enlarged Subject" layer. Ensuring that the "Enlarged Subject" layer is visible, parts of the background layer were carefully cloned on to the *Cloning* layer—this removed the distorted subject from the frame.

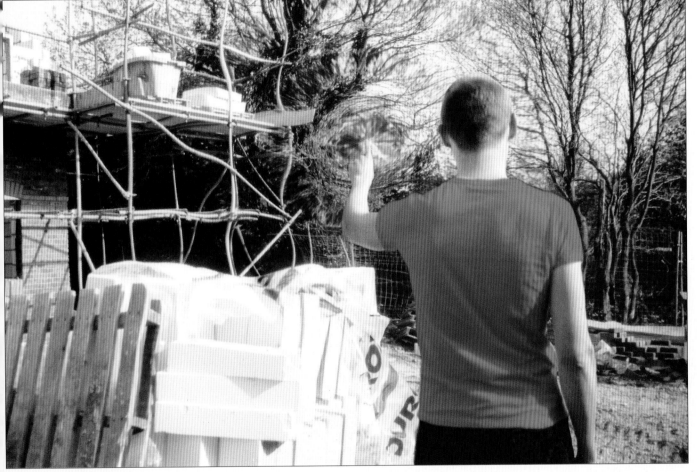

Compositing The Layers

To create the subject's glowing finger, a small square area in the center of the image was selected and then *Copy Merged* from the *Edit* menu; this copied all the layers. This was pasted on to a new layer and positioned above the background layer and named "Light." Next, the *Lens Flare* filter was applied to the Light layer. Finally, the subject's T-shirt and pants were colored by firstly copying and pasting them on to a new layer, then applying the *Hue/Saturation* command, ensuring that the *Colorize* box was checked.

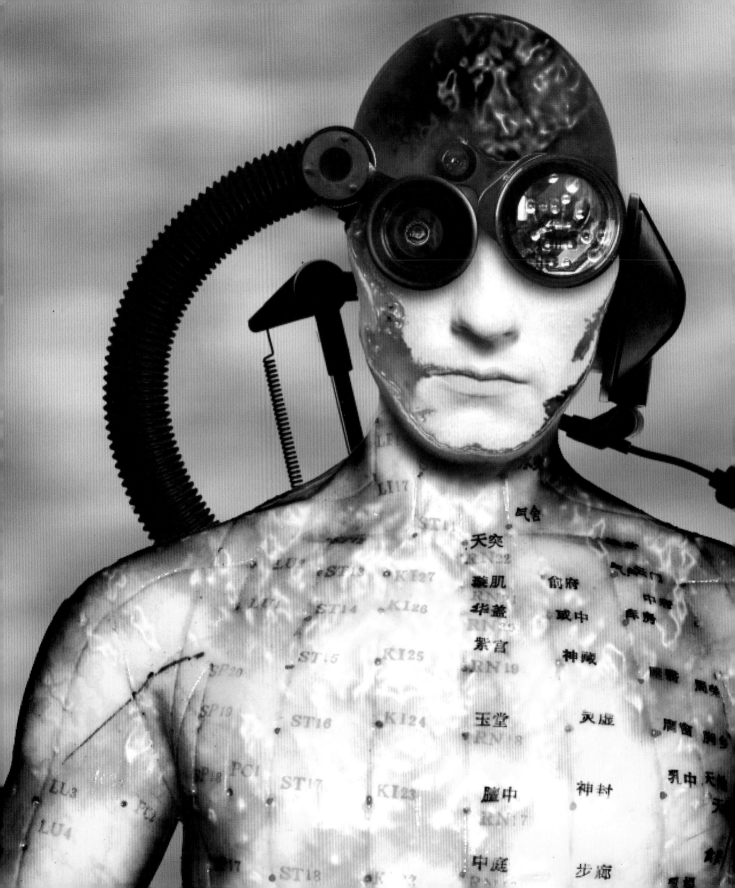

4

The human face and the human body were also popular subjects for the original surrealists. Dali took the forms of Hollywood stars, anonymous figures, or his wife, Gala, and warped them to create works where the body was shattered and reconstructed to create a variety of strange effects. Man Ray took his own muses, Kiki or Lee Miller, and used Solarization and Montage to produce weird, but highly personal portraits of them. Meanwhile, the great Belgian surrealists Rene Magritte and Paul Delvaux, exaggerated or hid the features of their protagonists to make works that forced the viewer to stop and stare. The surrealists managed all of this with paint or primitive photographic technique. Who knows what they might have achieved with digital tools?

figure work

CHANGING COLORS

Changes to the color of a person's hair, eye, or skin color can have a dramatic effect on that person's looks. Suntans in winter, hiding graying hair, or having an outrageous pink hairdo are all possible with digital-imaging techniques. As a joke among friends or a prelude to the real thing, whether you want a subtle enhancement or full-blown clown make-up we'll teach you some techniques for realistic color changes.

1 We could do something simple, such as give the girl a warm, golden suntan to match her surroundings. Why replicate real life, however, when we can do something more fantastic. First, let's make a selection of the girl. I'm also selecting some of her reflection in the water so that it looks natural when her color changes.

2 Control is key to making any change look good, so we copy the Background layer and add a *Gradient Map* adjustment layer. I set up the *Gradient Map* as shown.

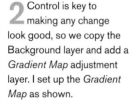

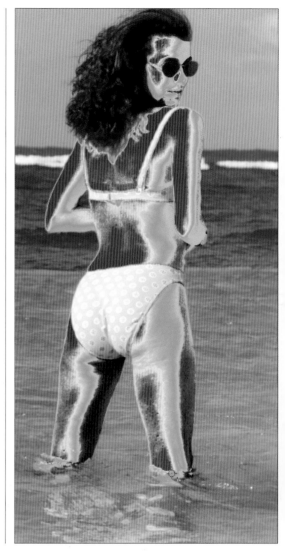

3 The result is interesting, but not quite the weird effect I'm looking for. I double click on the gradient map to adjust it, then click the *Reverse* checkbox to get this final rainbow skin effect. Note that it carries on to cover the reflection.

Changing Hair And Eye Color

1 Using *Curves* is just one method of changing color from Photoshop's vast arsenal of editing tools. One of the new innovations in Photoshop CS is a tool that is designed specifically to change color while maintaining the shadows, highlights, and textures of the subject. Its called the *Color Replacement* tool and we are going to use it to give a blonde, blue-eyed model a make-over, resulting in her sporting a youthful copper-tinted hair-style with green eyes.

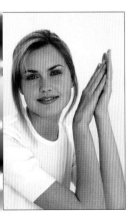

2 First, we need a selection of the girl's hair. Once you've got one, select the *Color Replacement* tool. It lives in the same tool set as the *Heal* and *Patch* tools.

3 Use the default brush settings in the tool's *Options Bar* and choose a color for the hair—I'm using R133 G42 B12 for a copper tint. Start to paint in the selection on a duplicate layer. You will notice that all the original shadows and highlights are preserved.

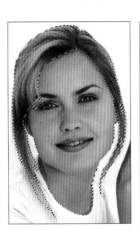

4 Depending on the accuracy of the original selection, you may have a few hard edges appearing, but these can be easily addressed by adding a *Layer Mask* to the duplicate layer and painting on the mask with a very low *Opacity* brush to subtly merge the two layers together.

5 Changing a person's eye color can all too easily render the eyes dull and lifeless due to their intricacy of texture and composition. Using the *Color Replacement* tool will aim to preserve those qualities as it did with the hair. Choose a green color for the eyes—I'm using R124 G177 B139. Paint over the eyes on a duplicate layer. This way the layer opacity can be adjusted to fine-tune the finished result. I've gone a little overboard with the strength of color for demonstration purposes. You may want to be a bit more conservative if you are looking to create a lifelike effect.

Figure Work

CHANGING COLORS

Other Techniques For Changing Eye Color

Of course, it's not only Photoshop CS that has the ability to do this. Before the Replace Color *tool*, different techniques had to be employed. This is one of my favorites, which results in a very photo realistic natural look and can be quite startling for portraits.

1 Make a selection of eye pupil. With the original photo layer active, press Ctrl/Cmd + J to copy and paste the selection to a new layer. Name that layer "eyes."

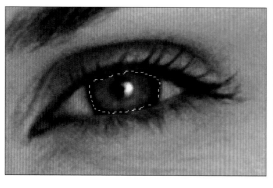

2 Apply a *Hue/Saturation* adjustment layer, making sure it is clipped to the eyes layer.

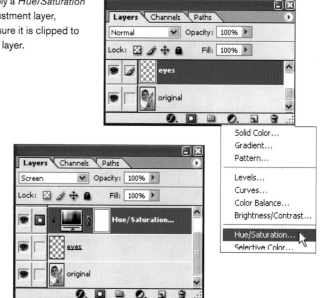

3 Apply the setting as shown to the *Hue* slider. This achieves a green color. The result is a very engaging eye with a good degree of brilliance.

Figure Work

4 If you are looking for a quite startling effect where the eyes will work like a magnet, change the eye layer's blend mode to *Screen*. The eye becomes almost hypnotic and cat-like. You can reduce the layer's *Opacity* if the effect becomes unnerving.

5 This is the finished result with the *Opacity* settings for both eye layers reduced to 60%.

COMPOSITING PEOPLE

Compositing people into scenes where they never actually existed can be among the most challenging of digital-manipulation tasks. To make things really difficult, we're going to composite a girl into an underwater scene and see how we can overcome all the problems associated with underwater imagery.

1 First of all, make a selection of the girl, then drag the selection into the pool image position in the bottom-right corner.

2 The scale of work required to make this idea look convincing now becomes apparent. The properties inherent in underwater photography make merging a person photographed on the surface a real challenge. The first problem is an object's buoyancy when submerged in water. The girl's flat, undisturbed hair is a dead giveaway immediately. To fix it, go to *Filter* > **Liquify**. Using the *Liquify Warp* tool, drag a few bits of the hair to form sweeping curves.

3 Color is our next biggest problem. The overall water scene is a number of shades of blue. We need to copy these and apply them to the girl. Using the *Eyedropper*, sample a pale blue and a deeper blue for the foreground and background colors.

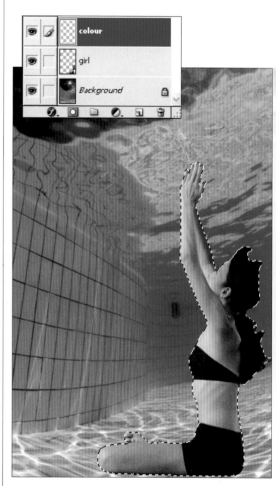

4 Load the selection of the girl by pressing Ctrl/Cmd + clicking the girl layer in the *Layers* palette. Now create a new layer called "color" above the girl layer.

5 Select the *Gradient* tool and drag a linear gradient, using the *Foreground to Background* option, from top to bottom through the selection.

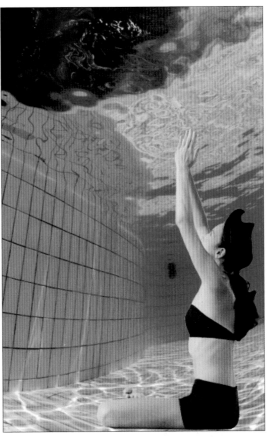

6 Deselect the girl and change the color layer's blend mode to *Color*.

7 Things are now starting to look believable, but not quite realistic. The highlights and shadows generated by the wavy surface of the water are a strong characteristic of underwater images, particularly on objects close to the surface. This pattern can be seen on the floor of the pool, and it would also be visible on the girl. Putting it there is our very next task. Add a *Pattern Overlay* layer style to the color layer by clicking the *Layer Style* icon at the bottom-left of the *Layers* palette.

Figure Work

COMPOSITING PEOPLE

8 In the *Pattern Overlay* dialog box, it may be necessary to load the required pattern set for our purpose. Click the pop-up menu button as shown to reveal the available pattern options. Choose the set called *Patterns*, then choose the pattern called *Zebra* from the top row of the swatches that appear.

9 By pure chance this pattern is a good replica of the pattern created by the water surface. Change the blend mode to *Overlay*, the *Opacity* to 35%, and scale the pattern up to 269%. All the settings used are shown in the example.

10 Suspended matter and reduced light are two of the main factors that affect visibility underwater. Even in a small swimming pool, diminished visibility will be apparent. The girl is just a little too well-defined at present. With the girl layer active, go to *Filter > Blur > **Gaussian Blur***. Apply a radius of 0.5 pixels. This is just enough to take off the sharp edge from the picture. Now reduce the girl layer's *Opacity* to 90%.

11 Just one step remaining. The outline of the girl is still very well-defined. This is common in many photo composites, not just those involving water, and it gives the image a distinct cut-out feel despite all the hard work on other elements. So a technique you may need to call upon often is a blurred border selection. It sounds like a lot of eyestrain and mouse-clicking is involved, but it's actually very automated and fast. Load the selection of the girl as before by pressing Ctrl/Cmd + clicking the girl layer in the *Layers* palette, then go to *Select > Modify > **Border***. Enter 3 pixels as the *Width*.

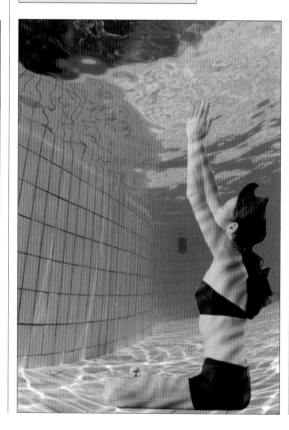

12 At first glance, it seems as if the selection has not changed, but zoom in and you'll see the selection has been turned into a border—not something you would want to try manually. Now we can blur just the edge of the girl to lose those crisp "cut-out" edges without affecting the clarity of the girl herself. Apply a *Gaussian Blur* with a *Radius* of 2.0.

13 Keep the selection active and repeat the process on the color layer to complete the image. I hope she's good at holding her breath.

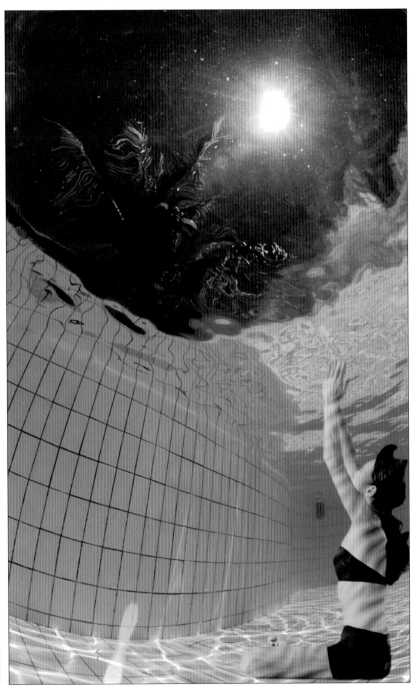

CREATING ALIEN HYBRIDS

Hollywood movie budgets for science-fiction blockbusters are among the biggest in the industry. But we are going to throw together a half-human, half-alien creature to match the best of them with a sackful of Photoshop trickery and a handful of objects you probably have lying around the house.

1 We only need the face area of the image, so select the face and delete the rest of the image, leaving a transparent background.

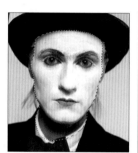

2 Our first object is a pair of binoculars. Make a selection of half of the binoculars and drag the selection into the working file.

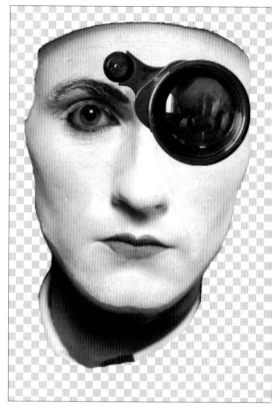

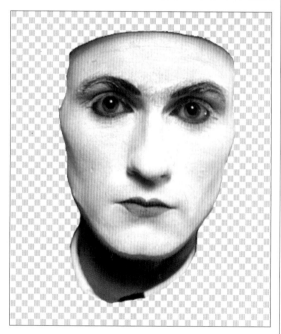

3 Repeat the same process for the opposite end of the binoculars. The two binocular pieces appear to have an obvious cut-out appearance, so we integrate them into the image by adding a drop shadow to each, using the *Drop Shadow* layer style.

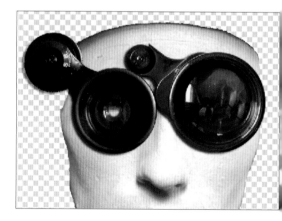

4 All the other components are added in the same way, arranging some layers below the face layer where necessary.

6 Press Ctrl/Cmd + and click the egg layer in the *Layers* palette to load its selection. Create a new layer above the egg layer called "texture", then set up a pale and dark green as the foreground and background colors.

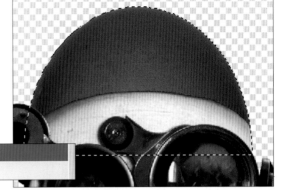

5 An egg is the perfect prop for the top of the head. Select the top half and place it in position.

7 Go to *Filter > Render > Clouds* to fill the selection in the texture layer, then go to *Filter > Artistic > Plastic Wrap*. Apply the settings as shown.

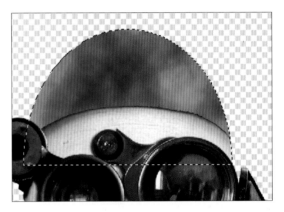

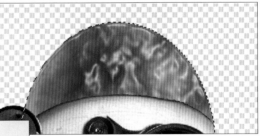

CREATING ALIEN HYBRIDS

8 Now for a nice alien-brain effect change the texture layer's blend mode to *Vivid Light*.

9 I want to achieve a similar look on some areas of the skin but in such a way that the effect seems to wrap itself around the face just as real skin would. On a duplicate of the face layer, go to *Image > Adjustments > Posterize*. Apply a setting of 4 levels.

10 Now use the *Magic Wand* tool to select one of the flattened colors. Delete the posterized layer and create a new layer in its place. Using a brown color similar to the egg, fill the selection, then with the selection still loaded create a new layer above the brown filled layer.

11 Now follow the same procedure as used for the brain. Using the same green colors, apply the *Clouds* filter to the selection followed by the *Plastic Wrap* filter and finally change the blend mode to *Vivid Light*.

12 We can hide the forehead and reveal the original effect applied to the egg for the full effect on the face. Apply a *Layer Mask* to the face layer and paint on the mask with black over the forehead to hide it. Then, using *Hue/Saturation,* change the lips' color to a pale green.

13 For the torso, an anatomical model is going to be used. Make a selection of the model and drag it into the working file, positioning the layer at the bottom of the *Layers* palette.

14 Paint on the face *Layer Mask* to merge the neck and model body together.

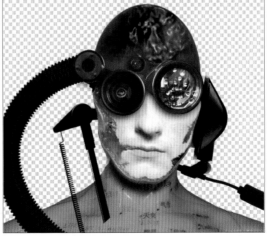

Figure Work

CREATING ALIEN HYBRIDS

15 To render the body, duplicate the body layer, then apply the *Clouds* filter to the body layer only, using red and yellow as the foreground and background colors. Make sure the selection is loaded so that the filter does not run on to the transparency.

17 The finished work has had the accessories trimmed away from the left of the body and a background has been dropped in. I also added a selection from an image of a circuit board to the right binocular, with the blend mode set to *Color Dodge*.

16 Apply the *Plastic Wrap* filter on top of the *Clouds*, and change the body copy layer's blend mode to *Linear Light*.

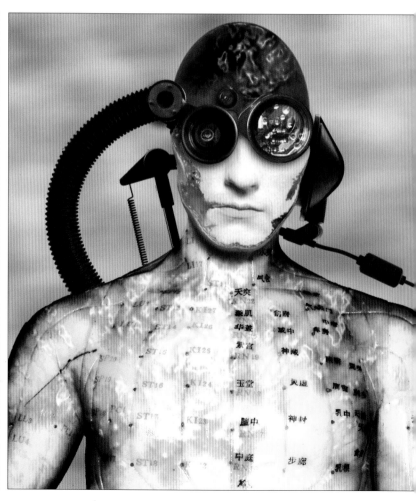

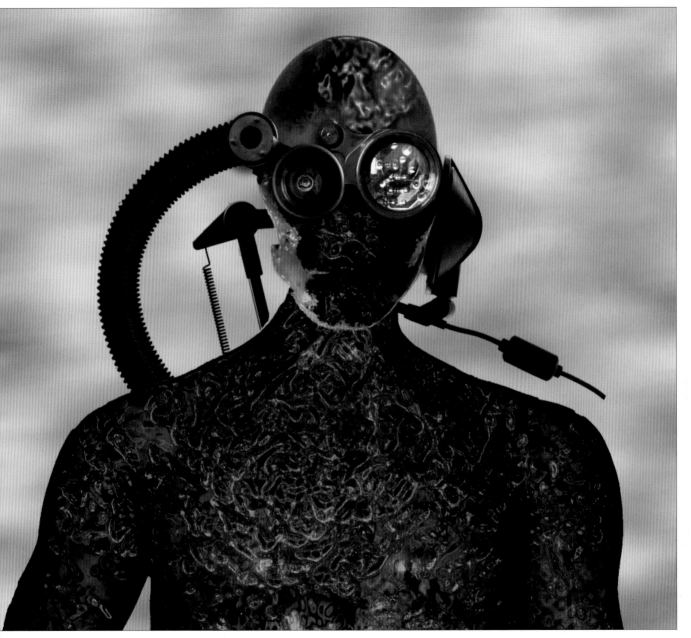

18 Once the basic structure has been assembled, different filters can have dramatically different effects. This alternative version is the result of applying the *Chrome* filter immediately after the *Plastic Wrap* filter was applied to the *Clouds*. Then the main body layer's blend mode was changed to *Color Burn*. The face *Layer Mask* was painted on to hide the white of the face, revealing the texture from the body beneath.

Figure Work

FUN WITH MOUTHS

Mention carnivorous or insect-eating plants and most people think of the Venus flytrap. A less well-known member of the category is the Sarracenia. It's every bit as carnivorous as its famous cousin, but its shape lends itself well to the adoption of some luscious lips.

1 Make a general selection of the mouth area. Select more than will be used to make life easier when the fine work is performed.

2 Drag the mouth into our carnivorous plant image, then scale and rotate it into position using Ctrl/Cmd + T for the *Free Transform* tool. When that's done, add a *Layer Mask* to the mouth layer.

3 The shape and color of the lower lip is quite similar to the lower edge of the plant. Use a small soft-edged brush and paint on the mask to blend the two components together.

When painting on layer masks for a subtle effect, its always better to work in several passes using a low *Opacity*. Although it takes longer, the results are worth the effort.

4 Now duplicate the mouth layer and its layer mask and rename the layer "mouth top." On the original mouth layer, paint on the mask to hide the top half of the mouth.

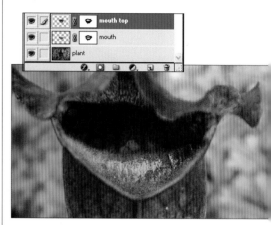

5 Now working on the "mouth top" layer, drag the mouth into position in the top part of the plant and, using the layer mask, hide the lower lip. The final effect will be an open mouth.

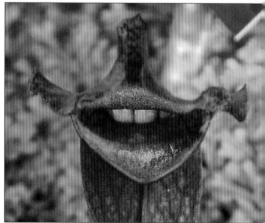

6 Next, we need a victim. Select a fly from a suitable image and drag into the working file. The fly is meant to be flying toward the flower, but he seems rather static. We'll apply some movement to the wing. Make a selection of the wing area and press Ctrl/Cmd + J to copy and paste it to a new layer.

7 Press Ctrl/Cmd + T for the *Transform* tool. Change the point of origin to the right corner of the wing and rotate the wing clockwise as shown.

8 Go to *Filter > Blur > **Motion Blur*** and apply the setting illustrated.

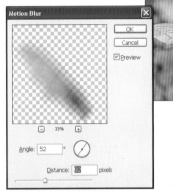

9 In the final scene, a name plate has been added, confirming the carnivorous nature of this plant.

SWITCHING LOCATIONS

Fallen Angels by Barry Jackson
The two images presented here are part of a series of images titled *Fallen Angels*. The angels in question have been banished from heaven and are forced to walk the earth in exile. While on earth, each searches in vain for a way back to heaven. Throughout the series, Jackson wanted to create a sense of despair, with the angels placed in gritty, earthly locations that seem far removed from any notion of paradise.

Far From Heaven
The idea for these images came to me after taking some photos in a local churchyard; I was struck by the beauty of the stone-carved angels and thought it might be interesting to place them in a more unusual setting. I took a number of photographs of the angels from various angles, so that when I took the location shots, I had an angel in the correct position to match each shot.

On Location
Each image was composed of two pictures, the location as the background and the corresponding angel. The bleak, confined urban spaces act as a direct contrast to the bright, airy beauty of heaven.

Adding The Angel
The angel was simply removed from its background using Photoshop's *Extract* tool and then positioned in the location shot. Certain areas of the background were then duplicated and placed in front of the angel, to place the angel in the picture rather than on the picture.

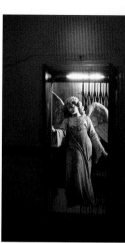

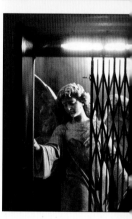

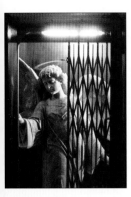

Lighting And Blending

I then used various lighting effects, the *Dodge* and *Burn* tools and selected blend modes on each of the layers to create the right mood.

Black And White

Finally, the layers were flattened before converting to black and white, using a black and white layer map.

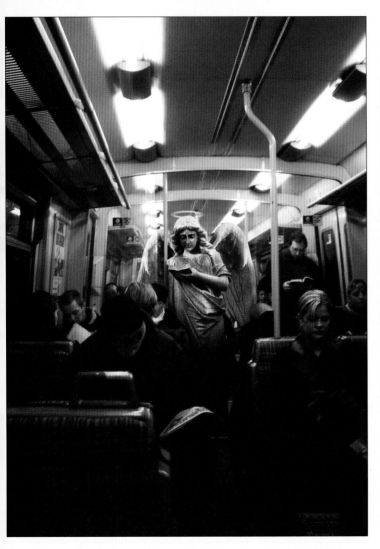

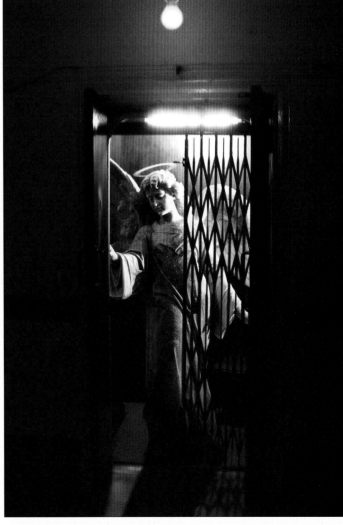

Figure Work

SURREAL PEOPLE

Siren by Laurence Acland

Layer Masks and filters can work together as a very effective means of effortlessly combining images. *Siren*, by Laurence Acland, artfully mixes traditional film photography with digital techniques to produce a striking image that is comprised of two separate shots of the same model.

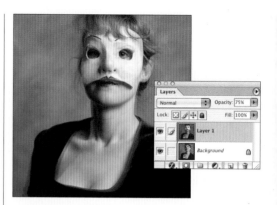

Shooting And Scanning The Images

I began this collage by shooting the model twice, once with the mask on and once without. A Hasselblad with a 120mm macro lens and Ektachrome film were used. Care was taken to keep the lighting and the position of the head as close as possible in each take. I still shoot on medium format as much for detail as for "feel." I know the digital cameras are getting very good (and I use a Nikon 5000 for some of my landscape work), but my comfort level after 25 years of using a Hassey often wins out in the studio. I next scanned in the film using my workhorse Nikon 8000. I kept the file sizes big (around 150Mb) since my intention was to produce big Giclée prints for gallery presentation.

Aligning The Images

Bringing the images into Photoshop, I pasted the masked face over the unmasked one, at first keeping the transparency down so I could align the two shots as best as possible. I made sure the outside edge of the mask lined up with the cheek.

Painting The Layer Mask

Next came the crucial part of joining the two images successfully. I added a *Layer Mask* to layer 1 (the masked face) and using a large airbrush (750 pixels) began painting black into the *Layer Mask*. Wherever black is painted in the *Layer Mask*, it hides the pixels in that layer. Thus I was able to gently obscure the unwanted parts of the mask and reveal the face beneath. By toggling back and forth between black and white, I added or subtracted bits of the mask in the composite until just the right blend was created. To "fix" the shadowy left eye, I used a smaller airbrush (30 pixels), again painting in the *Layer Mask* until just the right amount of

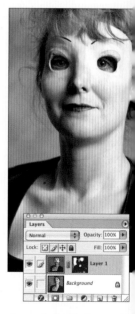

the eye in the Background layer was revealed. When a gentle brush stroke makes all the difference, the use of a Wacom graphics tablet is indispensable.

Adding The Background Painting

I then added the Dutch painting as layer 2, choosing the Blend mode as *Overlay* and once more added a *Layer Mask* to that layer, painting into it with black to hide those details obscuring the face. To get a better blend down at the bottom of the image I duplicated layer 2, compositing the new layer as *Normal* blend mode, reducing the *Opacity*, and once again painting into the *Layer Mask* to obscure the unwanted bits.

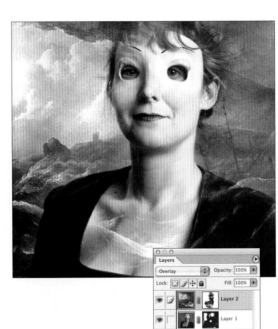

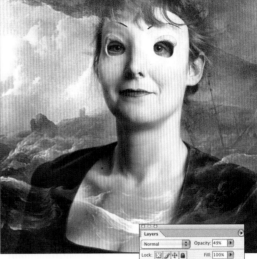

The Finishing Touches

To complete the work, I flattened the image before saving it. To give the image a painterly look, I first filtered the image with the marvelous *buZZ* filter (visit **www.fo2pix.com** for details), which gets rid of excess detail while retaining edge sharpness.

With the *History* brush, I brought back some of the detail in the eyes and face, using the saved flattened version as my history point.

Next, I ran the *Melancholytron* filter (see **www.flamingpear.com**) over the image to create a vignette effect, giving it a sepia cast and softening the area outside of the face.

To prepare the work for exhibition, I had my service bureau print it on heavy Arches watercolor paper, which I had shadow box-framed to complete the "arty" look.

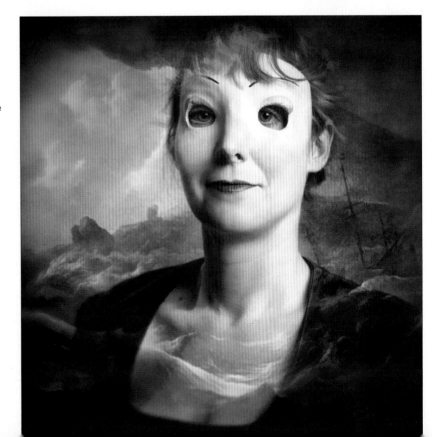

CARTOON IMAGES

Ruby Yelling by Colin Thomas

Digital imaging doesn't need to be obsessed with re-creating our reality—it can also be employed to re-create the distorted world of the cartoon. In his image, *Ruby Yelling*, Colin Thomas exaggerates his central figure to produce an effect reminiscent of the classic Warner Bros. cartoons.

The Model

This image of my daughter Ruby was originally shot on 5 x 4 film, in several parts, using a wide-angle lens. The images of her face, her tongue, the braids in her hair, and the image of the rest of her body were shot separately, to make it easier to keep them all in sharp focus.

Mouthwork

The images were scanned at high resolution and assembled in Photoshop to make the final composite image. Her face was enlarged to exaggerate the wide-angle effect, and her tongue was even more enlarged to make it fit her extra-big mouth.

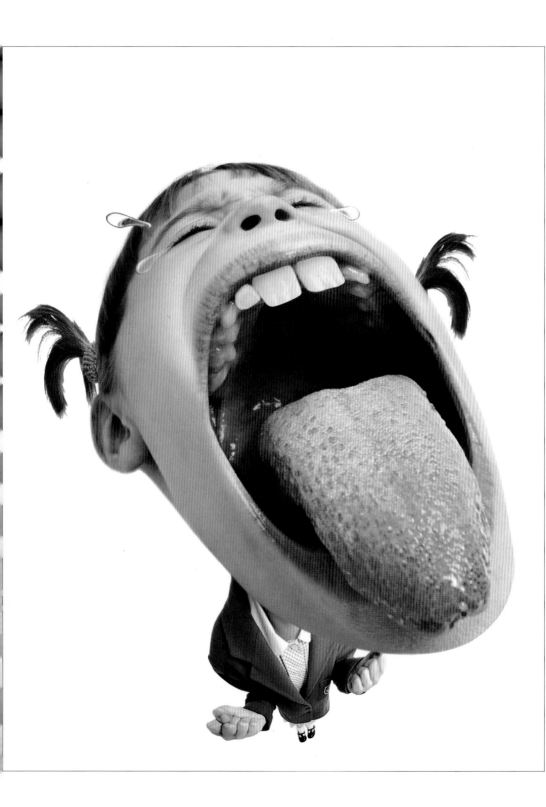

Compositing

When I'm working in Photoshop, I keep all the elements of the image on layers (and layer sets), so that I can adjust them easily and try out different ways of combining them. I use the *Transform* and *Liquify* tools to get an effect like this, combined with *Layer Masks* to control the visibility of each layer. I use *Curves* adjustment layers to control the colors of the image, and a range of other tools to get the effect that I want.

INANIMATE SUBJECTS

Manikins by Barry Jackson

Barry Jackson's *Manikins* are part of a series of images heavily influenced by the expressionist movie makers of the 1930s. These European film pioneers made movies characterized by an exaggerated display of emotion, a deeply personal and quirky visual sense, and a high-contrast use of black and white.

Posing

Each image starts with a simple artist's manikin, posed with the arms and face in the correct position.

Expressions

The model then posed for each expression, with the face in an appropriate position to map onto the head of the manikin.

Compositing

With the two shots taken, it's a case of laying the face layer on top of the mankin layer, masking out or deleting the unwanted portions, then blending the one layer on the other, so that some of the wood texture shows through the portrait layer.

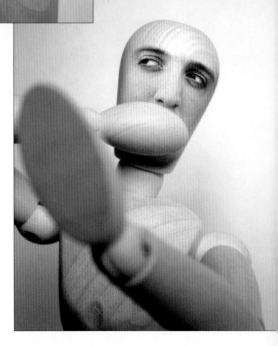

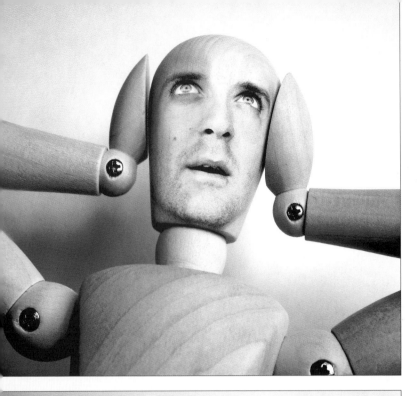

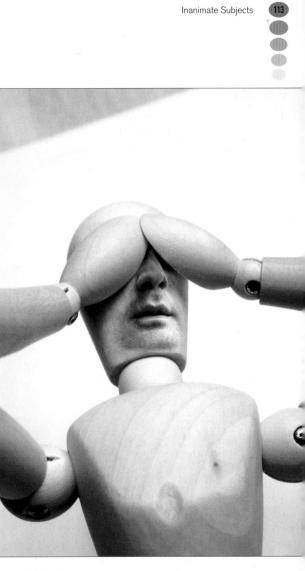

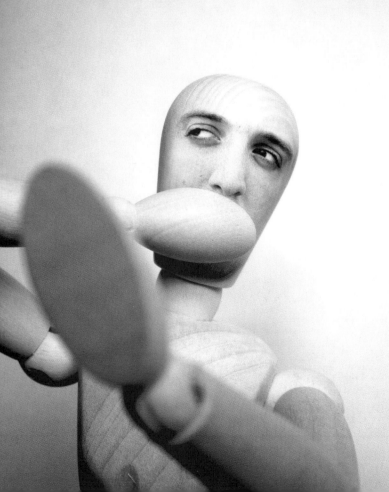

Expressionism

The sequence works
in color, but the high-
contrast, black-and-white
treatment is essential to
the dark, expressionist feel.
Monochrome just suited the
mood of the images better.

CYBORGS AND ROBOTS

...My Friend The Cyborg by Stephen Hardy

In this finely detailed piece, images of a face and a circuit board have been cleverly combined to give the human subject a sinister robotic appearance.

Overview

This image is a montage of sorts. It consists of a standard side-on portrait shot, on to which a series of layers was created. Into these layers I placed scanned images of circuit boards and built up other layers of "implants,"

produced in Adobe Photoshop using various small graphical shapes distorted using a range of filters. These shapes were "molded" to fit the face of the subject using the *Smudge* tool, *Rubber Stamp*, *Scale,* and *Distort*

tools. All of the layers were then assembled together using the various masks, and layer styles, while carefully controlling the *Opacity* and blending options between the layers, to create the final effect of the montage.

Facial Layer

The first image I used as a canvas skeleton, to which I could add the Photoshop prosthesis from layer 2, to give the appearance of electronic or biometric implants. This layer was darkened and masked to a certain degree so as to eradicate most of the background and to give a firm basis for the rest of the imagery.

Prosthesis

I used a number of different layers to draw and assemble the prosthesis for the face. I decided to accentuate the existing facial features and add additional veins/skeletal

features to the face using the *Smudge*, *Distort,* and *Scale* tools, before finally merging the layers into one, which I could blend into the final image.

Circuit Boards

The third layer is made up from a scanned circuit board of an old PC component. I used masking and various blending/ *Opacity* settings to give the skin on the subject's face the appearance of being stretched over a cybernetic skeleton.

Blending And Masking

This layer was created using a series of layers that were produced by merging the visible layers of the document and reinstalling this image into a new layer. This was then blended and masked to bring out various desired sections of the facial features/prosthesis and to darken the left side of the face into shadow.

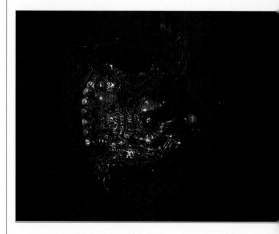

Fine-Tuning The Image
Finally, I added another
merged image and color
overlay to further accentuate
the features and add color
to the image.

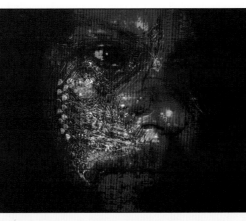

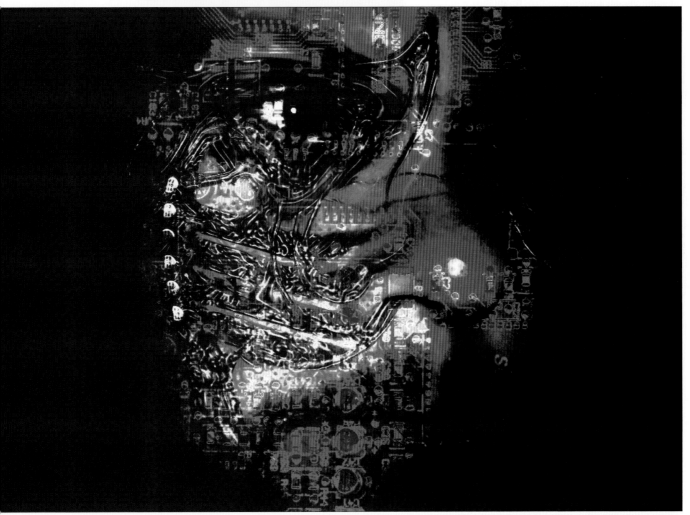

Figure Work

TRANSFORMING THE BODY

Metempsychosis by Vincent Chang

The delicate interplay of layer adjustment modes can create a bewildering range of special effects. In *Metempsychosis*, by Vincent Chang, the artist has used a wide range of layer adjustment modes to graphically depict the passage of the soul.

Shooting The Photographs

The photos of the two models for this image were taken in the same shoot, using the same lighting set-up, to ensure that when the figures were combined they would look as if they belonged in the same scene. When combining different elements in an image, it is important that the way they are individually lit is consistent, so there is no conflict with the overall light source of the image.

Retouching The Images

Before adding textures to the two figures, I retouched them using the *Paintbrush*, *Clone*, and *Blur* tools to smooth out imperfections and add extra highlights and shadows. To add texture, I built up layers of photographs of peeling paper on the female figure, and scanned watercolor stains on the male figure. I set these layers at a variery of *Opacity* settings to get the required mix.

Transforming The Figure

I then used the *Free Transform* tool to elongate the emerging female body to enhance the upward thrust of the composition. The overall colors of the figures were altered using color layers and *Selective Color* adjustment layers. The burst section at the top of the male figure was created from a photo of a torn piece of paper photographed under the same lighting conditions as the models.

Figure Work

Compositing The Images

The background was formed by combining two blurred photos, one of which was a result of a series of photos I'd taken while experimenting with slow shutter speeds and camera movement. Experimentation with camera settings and techniques can often produce interesting and unexpected results that can come in useful at a later date. The light surrounding the emerging body was then added using the *Paintbrush* tool on a number of different layers set to *Screen* mode, creating extreme highlights.

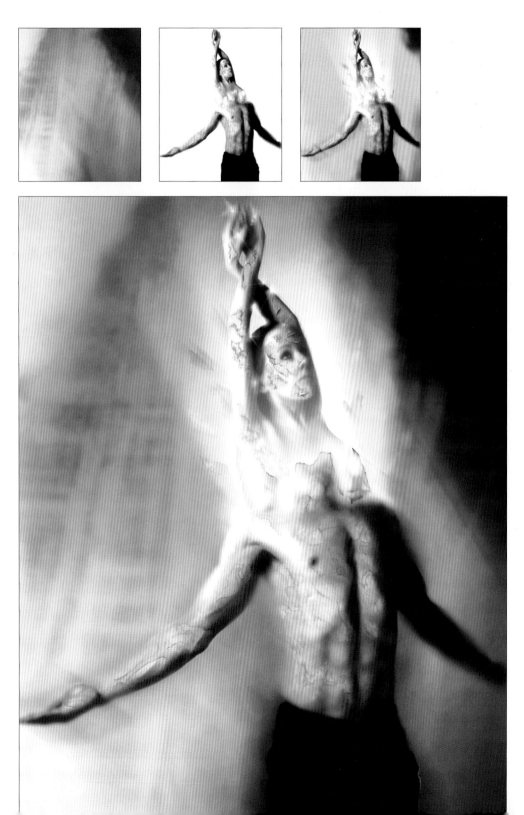

Figure Work

SURREAL BODY PARTS

Everyone Stares by Randy Luckey
In its use of flattened color and tone, *Everyone Stares*, by Randy Luckey, harks back to the work of Belgian surrealist pioneer René Magritte. The image itself is surprisingly simple in construction, but its message is clear.

The Concept
The impetus for this image was in response to a fellow photographer commenting on a nude photo that I had made. "Everyone loves a boob," was the quote that lingers. Indeed, those who seemingly take offence to anything related to such a study (male or female) will gape and gaze upon the photo or painting with wide eyes. This contrary aspect of things is essentially what spawned the work.

The Layers
This image was originally made up of a large number of layers and then flattened. The principal layers that comprise the work are: the *Colorized* viewing crowds, the nude within the frame, and the decorative frame itself. The wall was made using the *Gradient* tool.

Adjusting The Figure
The nude figure has been lightly altered—removing all from that portion of the image except for the woman's figure, as it is essentially irrelevant. The contrast was then adjusted so as to bring out the lines and hide the detail.

Framing The Image
I'd been looking to use the photo in some way, shape, or form for a time, though I hadn't found the relevant avenue to take. The museum visit solved that problem. The frame around the nude is an aberation of sorts, as I do not normally use clip-art in a work. This was simply pasted into place.

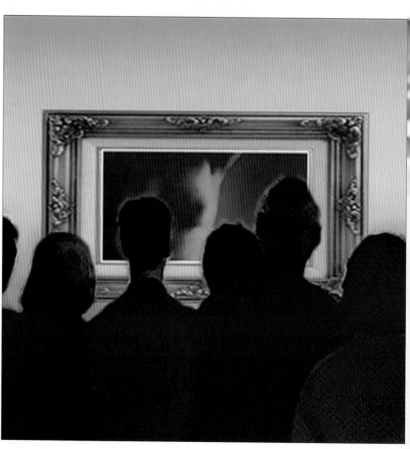

Lisa's Eyes by Randy Luckey

The eyes are said to be the window to the soul. For this reason, many photographers choose to focus upon the eyes as a means of creating an insightful portrait of their subjects. *Lisa's Eyes* takes this notion one stage further by completely eradicating the rest of the face, leaving the eyes framed by a fluorescent multi-colored border.

Focusing In On The Eyes

Every photographer has a few select models that go above and beyond the call of duty. Lisa is such a trooper. On a day in which we had her painted in what can only be referred to as "war paint," several rolls of film were shot.

In searching for that "something" in a person, invariably, it's the eyes that I'm taken with first. For this reason, I cropped out the majority of her face, leaving the horizontal view of her painted face and penetrating eyes.

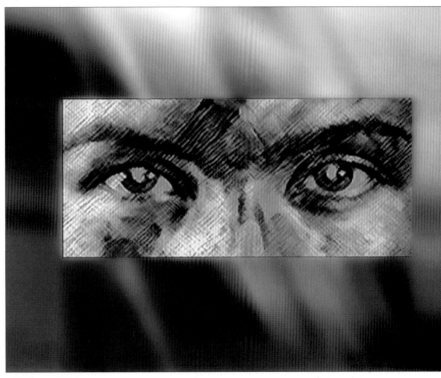

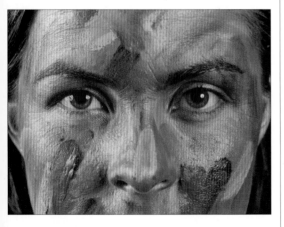

The Background

The background is simply a dark background with a variety of straight lines of varying thickness and colors set down and blurred with the *Gaussian Blur* filter.

Making Waves

The wave effect was achieved by way of a variety of filters until the appearance of a waving flag was created. The result I was looking for was that the eyes appear to float over a soft background.

Final Effects

In looking at what I thought to be the finished product, the balance of the photo didn't fall into place until I used a number of Photoshop's artistic filters on Lisa's painted face.

Crosshatched effects were the primary filters in this case. I wasn't necessarily looking for a "surreal look." The work simply appeared incomplete until these effects were put into play.

FIGURES AND FANTASY EFFECTS

Dawn by Gregory Stewart

In *Dawn*, by Gregory Stewart, the artist uses a dozen different layers to make disparate picture elements work together. Almost every layer has a different opacity setting; this creates subtle variances in color and tone, while ensuring that different parts of the image are seamlessly connected.

Assembling Background Elements

Dawn is a composite of three original images: a sunrise over water, a starry night sky, and a statue of Mercury atop a pedestal. The first step was to bring together the background of the starry sky and the sunrise with a *Gradient Mask*. Duplicating the image of Mercury many times allowed the manipulation of multiple layers to build up the effects that complete the piece.

Creating A Glow

To establish a "dreamy feel," the first step on the foreground image was to fill with white, then apply a *Gaussian Blur* with the transparency reduced to make a glow. With a *Solid Color* adjustment layer on the statue, the basis of the image was established, mirroring the sunrise hues.

Applying Filters To Create Movement

Next, multiple layers are stacked, with ripple effects, to create the ethereal feel of the image shimmering into a solid form. With each layer's ripple transformed, the *Opacity* was adjusted to build up the fluid movement. The final layers are at the core of the image effects. To develop the shimmer, a *Wind* filter is applied overall with the *Opacity* adjusted, leaving just a hint of the effect. Additionally, a *Mosaic* filter is used to give the image a digital expression.

Applying The Finishing Touches

Using multiple layers to build the effects of the image adds a greater flexibility to the various aspects of the overall piece. Adjusting the *Opacity* layer by layer gives you better control over what can be achieved. Ultimately, as a finishing touch, the sharpness is adjusted with the *Unsharp Mask* filter and a *Curves* correction brings the unblurred components out, while deepening the softer elements.

Mary by Gregory Stewart

Taking isolated figures and placing them on a more exciting or abstract background is an easy job for the digital artist. In *Mary*, Stewart has combined a relatively clean selection of the figure with additional layers to create a more ethereal vision.

Combining The Final Layers

Layer 9 is a *Radial Blur* on the original image with the transparency dropped very low. Layer 10 was filled with black and a *Radial Mask* gradient used, with the transparency lowered, punching up the top of the image while dropping back the bottom to heighten the feeling of grandeur.

The effects work with one another to create the smoky glowing feel. By manipulating the transparency and *Opacity*, the different effects have a means to show through where they work best.

Background Layer

Creating *Mary* began with a single image on a black background. Everything else in the finished piece was created in Photoshop using multiple layers with different effects and filters. The first step was to isolate and duplicate the image. Next, assembling the bottom layer as a composite of *Difference Clouds* and the original piece with *Lens Flares* created the base of the halo effect.

Difference Clouds And Lens Flare Layers

Layer 2 demonstrates another application of *Difference Clouds*, masked with the transparency reduced. Using one of the duplicates in layer 3, another *Lens Flare* was applied to create the halo of light. To add to the darkness of the image, layer 4 is a black fill, masked at an angle with the transparency reduced.

Creating A Metallic Appearance

Layers 5, 6, 7, and 8 are duplicates of the original image with different filters applied to develop the feel. Chrome and ink outlines create the rough metallic feel of the image, while adjustment layers of differing lightness and darkness deepen the effects, to add a feeling of movement.

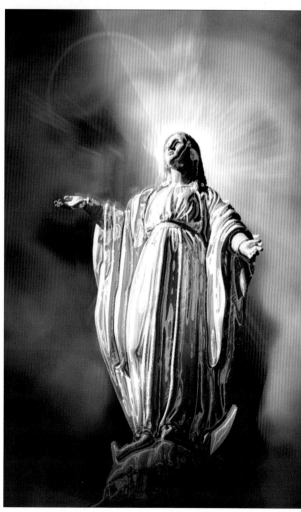

SKIN TO STONE

Original Sin by Thea Rapp

Here the artist uses a mirror-image copy of a figure to create a unique twin. Clever usage of layers, filters, and other Photoshop tools ensures that the two figures blend together seamlessly to create an intoxicating final image.

Extracting The Subject

I began the work with an original black and white fiber print. After scanning the image, I fine-tuned the contrast and the levels of the base image. The next step was to extract the model and paste the image on to a black background. Then I created a duplicate layer, flipped the image horizontally, and moved it to the right side of the canvas to create two models facing each other.

Adjusting The Figures

The eyes of the figure on the right were whitened with the *Rubber Stamp* tool and given depth with the *Burn* tool used on the shadows to redefine the shape of the eyes. After creating a duplicate layer of the model on the right, I used the *Craquelure* filter with the *Spacing* at about 27, *Depth* of 3, and *Brightness* of 10, then reduced the *Opacity* of that layer to 50%. I merged the two top layers, leaving one layer with the two models and a black background.

Adding The Apple

The apple was extracted and pasted to become the top layer. Next, I created a layer, via copy, of the two hands and put the apple in between the copy layer and the merged layer, so that the apple appears to be between the two hands. The leaf of the apple was cut and pasted on to its own layer and moved to become the top layer, so that it appears to be coming out between the fingers.

Placing The Snake

After extracting the snake, I pasted it into the image so that it became the topmost layer. In order to make the snake look as though it was twisting around the arm, I made a layer, via copy, of the right arm above the elbow, then moved the snake layer underneath the copy layer.

Creating The Border

The border was created by expanding the canvas size to make the edge white. Then I used the *Marquee* tool to create a square selection that begins about a 1/4 inch away from the image and selected the inverse. I used a linear black white gradient fill on the border. Then I beveled the border and applied a *Drop Shadow* to make it appear to be floating just above the surface image.

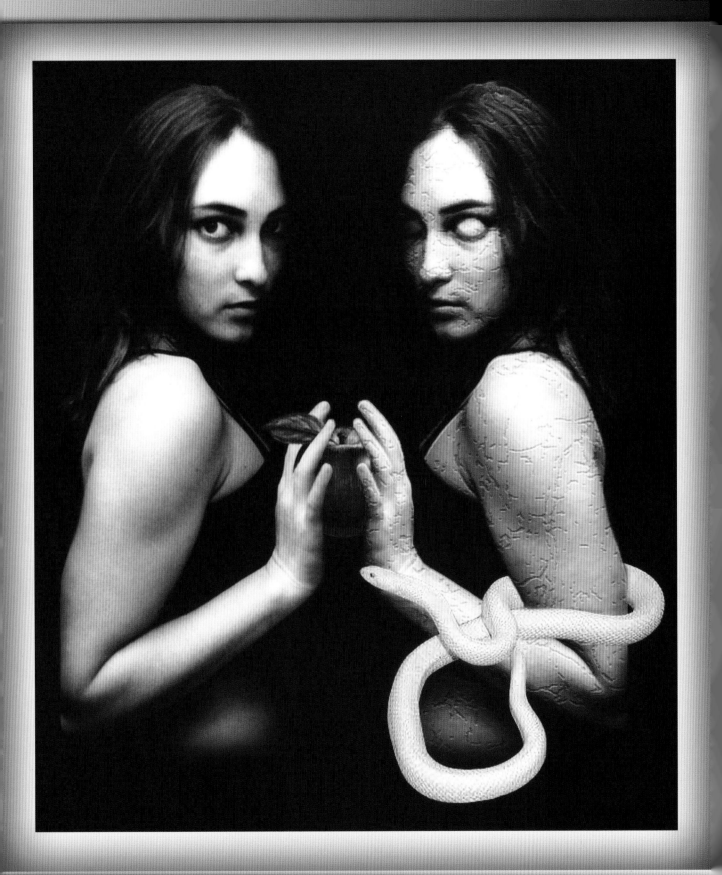

CREATING CROWD EFFECTS

10 Men At The Museum Looking At Framed Objects by Randy Luckey

In *10 Men At The Museum Looking At Framed Objects* the artist creates a crowd scene comprised of only one original figure. In doing so, he manages to produce an image that is both surreal and a wry piece of social commentary.

The Concept

The piece was started with an image that I took of a friend while visiting a Renoir retrospective at a local museum. He wanted a snap taken of himself in front of a painting by Renoir. The impetus to adjust and augment the image was provided by the reddish color of the museum's walls, seen via the sweeping brush strokes surrounding the Renoir.

Preparatory Steps

Although I felt that the red color of the museum was awkward to work with, it nevertheless suited my purposes. I began the work by turning most of the wall into dark gray shades. I also had to stretch the width of the room significantly. This was done with the *Clone* tool.

Using Clip-Art

The completed work is actually a composite of six images: the framed objects—from left to right— the Renoir (as well as the museum wall); the black and white photograph of the group staring at the painting; the bald man with glasses holding a camera; and, finally, the frame around each selection. Incidentally, this piece, along with my work *Everyone Stares* (*see page 118*), can be viewed as anomalies, as these are the only occasions that I have elected to use clip-art. In both cases, the frame of the painting is clip-art.

Adding The Figure

Creating the framed objects was the simplest task, as it was simply a matter of dropping the selections into the frames. Choosing the proper image to insert was also easy, as the "viewing at the museum" aspect of things I wanted to remain intact. From an earlier session in which I photographed a colleague wearing glasses while playing with an antique camera, I chose an image based upon his facial expression. The camera that he is holding is still visible and easily seen.

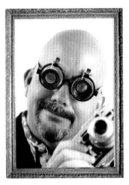

Black And White Imagery

The center image, taken during an earlier visit at the same museum, has always struck me as amusing: the crowd gazes upon a king like figure as if they were blindly listening to every word. It reminded me somewhat of the current political scenario in America.

With regard to the 10 men, a friend at the time was commenting that I don't shoot enough color images. I was almost beginning to agree with her, so I made more of the men in color than in black and white. I remain of the opinion, however, that the world looks better in black and white.

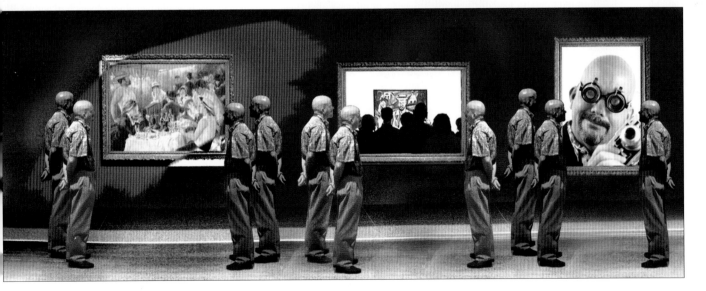

SURREAL PORTRAITS

J.G. Ballard by Colin Thomas

The degree of control that image-editing software brings to the artist is particularly effective when creating portraits. *J.G. Ballard*, by Colin Thomas, is a portrait of the reclusive writer that graphically attempts to "get inside" the writer's head.

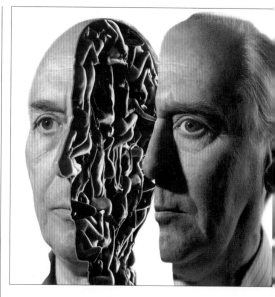

Shooting The Photographs

The *Ballard* image was made for a British newspaper to illustrate a feature about the author J.G. Ballard. We took a straightforward portrait of him at his home, and then combined it with the images of an "orgy" which were shot in the studio.

Creating An Orgy

Actually, there are only two people used in the orgy. They posed in as many different positions as they could think of, intertwined with each other. I then combined about 15 images of the two of them to create the composite orgy scene.

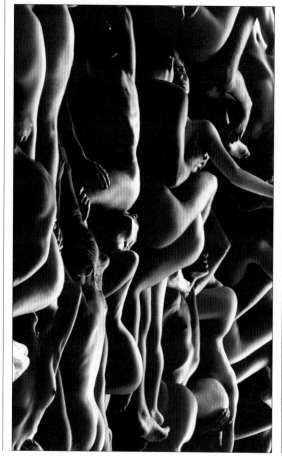

Compositing The Layers

The orgy image was then placed behind the image of Ballard's face, which was "cut in half," following what would have been a vertical line down his face in the real 3D world. Then the "edge" was created, adhering to the cut line in the face and giving it apparent thickness. The layer containing the "edge" was colored to look like skin but darker, and some real skin texture was added.

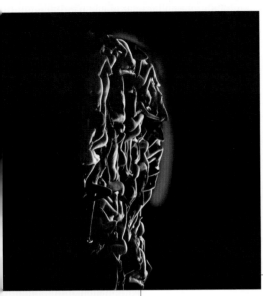

The Final Adjustments

At the art director's suggestion, the black and white uncut image of Ballard was added. Initially, the client was worried that Ballard would not be recognizable when cut in half, but I think the whole image looks better with one complete Ballard and one exploded Ballard. Well, it was fun to make, and it attracts a lot of attention in my portfolio.

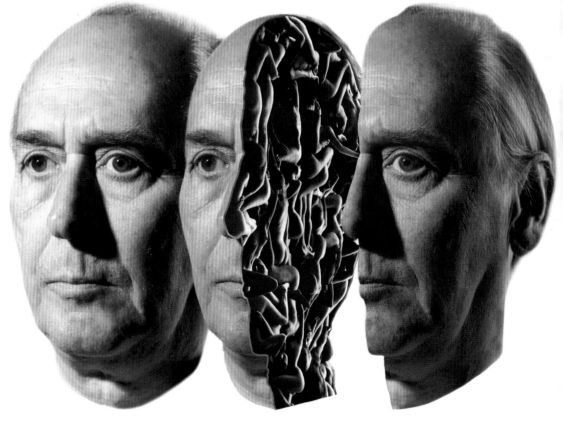

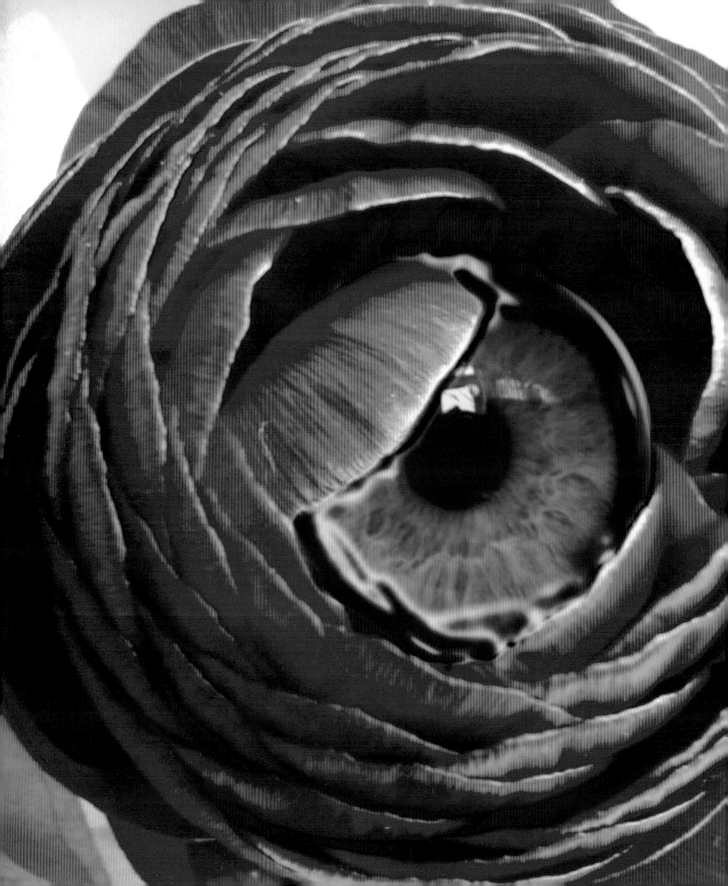

5

The natural world and its animal and vegetable denizens can be another rich subject area for digital surrealism. With a few twists, animals can be turned into monsters, the human form can merge into plantlife, and strange or shocking juxtapositions can be created. Think of Dali's Elephant-Giraffes and Magritte's apples if you need inspiration, or simply take a tour through the following pages.

flora and fauna

TRICKS WITH COLORS

Color editing has always been a strong point of image-manipulation programs. Normally, fine adjustment of color for greater authenticity is all that is required. However, the potential for outrageous changes of color also exists. The more unlikely the color combination, the greater the impact...and blue bananas are about as unlikely as you get.

1 Select the bananas and drag them into the ocean image. Rotate the bananas as if they had just been dipped in the water.

2 Make partial selections of the bottom half of each banana. These will be the areas that will appear to have been dipped in the blue water. Add a *Hue/Saturation* adjustment layer to the bananas layer, making sure the two layers are combined as a *Clipping Mask*. Now drag the *Hue* slider to the right to achieve a blue similar but not exactly the same as the blue water.

3 Once you are happy with the blue color, merge down the adjustment layer with the bananas layer, then make a selection of the lower section of the banana on the left. Activate the bananas layer and press Ctrl/Cmd + Shift + J to cut and paste the selection to a new layer.

4 This lower section needs to seem as if it is underwater and distorted by the water refraction. Go to *Filter > Distort > **Wave*** and apply the settings shown, then reduce the layer's *Opacity* to 80%.

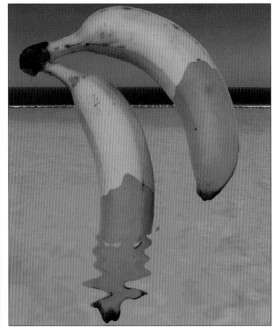

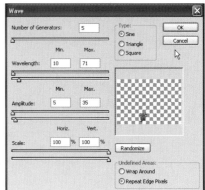

TRICKS WITH COLORS

5 As the banana on the right is clear of the water, we'll make a drip of liquid appear just below it and some ripples suggesting that several drips have already fallen from the banana. Make a high-feathered elliptical selection beneath the banana. Activate the Background layer and press Ctrl/Cmd + J for a copy of the selection on a new layer.

6 Load the selection into this new layer by pressing Ctrl/Cmd +, clicking the layer in the *Layers* palette, then go to *Filter > Distort >* **Zigzag**. Apply the setting shown. This works well for calm water disturbed by something dripping into it.

7 Now for the drip of water. Make a selection of the water drip and drag it into the working file. Position the drip between the banana and the ripple in the water. The drip was captured before it had fully formed, but we can easily remedy that and shape it as required. Go to *Filter > Liquify*. Choose the *Liquify Warp* tool and a large soft brush. Drag from the centre of the drip upwards to form a teardrop shape.

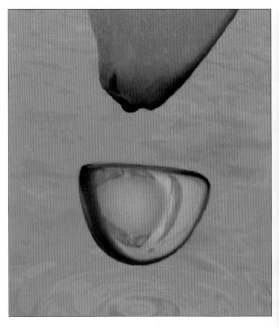

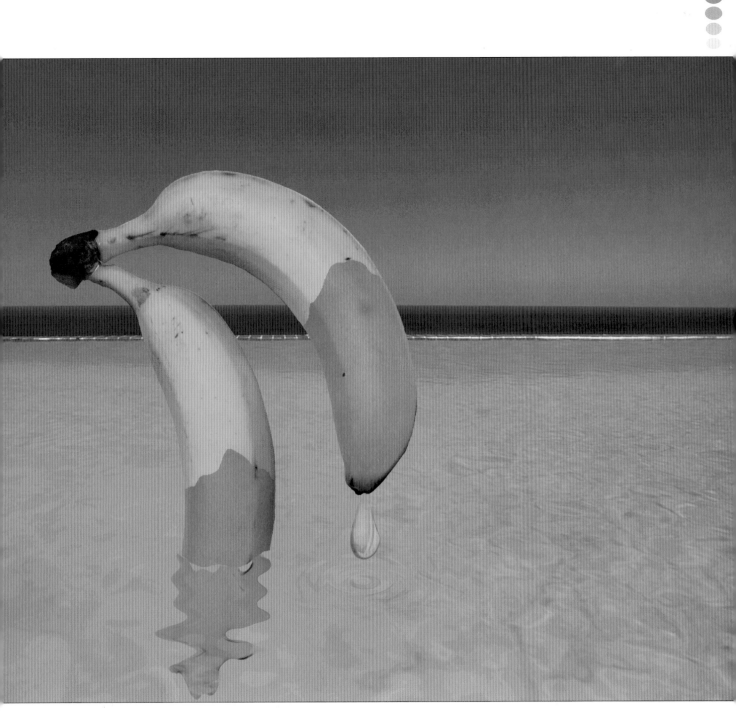

8 Finally, scale the drip to fit and change the layer blend mode to *Overlay*. For a more pronounced drip, try *Vivid Light* or *Linear Light*.

MAKING MONSTERS

Some of the fiercest monsters the human imagination can conjure up can start life as the most innocuous and cutest of the wildlife kingdom. Who could possibly fear a goose and a cuddly chimpanzee? Well, let's see as we use them to form the basis of a blood-chilling night creature.

1 Let's start by adding some wings. Make a selection of most of the bird's wing apart from the top area and drag this selection into the chimpanzee image, positioning it near the shoulder on the left.

2 The wing was originally photographed in motion, which accounts for its soft focus. This doesn't look right against the sharper focus of the chimp, so we'll use a *Sharpen* filter to bring the two elements closer together. Go to *Filter > Sharpen > **Unsharp Mask*** and apply the settings displayed.

3 Add a *Layer Mask* to the wing layer and paint on the mask in black to hide parts of the wing that would be behind the chimp's body.

The mask can also be used to shape the lower part of the wing to create a more jagged bat type of wing.

4 The color of the chimp's fur will be used as the basis for the color of the wing. Use the *Eyedropper* to sample a middle-range color from the fur. Select the *Color Replacement* tool and paint over the wing area.

5 The chimp's fur is actually a range of colors, so to copy this more faithfully on to the wings, make a second *Eyedropper* selection from a different area of the fur and paint some more random patches on to the wing using the *Color Replacement* tool.

6 For the second wing, all the work has been done. Duplicate the wing layer and flip it horizontally (*Edit* > *Transform* > **Flip Horizontal**). Position the wing and edit the *Layer Mask* as required.

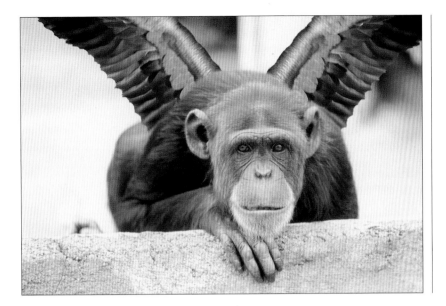

7 This cute face is far too angelic to be a believable monster, so we are going to demonize him with some body sculpting. Digital body sculpting is often thought of in terms of making a human figure more slender or shapely, but it equally applies to distorting a figure to grotesque proportions. The perfect tool for this is the *Liquify* filter.

Let's begin by making some bat like pointed ears. Activate the background layer, then go to *Filter* > **Liquify**. Use the *Liquify Freeze Mask* tool to draw an area that will not be affected when the ear is changed. This prevents too much distortion in the surrounding area.

8 Now use the *Liquify Warp* tool and drag upward to create a pointed ear. If the first attempt isn't successful, Ctrl/Cmd + Z works to undo the stroke, then try again.

9 Repeat the process on the other ear, first using the mask to isolate areas to be unaffected, then use the *Warp* tool to point the ear. After clicking *OK*, you will notice the ear on the right is hidden by the wing, so you will need to edit the wing layer's *Layer Mask* to reveal the pointed tip of the ear.

Flora and Fauna

MAKING MONSTERS

10 Before going any further, make a selection of the eyes and with the Background layer active press Ctrl/Cmd + J to copy and paste the selection to a new layer. Hide the layer as we will be using it shortly.

11 Go back to the *Liquify* filter so we can make the brow and nose more demonesque. The brow is changed in three moves as defined by the red arrows. You may find it easier to use multiple short strokes to achieve the desired effect. If everything goes awry, remember the *Reconstruct* tool allows you to drag over the distortions to take you back to the beginning so you can try again. The pupils have been masked out with the *Freeze Mask* tool to minimize any effect on them as much as possible. Lastly, work on the nose. Use the *Warp* tool and drag the nostrils upward.

12 Even though we masked out the eyes, they have still become distorted at the edges. This is why we took a copy of them earlier. We can now reveal the copied eyes layer so that they appear without distortion. However, the pupils are a little too big for the eye socket since it has been reshaped. Add a *Layer Mask* to the eyes layer and paint with black on the mask to hide the edges.

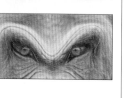

13 No demonic creature would be suitably attired without red eyes so press Ctrl/Cmd + U to bring up the *Hue/Saturation* command and change the *Hue* to red (-26) with fairly strong *Saturation* (+45). To make the eyes really piercing, change the layer's blend mode to *Vivid Light*.

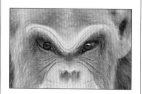

14 The next element to add is a ferocious-looking jaw. Make a selection of the jaw and drag it into the working file. Position the jaw over the chimp's mouth, scaling the jaw as necessary.

15 Add a *Layer Mask* to the jaw layer and paint with black on to the mask to blend the new jaw into the chimp's face.

16 The lower jawbone has no covering as yet, so we'll add some of the chimp's fur. Create a new layer above the jaw layer called "fur." Using the *Clone Stamp* tool, take a sample from the right side of the chimp's face by pressing the *Alt* key and clicking the area to sample. Now paint with the *Clone Stamp* tool over the bone on the right side of the lower jaw.

17 Repeat the process with the left side of the face to complete the entire lower jawbone. If it's a photographic image you are looking for, then we've come to the end.

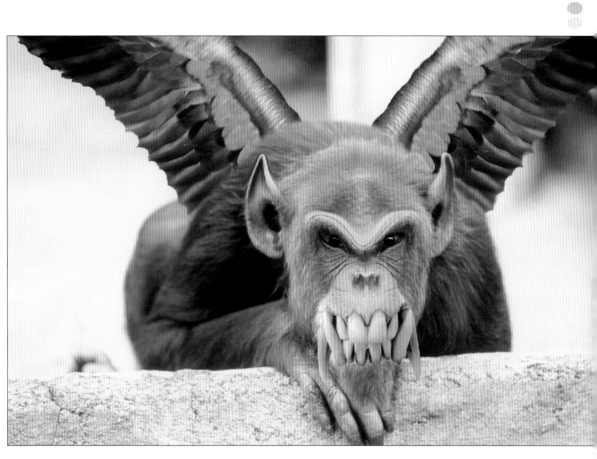

18 However, this kind of character also lends itself well to specific styles of art. For instance, to create a dark Gothic style painting, try *Filter > Artistic > **Fresco***.

19 For a fantasy comic-book style, try *Poster Edges*, also found under the *Filter > Artistic* menu.

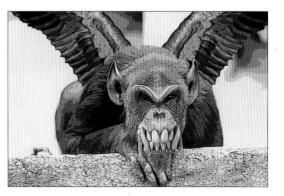

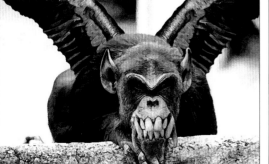

Flora and Fauna

SURREAL LEAVES

Nature seems to mimic itself with surprising regularity. Close inspection of everyday things that we take for granted can often bear uncanny resemblances. A bit of digital know-how is all that's needed to turn these similarities into whole new species.

1 The basis for our new species is a human hand. Make a selection of the five-fingered appendage and drag it into the palm leaf image. Scale and position the hand at the base of the palm so that the fingers stretch out into the palm fronds.

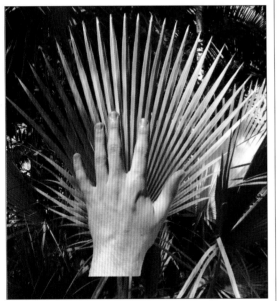

2 Only part of the fronds will be used and the background is also very busy and distracting, so we'll make a selection of the required palm fronds only and then remove the entire background. Make a selection of the fronds as shown. The selection is displayed in *Quick Mask* mode for clarity. Delete the background area so all that remains is the chosen area of the palm.

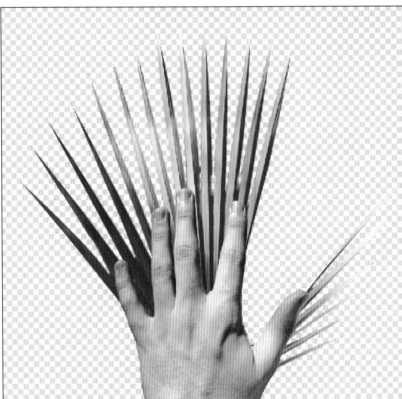

3 We need to replace the natural color of the hand with a color that matches the palm. There are a number of ways of doing this. Let's utilize the *Color Replacement* tool new to Photoshop CS. First, use the *Eyedropper* to sample a color from the leaf, then select the *Color Replacement* tool using the settings as shown from the tool *Options Bar*.

4 Painting over the hand colors it green, but keeps the textures and shading untouched.

5 Perhaps the most important part of this project is the blending of the hand into the palm. Add a *Layer Mask* to the hand layer and paint with black on to the mask to hide the fingers. The area where the base of the fingers meets the fronds is critical, so zoom in and use a small brush in this area to blend the elements together.

SURREAL LEAVES

6 Rather than the hand floating in mid-air, we'll attach it to another plant growing out of a pot. Make a selection of part of the plant and the pot. Drag the selection into the main working file, positioning the layer at the bottom of the *Layers* palette.

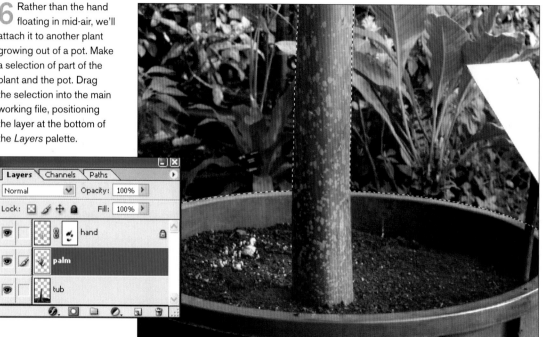

7 *Scale* the tub image so that the trunk of the plant fits on to the hand as if it were the wrist, then paint on the mask to blend the hand and trunk together.

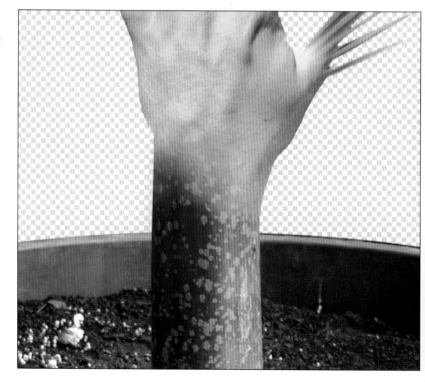

8 The color of the plant trunk is too different to that of the hand, so this time we'll take some color from the hand and add it to the trunk. First, sample a color from the hand using the *Eyedropper* tool as last time, then select the *Paint Brush* tool and change the blend mode to *Color* from the tool *Options Bar*. Paint over the trunk and we are left with quite a subtle change of color sufficiently close to match the color of the hand.

9 All that remains is to drop in a suitable background image and we have a plant to make your flesh creep.

WEIRD FLOWERS

Photoshop's extensive layer and *Layer Mask* capabilities are the power behind many of today's best digital image illusions. But the greatest challenge remains unchanged: how to disguise the fact that elements are on different layers. The more tricks you can employ to make your multiple layers appear to be one cohesive entity, the greater your prospect of a successful illusion. In this tutorial, we'll use the pupil of a human eye as the center of a flower and try to bond the two as if that's what nature intended.

1 First, make a selection of the eye and drag the selection into the flower image.

2 The inner petal will appear to wrap around the eye almost like a flower eyelid. Hide the eye layer and draw a selection around the inner petal as shown.

3 Reveal the eye layer, then add a *Layer Mask* to the eye layer and paint on the mask with black with a low *Opacity* brush setting to soften the edge of the eye where it meets the flower.

4 With the eye layer still selected, click the layer style icon at the bottom of the *Layers* palette and choose *Bevel and Emboss*. Quite a few settings have been changed here, so we'll tackle the dialog box in two halves. First, the top half shows the structure. A smooth *Technique* is applied at a high *Depth* level. Relatively high *Softening* is used also.

Bevel and Emboss
Structure

Style: Emboss
Technique: Smooth
Depth: 421 %
Direction: ● Up ○ Down
Size: 18 px
Soften: 7 px

5 The lower half of the dialog box shows the shading, but the main change here is the gloss contour drop-down box. This actually gives you access to a number of predefined curves, the same kind of curves you use when you are adjusting color or brightness. Click the drop-down box and choose the curve shown. You may find it interesting to click through the other options and see the effect it has on the image.

6 If you feel really adventurous, you can click on the main thumbnail to open the contour editor and manually adjust the curve yourself.

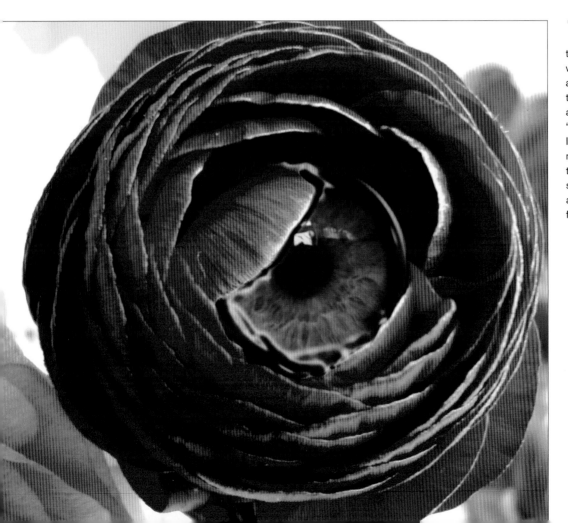

7 The result of the *Bevel and Emboss* setting is to make a kind of gel effect which sticks to the petal and is quite appropriate for the composition of the eye, allowing it to become "seated" within the flower. If you now paint on the mask around the edge of the eye, the effect will be similar to painting with oil and water or running your finger over an LCD screen.

DANGEROUS CREATURES

Alligator by Todd Pierson

Surreal imagery is often playful imagery. Combining fierce animals and small children might be too dangerous for reality, but in the digital world it's just good fun. Here, Todd Pierson breaks a cardinal rule of entertainment—never work with children or animals—to produce a cool image with instant appeal. This image consists of two main images, the kids, then the alligator, but it also required some post-production decoration in order to make the scene look more complete.

Conceptual Art

Whenever I start a concept, I usually try a few tests to make sure that the set will work visually and be a success. I first placed one of the chairs in my kitchen to see how the camera angle, floor, wall, and picture on the wall would all work together. This also gives me an idea of how much floor and wall I need.

Rough Work

I then took the chair, picture, wall border, and floor and placed them very roughly into a photo using Photoshop. I didn't care about details—I was still making decisions on color and props. Later you will see that I used a different picture on the wall. I needed something more fun.

Wallpaper

The pattern on the wall was needed to make the wall seem less blank. To save loads of time, I took this zebra pattern from a piece of fabric and placed it in the scene using the Luminosity blend mode set to 4% *Opacity*. The layer was on top of the other layers, so I had to mask out the parts of the scene I didn't want the stripes on.

Finishing The Set

After painting the two panels that make up the wall, I braced them together and completed the set. The picture on the wall was a stand-in. I usually shoot the set without any subjects to have an empty room I can use if I need it. In this case, I needed to mask in parts that would normally be covered up when the kids are in the chairs and the alligator is on the floor.

See You Later...

The alligator was the first subject to be photographed. This alligator was actually only 5 feet long. I could have brought in a 9-footer, but the extra cost wasn't worth it, knowing that I could enlarge it digitally. The trainer had some tricks to get him to open his mouth. I shot 30 images of him in a range of different positions.

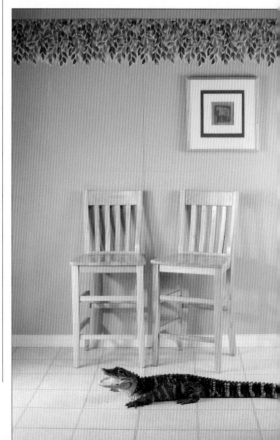

Angling For Cats

Now I had to get the kids to have really fun, playful faces showing no fear. So we brought in two playful cats and put a mouse toy on the end of the fishing pole. The cats ran around and the kids played a game with it, keeping the mouse away from the cat. It worked like a charm. All five models had a good time. I used five kids because I didn't want to take any chances with not getting a good expression.

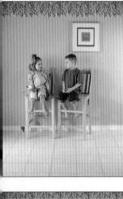

Arms Raised

The best shot was these two kids, but the girl's arm was low and I wanted her to be holding it up high. Here, you can see where I masked out her arm and I then took a shot with her arm up and stripped it into place.

Putting It Together

Finally, adding the worm and stripping the 'gator into the shot completed the image. I used a fake worm so it would stand out better. You had to be able to tell what it was at a quick glance.

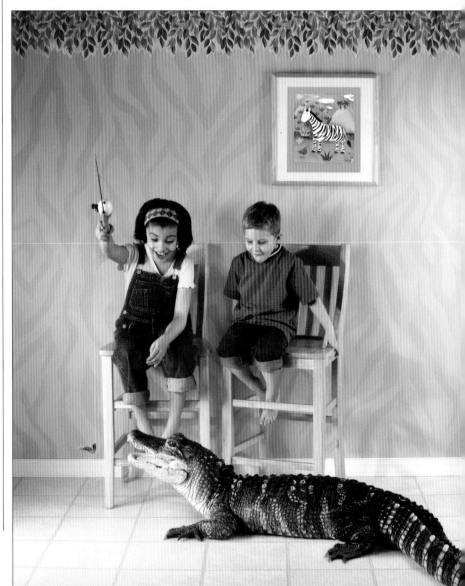

Flora and Fauna

COMBINING PLANTS AND PEOPLE

Peach Girl by Colin Thomas

In *Peach Girl*, the artist cleverly combines a classic nude with an image of a peach hanging from the tree. In doing so, he also repairs flaws in the plant by adding replacement leaves to create a stunning and evocative image.

Shooting The Peach

The *Peach Girl* image was made for an advertising campaign for a skincare product. We shot the image in wintertime, so we had to have the peach flown in from South Africa, still attached to its branch and packed in damp cloths in a packing case. As you can see, it arrived looking fresh and still in one piece, so we shot a picture of it quickly. Then we shot pictures of the model to fit.

Shooting The Model

Silver, the model, lay curled around a large cushion on the floor, and we rigged up the camera directly above her. We shot the pictures with a bank of soft lights through a Perspex screen. The selected images of the peach and of Silver were drum-scanned at high resolution and combined in Adobe Photoshop to make the finished composite.

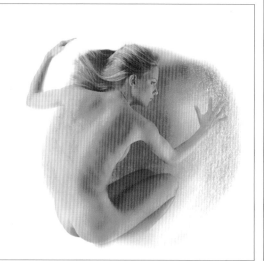

Compositing

It's a fairly simple composite; most of the layers are used for improving various attributes of the peach and its branch. The image of Silver was cut out using a path in Adobe Photoshop, making a feathered selection from the path. Then a mask was added to the layer containing the cut-out image and the edges of Silver's image were selectively painted away using the *Brush* tool in black at low *Opacity* settings. This helps to stop her looking too "cut out" and makes her blend with the peach better. Also, it made it easy to hide her feet and part of her hair, which didn't fit the peach exactly.

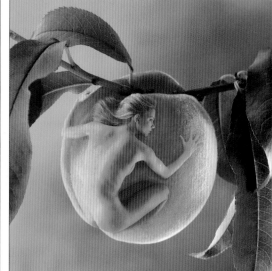

Adding
Adjustment Layers

Finally, there is a *Curves* adjustment layer between the image of Silver and the mottled surface of the peach that has been painted on in the same way. This creates a soft shadow of her body on the surface of the peach .

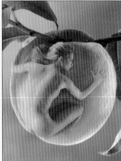

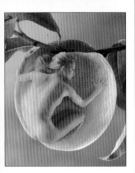

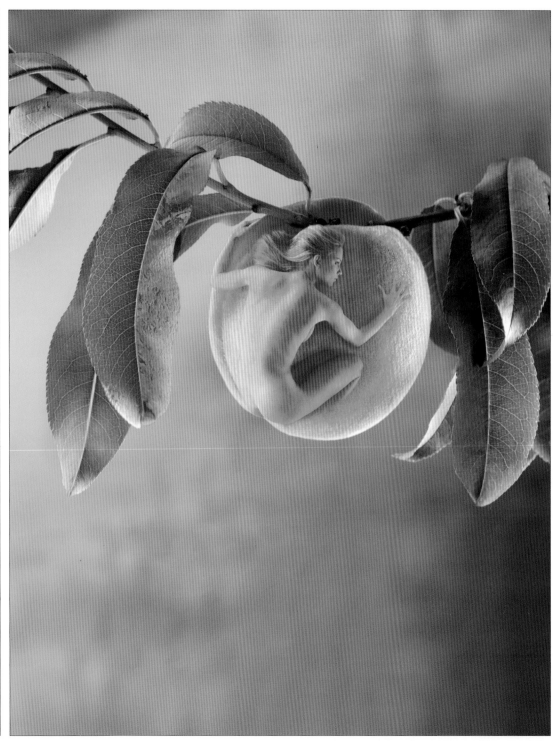

FANTASTIC FLOWERS

Flowers by Jerry Ritchie

In *Flowers*, by Jerry Ritchie, the artist uses two separate image-editing programs—Adobe Photoshop and Ultimate Paint—to give a photograph of flowers an ethereal appearance. Combining the individual strengths of different programs is an ideal means of creating special effects that might otherwise be impossible to achieve.

Making Color And Tone Corrections

This image was created using two different graphic programs, Adobe Photoshop and Ultimate Paint. The image was initially opened in Adobe Photoshop, with the first step being to make minor corrections in the image using the auto levels command. The image was further manipulated using the *Image > Adjust > Variations* command.

Saving The Image As A JPEG

The image was set for *Midtones*, halfway between fine and coarse, and the *Show Clipping* box was checked. A one-step increase was made using the *Darker* command and a one step increase for *Magenta*. At this point, the image was saved as a JPEG at the maximum quality of 10.

Using Ultimate Paint

Next, I opened the JPEG image in Ultimate Paint and applied the *Color Glow* filter. This brought up the *Tools* folder for the filter. I set *Color 1* to yellow and *Color 2* to blue. The *Radius* was set at 70 and the *Mode* to four at *Normal* setting. Applying the filter to the image turned the shot into something more "surreal." I often use more than one image-editing program to achieve the results I am searching for.

ADDING STRIPES AND SPOTS

Return to Nature by Paul Maple

The huge diversity of special effects available in Adobe Photoshop is particularly impressive when applied to an image that is already strong in its own right. *Return To Nature*, by Paul Maple, uses layers, masks, and filters to bring a new perspective to a photograph that could easily hang in any gallery.

The Background

The intention of the image is to demonstrate how humanity fits in with nature—that humanity is a part of nature. The idea of blending a model into a natural background was chosen to illustrate this point.

The tonal values of the image are assessed and adjusted using the *Levels* command. A new darker black point is established, resulting in deep shadows and improved overall contrast.

The Right Tone

The image is converted into *Duotone* mode. A four-color Duotone is used which has the effect of increasing the color fidelity of the image, creating a subtle, more complex spread of tones and colors. To boost this color effect further, the image is converted into RGB (Photoshop's preferred working color space) and the *Saturation* increased using the *Hue/Saturation* command.

Having established a "feel" for the image, a glow effect was created to allude to an ethereal quality. This is achieved by using the *Color Selection* command from

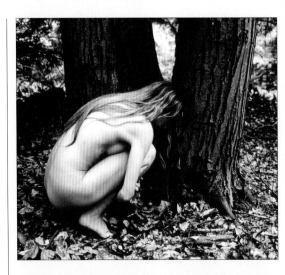

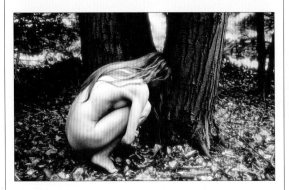

the *Select* menu. Having made a rough color selection based upon the highlights within the image, this selection was then placed on to a new layer ("glow effect") in order to control the intensity of the effect. Next, a *Gaussian Blur* filter is applied to the "glow effect" layer to soften the highlights, creating a glow within highlight areas only. A *Layer Mask* is added, and highlights within the model's body are removed.

Creating The Skin

A picture of bubbles in a puddle of ice is positioned over the subject. The Opacity of the "ice bubbles" layer is reduced to 29% and the layer's blend mode is set to *Multiply*.

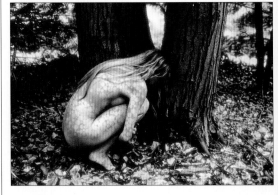

Adding The Finishing Touches

The *Hue/Saturation* command is applied with the *Colorize* box checked—this unites the color of the ice bubbles. Careful selection of the color is important to create the right effect. A *Layer Mask* is then added to the "ice bubbles" layer. The hair is carefully painted out on this layer, to reveal the hair below on the "background" layer. To make the ice bubbles fit better with the contours of the body, paint is gently applied to the layer mask on the "ice bubbles" layer—this removes any light within shadow areas.

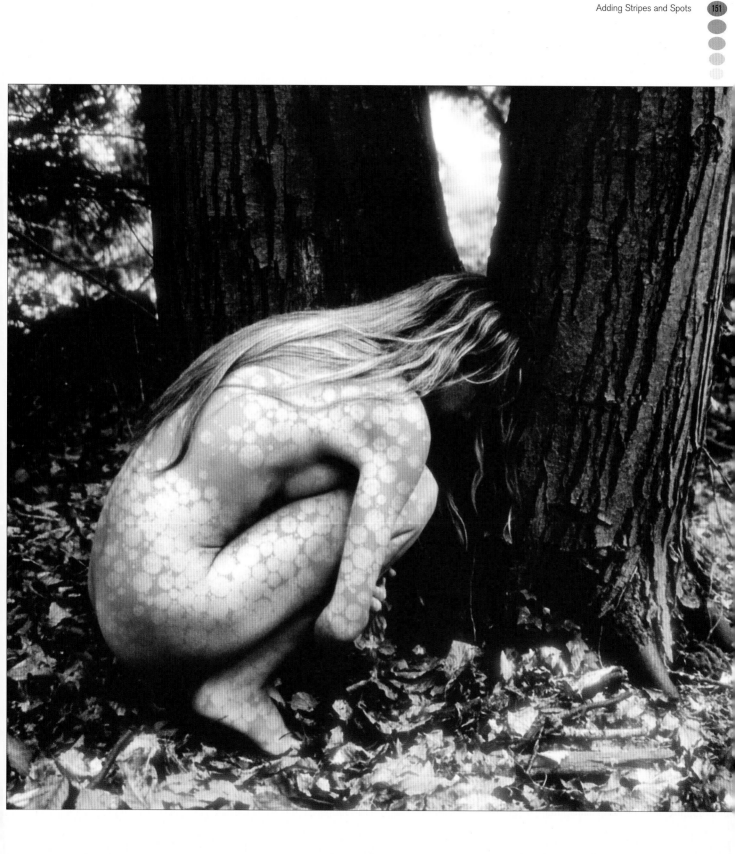

IMPOSSIBLE CREATURES

Mask by Thea Rapp

Mask is another example of an image created using mixed-media techniques. The image takes advantage of the unique clarity of traditional film photography, and uses digital image-editing techniques to produce a unique and inventive work.

Extracting The Face
I began the mask with an original black and white photograph printed on selenium-toned fiber paper. After scanning the image, I extracted the face and pasted it on to a black background. Using the *Eraser* tool, I removed the inside of the mouth, leaving only the lips. I also removed the eyes to create a mask.

Creating The Ribbons
To get the ribbon effect on the side and forehead of the mask, I first used the *Smudge* tool with various soft brush sizes to pull the edges out into uneven strands. With a combination of the *Dodge* and *Burn* tools, I gave the ribbons and facial features depth and perspective. I used the *Dodge* tool to pull out the highlights and used the *Burn* tool to accentuate the shadows.

The Porcelain Effect
Next, I created a duplicate layer and pulled the existing ribbons out further on the bottom layer with the *Smudge* tool to create the layered look. I used the *Diffused Glow* filter with no grain and increased the contrast of the top layer of the mask to give it the appearance of porcelain.

Pasting The Snake Into Place
After extracting the snake image, I pasted it into the mask image. I used the *Marquee* tool to select the upper portion of the mouth of the mask and made a layer via copy. Making the copy layer the top layer enabled the snake to appear as if it was coming out of the mouth, under the top lip and over the bottom lip.

Creating The Border
To create the border, I made a selection about an inch from the edge of the image and selected the inverse. Then I used a coarse weave pattern fill at a scale of 30%. The inner part of the border was selected at about 1/2 inch from the outer edge of the image. To achieve the spike effect, I used a small *Ripple* filter at an amount of 990% on the selection and brought the brightness down to make it appear recessed from the rest of the border.

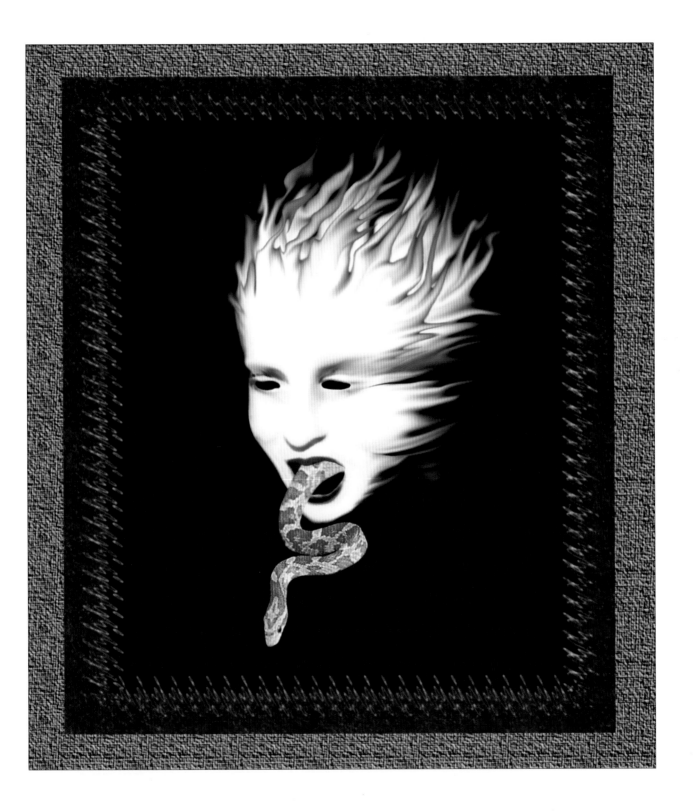

Flora and Fauna

MYTHICAL CREATURES

Phoenix by Thea Rapp

In this dramatic piece, the artist mixes traditional film media with digital imaging to create the distorted face of a mysterious figure. This type of effect would have been almost impossible to create in pre-digital days.

Scanning The Background Image

I began *Phoenix* by scanning a black and white 35mm negative as a color negative to give it a signature red color. After doing this, I pasted the image on to a black background, created a duplicate layer, ran auto levels, and reduced layer *Opacity* to 50%.

Creating The Face

I merged the top two layers, then created two more duplicate layers, changing the *Opacity* of the top one to 50%. Next, I flipped the top and bottom layers horizontally and erased certain areas of the top and middle layers with a soft brush. By revealing small portions of the different layers, I created the double eye and the soft lines on the face. I then used a *Polar Coordinates* filter on each layer to create the shape of the image.

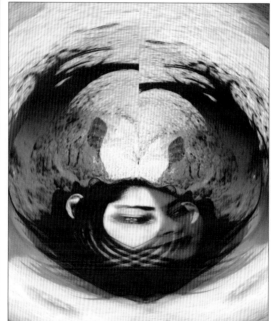

Cleaning Up The Image

Having merged the top three layers, I used the *Rubber Stamp* tool to clean up the wings and the face. With a combination of the *Dodge* and *Burn* tools, I pulled the head and body of the phoenix out of the background. The *Dodge* tool was used to pull out the highlights and the *Burn* tool to accentuate the shadows.

Merging And Blending Layers

I merged the existing layers, created a duplicate layer, and used the *Accented Edges* filter with an edge brightness of 9 on the top layer to intensify the dark lines of the image. The top layer was then blended using a soft light layer mode at 30% *Opacity*. After merging the top two layers, I used the *Elliptical Marquee* tool to cut an almond-shaped selection on the head of the phoenix to create the eye.

Spherizing The Image

On the background layer, I used a 35mm prime lens flare, along with a glowing *Edges* filter, to create the eyeball and then flattened the image. Using the *Elliptical Marquee* tool, I made an oval-shaped selection around the central image that touched the outer edges of the canvas and used the *Spherize* filter on the center of the image. With the same *Marquee,* I selected the inverse to create the border. To finish, I used the *Gaussian Blur* filter and brought the color *Saturation* up to 150%.

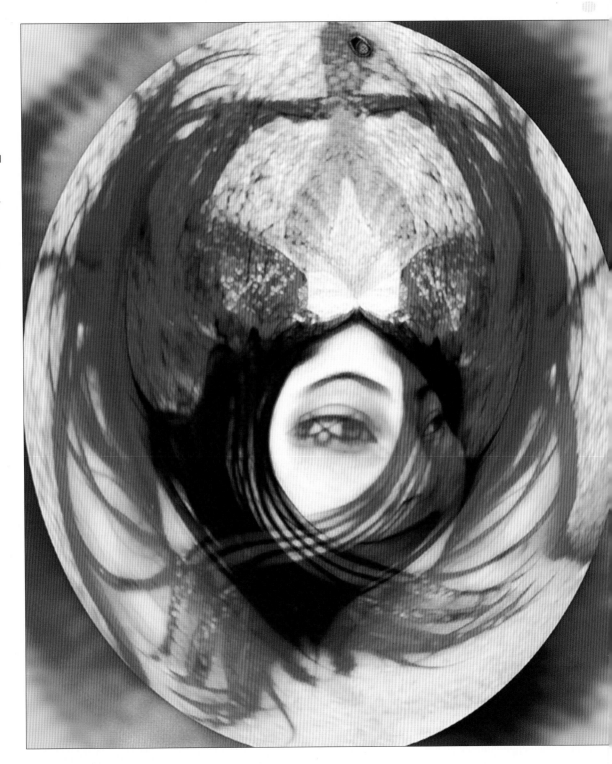

AVIAN INSANITY

Birdswirl by Richard Ainslie

Third-party filters such as the innovative Kai's Power Tools suite can bring a whole new dimension to your images. The user interface may be different to what you are accustomed to, but then so are the end results. *Birdswirl*, by Richard Ainslie, uses the *KPT Twirl* filter to create a compelling image.

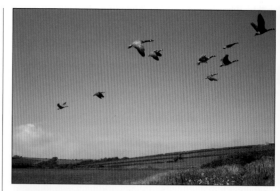

The Background

It would be easy to imagine that all successful images start with a good idea and are brought to completion through precise and painstaking craft, like Michelangelo removing bit by bit everything that didn't look like David. Sometimes it does work like that, or so I'm told. It's not something I would know from experience.

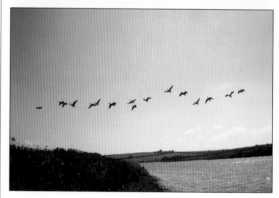

Using The KPT Twirl Filter

This image *Birdswirl* was originally the result of experimenting with the *Twirl* filter in Kai's Power Tools 3.0—a set of filters that have a reputation for being weird and wonderful. These days, of course, you can do the same without leaving Photoshop. You simply make a selection of what you want to twirl, run the *Twirl* filter, and move the *Angle* slider up and down until you get the effect that you're looking for.

Pasting In The Birds

Then I thought of adding some birds, either being drawn in or flung out of the maelstrom. A day or two earlier I'd snapped some Canada geese overhead. I used a 2-megapixel Kodak, primitive by today's standards but perfectly capable of producing usable results. Fortunately, the sky was cloudless and, since none of the birds was blue, it was easy to use the *Magic Wand* tool to select the sky, invert that selection, and then copy the birds and paste them on to the twirled sky.

This process was repeated four or five times with each of two different bird photographs. Before pasting each layer, I would use *Image > Rotate Canvas* to achieve the desired angle and then paste and move it into place on the sky. The smaller birds, which I'd reduced in size using the *Transform* command, were placed in the middle to add depth.

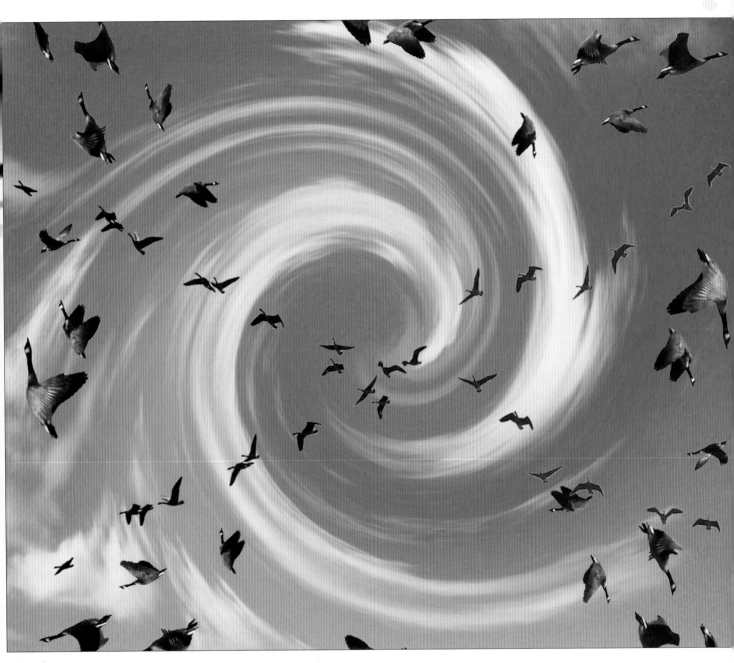

A Simple Result

The result is not what you'd call photo-realistic, but it's none the worse for that. I thought of bending the lines of flight so they more closely mirrored the movement of the cloud. But then I quite liked the simple way it fitted together using the most basic of shapes. So that's the way it stayed.

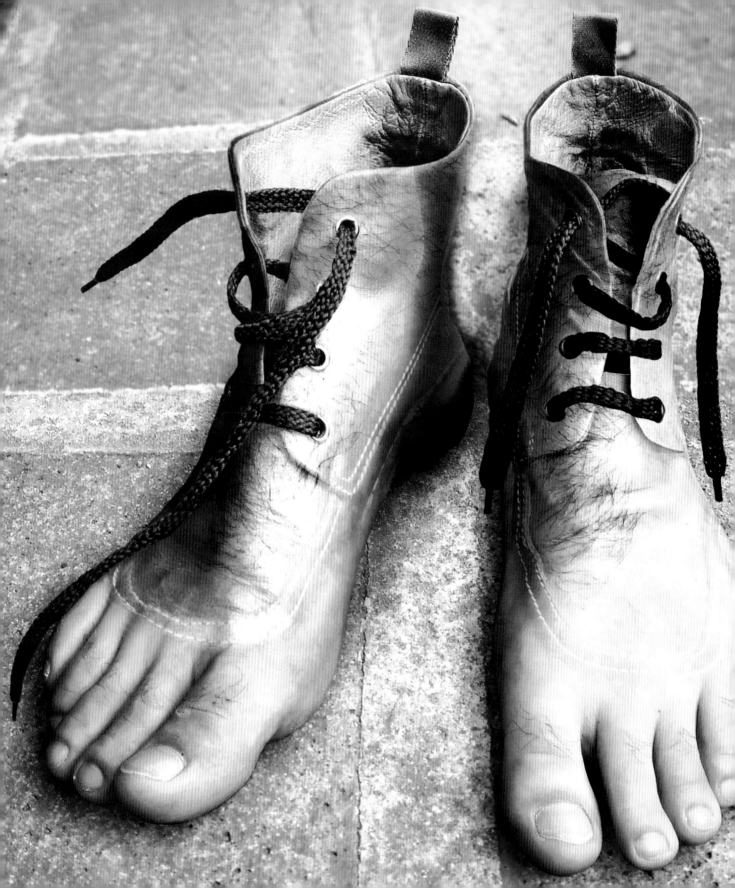

6

While Surrealism thrived on the use of found objects and the re-use of existing art, there are times when, to achieve a particular effect, you need to shoot something specifically for the work you have in mind. In other cases, your finished work might owe more to digital special effects than anything shot with a digital camera. The following pages are full of examples. It's time to set your mind free!

studio work

COMPOSITING STUDIO PHOTOGRAPHY

There's nothing too surreal about an everyday item like a banana, and nothing too exciting about a studio shot of a model. Combine the two, however, and you can create something a little more appealing.

1 Our first task is to add some canvas to the girl image, to make some room for the banana. The girl also needs to be streamlined a little to fit comfortably into the bottom half of the banana. Erase away the bottom-left area of her jeans and part of her top below the armpit.

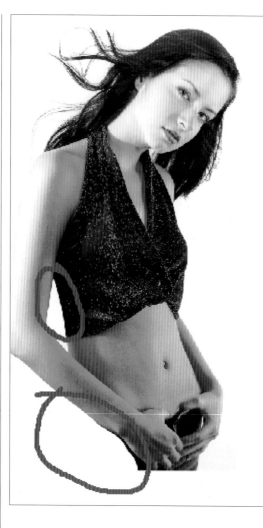

2 Make a selection of the banana and drag it into the girl image, positioning its layer at the top of the palette. Press Ctrl/Cmd + T for the *Free Transform* tool and rotate and scale the banana to fit. Finally, add a *Layer Mask* to the banana layer.

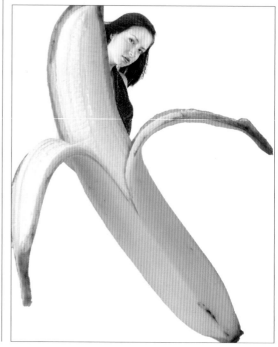

3 It's important to look for areas of overlap when compositing. This helps to unite the different elements and avoids the cut-out layer upon layer look. In this instance, we can make the girl's arm appear over the top of the folded banana skin. Make a selection of the arm. Click the mask thumbnail of the banana layer to activate it. Now fill the selection with black.

4 Now paint on the mask to reveal the rest of the top half of the girl, which in turn will hide the top half of the banana.

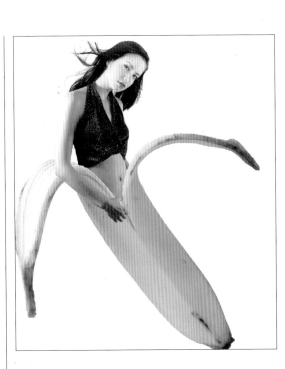

5 In a real-life situation, the girl's arm and hand would cast a shadow over the banana skin. Activate the banana layer and use the *Burn* tool to paint the area around the arms and hand to depict shadow.

Studio Work

COMPOSITING STUDIO PHOTOGRAPHY

6 Now activate the girl layer and repeat the process on the girl's stomach where it is overlapped by the banana skin.

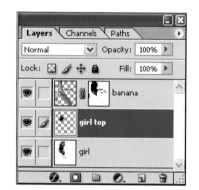

7 To stick with the theme, we are going to swap the girl's glitter top for one made more appropriately of a banana leaf. Make a selection of the girl's top, and, with the girl layer active, press Ctrl/Cmd + J to copy and paste the selection to a new layer.

8 Now make a selection of the banana leaf. Drag the selection into the working file, positioning the leaf so it covers the girl's top. The leaf layer should be above the girl layer. Make a *Clipping Mask* between the girl top layer and the leaf layer.

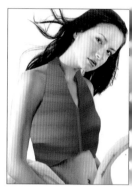

9 Finally, to remove the flatness and shape the leaf around the girl's body, use the *Dodge* and *Burn* tools to emphasize shadow and highlight. Use the *Burn* tool to create some shadow under the leaf on the girl's stomach. Paint on the girl layer to achieve this.

10 Now run the *Burn* tool along the edge of the leaf on the leaf layer to form a natural edge and avoid any hint of a cut-out.

Studio Work

PLAYING WITH SCALE

Surreal imagery is often about playing with contexts: making something large small, transforming a symbol into something literal, or just mixing things up in strange juxtapositions. Humor also helps, and this image is nothing if not playful. When it comes to changing the scale of objects within images, Photoshop has no limitations. Giants can become microscopic—and vice versa—but making extreme changes of scale look believable takes a little more know-how. In this tutorial, we are going to take a full-size real automobile and merge it into to the miniature world of a popular board game.

1 Make a selection of the automobile and drag it into the Monopoly image. Use *Edit > Transform > **Scale*** or Ctrl/Cmd + T to reduce the size of the vehicle. Position it so it partially obscures one of the dice. This will help to make it seem as part of the original.

2 Before going any further, we need to address the problem of color matching. The automobile was photographed outdoors, while the Monopoly board was taken under tungsten light. This accounts for the warm quality of the light, which contrasts with the faint blue light of the automobile. Photoshop's *Match Color* command is not always successful—and the same goes for many automated commands—So we will use a tried and tested technique from the early days of Photoshop to match the colors.

Add a *Curves* adjustment layer to the automobile layer. Make very small changes to the red and blue curves as shown.

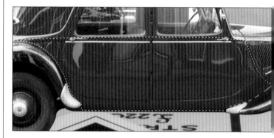

3 Make sure that the automobile layer and adjustment layer form a *Clipping Mask*.

4 One of the great troublesome areas when creating these kinds of montages is removing or matching reflections. Glossy automobiles are characterized by their multiple reflections, so rather than painting out the original reflection, we are going to generate our own based on the actual new environment. This not only looks highly realistic but also maintains the shiny appearance of the vehicle. Make a selection of part of the lower half of the automobile as shown.

5 Create a new layer above the *Curves* adjustment layer called "gradient." Use the *Eyedropper* to sample a light and a dark color from the automobile, then drag a *Radial Gradient* through the selection. Deselect the gradient.

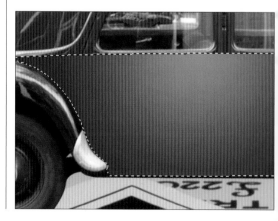

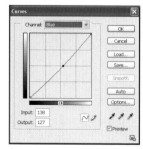

6 Create a selection of an area below the automobile that will be used for the reflection in the lower part of the vehicle Activate the background layer and press Ctrl/Cmd + J to copy and paste the selection to a new layer. Name the new layer "reflection."

7 Drag the reflection layer above the gradient layer, then go to *Edit > Transform > Flip Vertical*.

8 Convert the reflection and gradient layers into a *Clipping Mask* (*Alt* click while holding the cursor on the border of the two layers in the *Layers* palette.) Now we can drag the reflection layer in position to simulate a true reflection.

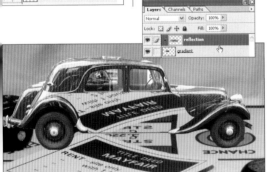

9 To make the whole effect look realistic, change the reflection layers blend mode to *Soft Light*.

10 The door frames and chrome work now need to be revealed. Create a pen path that outlines all the door areas on the lower part of the automobile. Choose a brush about the same width as the door seams and set the foreground color as black.

Activate the *Layer Mask* on the gradient layer and from within the path palette click the icon at the bottom of the palette to convert the path to a stroke. This process will paint the black line on to the *Layer Mask,* thereby revealing the actual seams of the automobile doors.

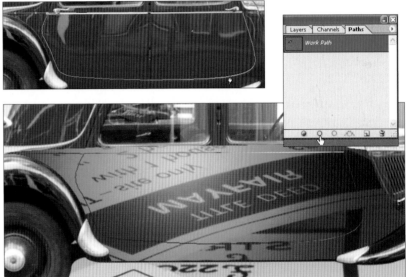

11 Repeat the process to reveal all the door seams and door handles.

PLAYING WITH SCALE

12 The automobile is meant to be behind the dice on the left. Make a selection of the dice, then invert it (Ctrl/Cmd + I). Activate the automobile layer and add a *Layer Mask* to it. The result is a perfect exchange in the order.

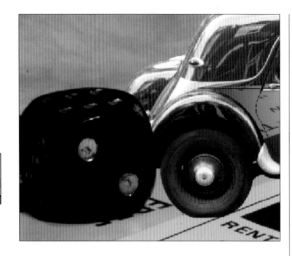

13 There are still a few reflections to deal with—one on the top left of the automobile and one on the trunk. The process is the same as with the vehicle's doors. Make a selection of the area and drag a *Gradient* through the selection on a new layer. Because of the angles there is nothing visible that would reflect in that part of the vehicle, so the gradient can be left as it is.

The rear wheel arch also has a reflection, but this should be reflecting the dice because of its proximity. Follow the same procedure as for copying the Monopoly board beneath the automobile.

14 Without shadows, the automobile seems to float above the ground, so that's the next task. On a new layer below the automobile layer, create a high-feathered selection describing the shape of the shadow beneath the vehicle.

15 Fill the selection with a deep green color based on the Monopoly board, then change the shadow layer's blend mode to *Multiply*.

16 The last job is to replace the view through the automobile windows. The original background already exists, so all we need to do is add to the existing *Layer Mask* on the vehicle and add a bit of embellishment to suggest the glass.

Make a selection of the rear window area. Activate the automobile *Layer Mask* and fill with black.

17 The flat gray color visible through the window is the actual background, so all we need to do now is to reintroduce the glass. Make a selection of the rear window area. On a new layer, drag a white to transparent linear gradient from top to bottom.

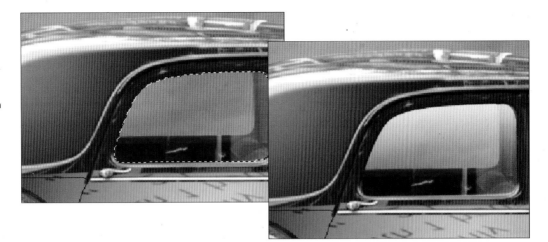

Studio Work

ARTIFICIAL PYROTECHNICS

Choosing just the right moment to capture a burst of flames or an explosion requires more than a healthy helping of luck, so it seems a good topic to try out a couple of techniques to create our own digital pyrotechnics.

Flame Bursts

1 To begin, make a selection of the gargoyle and drag it into the dark sky background. This effect will have greater impact on darker background colors, so bear that in mind when you select your images. Rotate and position the gargoyle in the bottom-right corner of the sky image to allow room for the flames to spurt from its mouth.

2 Make a feathered selection of the area to contain the flames. This doesn't have to be too accurate as the finished flames can be transformed as required. Create a new layer called "flames," and set up the foreground and background colors with pale and dark gray colors.

3 Now click on the flames layer to make it active, then fill the selection by going to *Filter > Render > Clouds*.

4 Keep the selection live and go to *Filter > Render > Lighting Effects*. Use the default spotlight with the source in the bottom-right corner of the preview window. Apply all the settings as shown.

5 To make the result start to look like flames, we add some color. Use the *Hue/Saturation* command (Ctrl/Cmd + U) to apply an overall yellow color. Make sure the *Colorize Check* box is enabled as in the example, and change the flames layer blend mode to *Hard Light*.

6 Now, to strengthen the flames illusion, duplicate the flames layer, then use the *Hue/Saturation* command again to change the color of the duplicated layer to red. Don't use the *Colorize* option this time as we have sufficient color in order to make a change. When you've finished adjusting the *Hue* and *Saturation*, merge the two flames layers into one.

7 We only want to see the lighter red and yellow areas of the flames layer and to hide the very dark areas generated by the *Lighting Effects* filter. A quick and easy way to do this is to change the flames copy layer's blend mode to *Screen*. However, doing this can have the effect of draining too much color from the flames.

8 To re-establish the strength of the colors bring up the *Levels* command (Ctrl/Cmd + L) and drag the *Black* and *Gray* sliders to the right a little. The result is a deeper, more dynamic flames effect.

9 Finally, add a *Layer Mask* to the flames layer. Paint on the mask with black using a soft-edged brush at low *Opacity* to remove any sharp edges that might have appeared and to generally shape the flames around the gargoyle's mouth. If necessary, the entire flames layer can be rotated for greater alignment with the mouth.

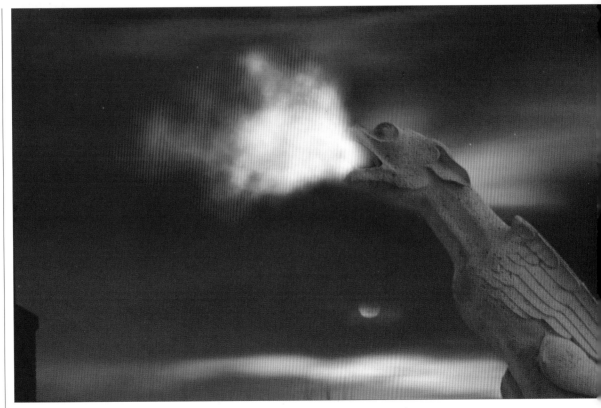

ARTIFICIAL PYROTECHNICS

Creating Artificial Explosions

We can use a similar technique with a few additional twists to turn the flames into a very dynamic explosion. Let's think the unthinkable and create a catastrophic event on our moon.

1 Create a feathered selection describing the area to be covered by the explosion, then create a new layer called "explode."

2 Using pale and dark gray as the foreground and background colors apply the *Clouds* filter (*Filter > Render >* **Clouds**).

3 Press Ctrl/Cmd + U to bring up the *Hue/Saturation* command and apply a strong red with *Colorize* enabled.

4 To give the explosion a bit more body, we're going to add a filter. Go to *Filter > Artistic >* **Plastic Wrap**. Apply high settings to make it really obvious.

5 Duplicate the explode layer, and use the *Hue/Saturation* command to change the new layer to a strong yellow.

6 To blend the two colored layers together, change the top explode layer's blend mode to *Overlay*. Merge together the two explode layers. If the top one is active, press Ctrl/Cmd + E to merge them down.

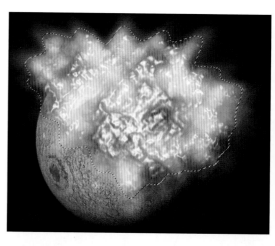

7 The dynamism of the explosion will be created by using one of the blur filters. With the explode layer active, deselect the selection, then go to *Filter > Blur >* **Radial Blur**. Apply the settings displayed below.

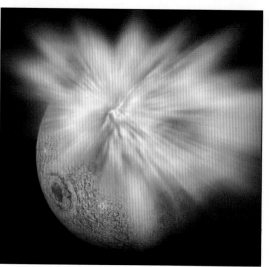

8 Change the explode layer's blend mode to *Hard Light*, then duplicate the explode layer and change its blend mode to *Dissolve*, reducing the layer *Opacity* to about 25%.

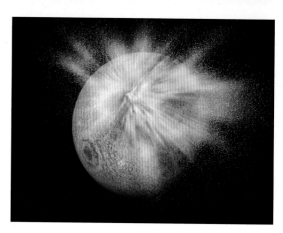

9 Finally, to give the explosion a white hot center, create a black-filled layer at the top of the layer palette. Go to *Filter > Render > **Lens Flare***. Apply a 105mm flare with the *Brightness* set to 82%.

10 To hide the black area of the layer, change the *Lens Flare* blend mode to *Screen*. The benefit of applying a lens flare in this way is that the layer *Opacity* can be adjusted to provide the right amount of flare and perhaps more importantly the position of the flare can be changed independently of the other layers.

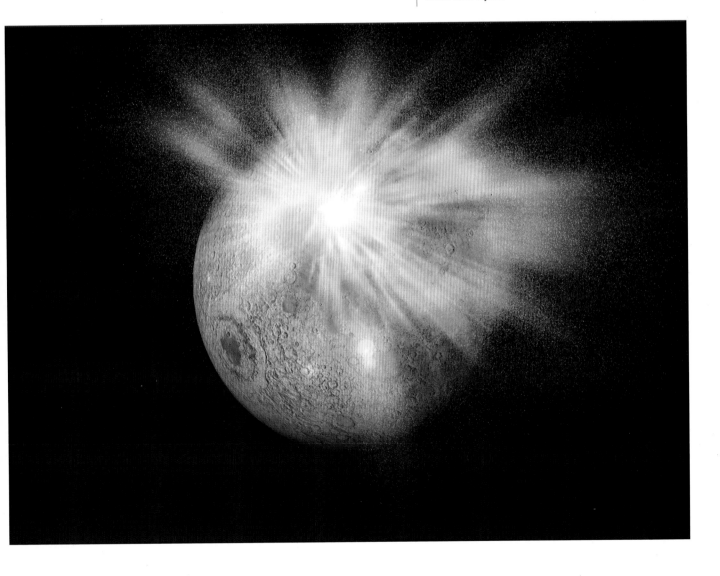

CREATING A SURREAL WORLD

Salvador Dali's unique style has spawned many imitators throughout the art world. Not solely restricted to the painted medium, many a pastiche can be found in the world of photography, movies, and television. Here, we use all the power of computer manipulation of images to create our own Daliesque world.

1 One of Photoshop's standard gradients has strong associations with a characteristic Dali background. His broad, relatively flat application of color divided equally into sky and earth is typical of the Photoshop chrome gradient. We are going to use that as our background. Drag the linear gradient from top to bottom of the canvas, holding the shift key as you drag to keep it perfectly straight.

2 Create a layer called "cloud," then draw a feathered cloud shape selection in the sky. Choose two contrasting colors for the Foreground and Background colors, then go to *Filter > Render > Clouds*. This works well for the style we are creating as the cloud is not too photographic.

3 Take an image with a suitable mountain range, select the mountain, and drag it into the working file. For the mountain to work in this image, it can't seem quite so photographic, so to simplify the mountain detail, go to *Filter > Artistic > Palette Knife*. Apply the setting shown.

4 One of Dali's more famous works depicts a bent watch as if it has melted. We are going to reproduce that idea. Start by cutting out the main area of the watch.

5 Go to *Filter > Liquefy*. Choose the *Freeze Mask* tool from the toolbox on the left of the dialog box. Mask the area to be protected before making the distortion.

6 Choose the *Liquefy Warp* tool. Using a large brush, click and drag from the center of the watch to the left at about a 30-degree angle. If you don't get it right first time, just press Ctrl/Cmd + Z and try again. It takes practice to achieve the right distorted effect. When you're finished, drag the distorted watch on to the working file.

7 The watch is going to be hanging over a tree branch, staying faithful to one of Dali's works. Select the branch and drag it into the main file, positioning it so that the watch appears to hang over it.

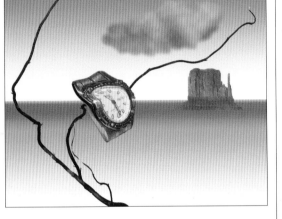

8 Finally, we'll create a long, late afternoon shadow being cast from the mountain. Load the mountains selection by holding down Ctrl/Cmd +, clicking its layer in the *Layers* palette. Feather the selection by a high value.

9 Create a layer called "shadow" above the background layer, then fill the selection with a color a little darker than the current background color. Go to *Edit > Transform > **Distort***. Drag the handles to simulate the shape of a long, cast shadow. Change the layer blend mode to *Multiply* and reduce the *Opacity* to 30%.

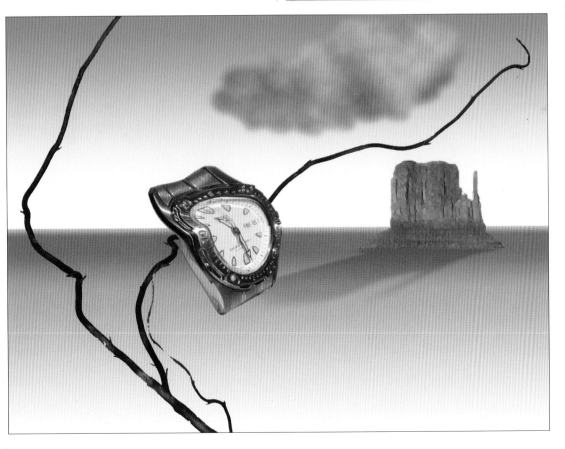

Studio Work

SURREALIST MONTAGE

Layers are the secret to all successful montage work. These images, by digital photographer Barry Jackson, were created from separate components, each specially shot with their use as part of the final montage already in mind.

These Boots

The image is made up of three photographs. Each was opened in Photoshop as a separate layer. Work could then be done on each of them individually, creating masks in order to remove backgrounds, resizing images to match one another, and adjusting colors. The final image was produced by blending the layers while controlling the levels of *Opacity* between them.

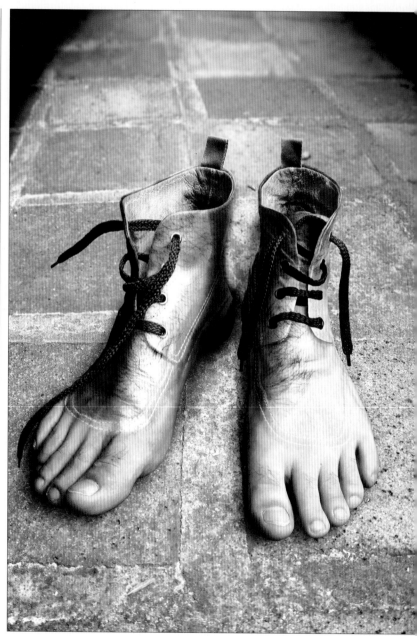

Background Layer
The first photograph is one of the empty path. It forms the background layer, at the base of the stack.

Boots Layer
The second shot is of the boots placed on the path. Opened as a separate layer, the boots can be resized to fit the feet. The path is erased from this layer.

Feet Layer
The third shot is of the naked feet placed in exactly the same position as the boots. They are carefully masked and the path is removed.

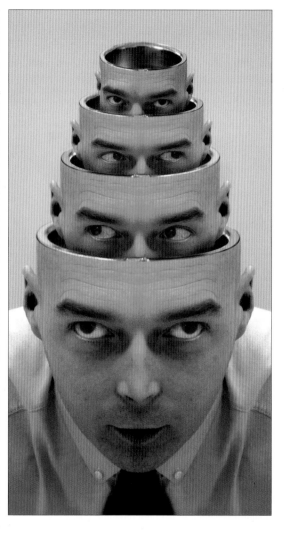

All Layers
The image is beginning to come together. Reducing the *Opacity* of layer 2 makes the boots semi-transparent. The feet are therefore visible while the front of each boot is erased.

Russian Doll
This image was obviously inspired by the brightly colored wooden Russian dolls, which open up to reveal another doll inside. It was created from just one head shot, cut in half and mirror-imaged to create a symmetrical appearance. The eyes of each head were adjusted to give the impression that each head is looking in a different direction. The pillbox was used again to create the smooth, metallic opening to each head.

Jack in the Head
Jack in the Head was inspired by childhood memories of watching Terry Gilliam's surreal animations in *Monty Python's Flying Circus*. It was created from three individual images— the head, the puppet, and an open pillbox. These were layered together to produce the effect of the jack popping out of the man's head.

Studio Work

FLAME AND FIRE EFFECTS

Suffering by Vincent Chang

In *Suffering* the subtle usage of layers and adjustment layers has produced an image that seems to be ablaze with color. The techniques used by the artist in this powerful picture can be applied to practically any image where you wish to produce a "fiery" effect.

Creating The Glow

The strong orange glow of the finished image was achieved by repeatedly duplicating the face (including textures), then blurring these layers, setting them to the *Hard Light* blend mode, and overlaying them in various places over the image. The stronger shadows, too were created using duplicate layers of the face but with their blend modes set to *Multiply*.

Shooting The Photographs

Before embarking on a photo-shoot for a project, I produce rough sketches of how I intend the final image to look. With the sketches as a guide, I then take a series of photographs with slightly varying poses, expressions, and angles, so that there is a selection of material to choose from and work with. In this case, there was no one particular photo that quite captured the expression that was needed, so I cropped the eye from one photo and merged it with the head in another to achieve the desired expression. This is one of the advantages of taking a series of photos during a shoot and is a method I often use to produce the exact pose I require.

Building Up Texture

To create the distressed, peeling-skin effect of the face, I used photographs of rust, peeling paint, and peeling wallpaper. With these, I built up layers of texture on top of the face, which were blended together using various layer-blending modes and *Layer Masks*. I have found it very useful to build up a library of stock photos of textures, which can be used like this when needed.

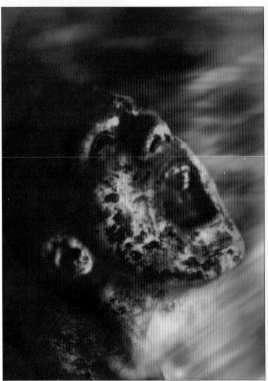

Using Mixed Media

The whole image was built upon a scanned background I'd created using mixed media that included paint, texture paste, and crushed eggshells. The various layers then interact with each other and this underlying background layer, creating new textures and subtleties throughout the image.

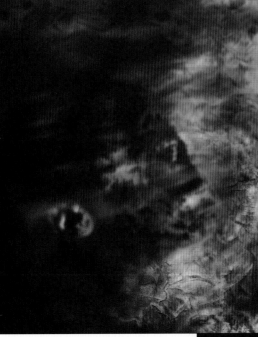

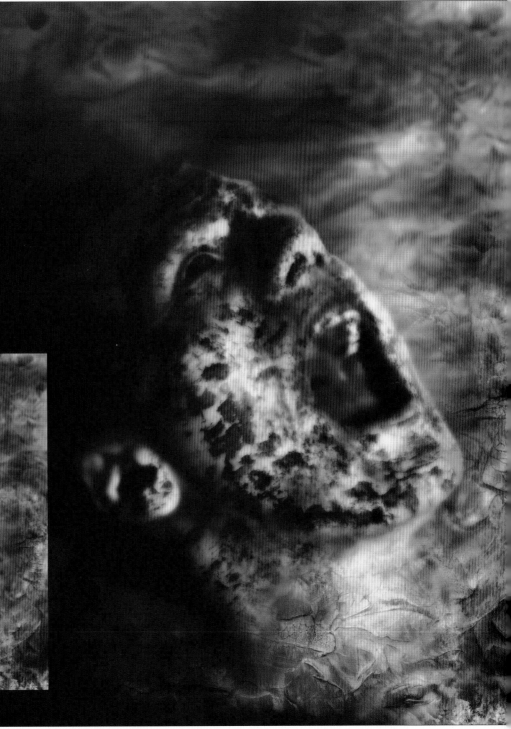

SHOOTING THE IMPOSSIBLE

Sofa by Todd Pierson

In another of his signature photomontages, Todd Pierson has created a convincing illusion of surreal strength. This strong girl shot was more difficult than originally suspected because the couch had to be both safely supported and prevented from sliding on the wood floor once it was tipped up. To make the effect slightly easier to pull-off, the whole set was built in Pierson's studio, and his own three-year-old daughter became the star of the shot.

Lifting The Couch

I first had to block the couch up and placed a 2 x 4 against it and the other side against the wall. I had my male model come in and give me the surprised, shocked look I needed. The seams in the wall are part of my studio. I knew they wouldn't be a problem because of the extensive Photoshop work I had to do on it.

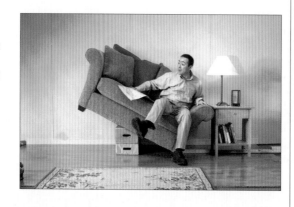

Superhuman

I then had my three-year-old daughter come in and, being careful not to move anything, instructed her on what to do. (She takes direction very well.) She had to be in just the right position so it was obvious what was going on. Likewise, the doll under the sofa was chosen because it was easy to read as a toy.

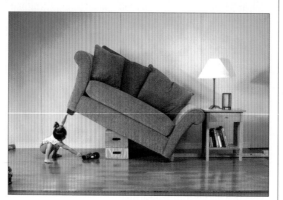

Bracing And Tipping

This photo was made without the blocks or 2 x 4 brace because I needed to have the wood floor, the space under the couch, and the wood floor reflections for stripping into the main shot. I also used monofilament to hold the lamp as if it was falling. The table was also blocked up as if it was tipping.

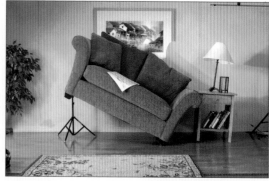

Additions

After shooting the images, I realized I really needed some other props to complete the room. This is why it's so important to plan ahead and make sure you have the set the way you want it before you shoot. Adding this photo and tree meant extra work for lack of planning the finished image.

Compositing

This is how the masking looked as I worked on the final image. The tree, floor, reflection, table, picture, and girl had to all be added in exactly the right position to make it look believable. Then the shot was complete after doing some detail work and cleaning up edges. You have to remember to always soften the edges of stripped-in items to make them blend into the shot.

And there you have it. The strongest three-year-old you will ever meet!

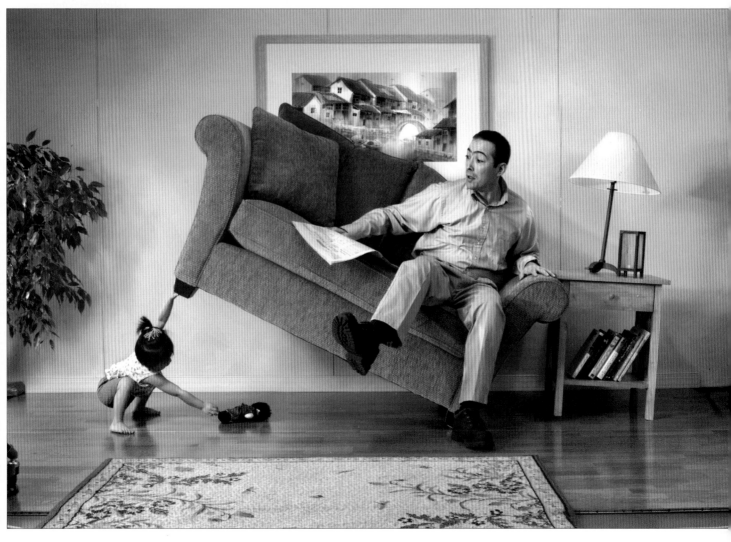

STUDIO COMPOSITES

Jigsaw by Colin Thomas
Creating composite images using inanimate objects is difficult enough, but for his image, *Jigsaw*, Colin Thomas relied on the patience of a live model. The result is a witty and arresting image that puts a new spin on the nude.

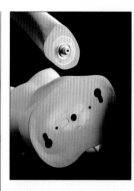

The Concept
This image started out as just a scribbled idea on my sketch-pad and it has ended up being used all over the world to advertise everything from scalpels to an Off-Broadway show.

Shooting The Body Parts
When I showed my scribble to a model and to a make up artist that I know, they gave me funny looks. But, all credit to them, they agreed to help me make the images of all the body parts. We shot the original images using a Hasselblad, on color transparency film.

Manikins
I also used this shot of manikin ends to create the idea of a real-looking body that could be assembled later.

Putting It Together
Then I had a selection of the transparencies scanned at high resolution, and spent a couple of weeks trying out different compositions in Photoshop until I was happy with the overall result. The elements were retouched using a range of Photoshop's tools: *Cloning, Healing-brush, Curves,* and *Levels.* The composite was made using layers and masks, and shading from the "body parts" was created using adjustment layers.

STRANGE FILTERS

Waiting For The Transport by Federico Santi

Waiting For The Transport is a great demonstration of the ways in which Photoshop's filters can completely transform an image. In this image a total of five separate filters have been used to add depth, color, and sparkle to an original image that was very flat in appearance.

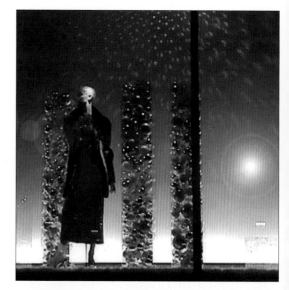

Five Step Process

I stopped using a wet darkroom in 1998. My previous darkroom work allowed me to capture the stark reality of the moment. Digital imaging allows me to express my interpretation of what I see and what I want the viewer to see, with my only limitation being my imagination. Using Adobe Photoshop, it took five filter manipulations to create the final image.

Night-time Shot

The first image is of the original shot. The image was taken of a department store window, late at night, using a Sony Mavica MVC-FD91. The camera was hand-held. Hot lights of store windows provide good contrast and good illumination. There was modern starkness to the image and I knew that I wanted to create a sci-fi look to the shot.

Adding Lens Flare

The first filter used was a *Lens Flare*. The circles and flares contrast with the vertical lines of the image. The *Lens Flare* filter usually creates other interesting flaring across the image.

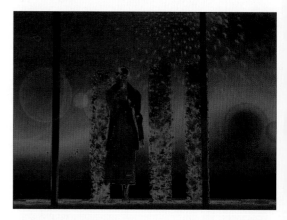

Solarizing The Image

Next, I used the *Solarize* filter, which gave the image a fantasy appearance. Colors were then changed and highlights were altered.

Balancing The Levels

Next, I used Image > *Adjust* > **Auto Levels** in order to balance the highlight and shadow values.

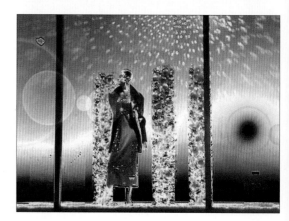

Adding Lighting Effects

Then I used the *Lighting Effects* filter to add depth and texture to the image, and I adjusted the effect with the *Fade Adjustment* command to get to the desired image.

Final Adjustments

The final image was achieved by adjusting the brightness and contrast function. I started with a fairly flat image and transformed it to another time and dimension. Texture, lighting, and altered colors create a mysterious and other-worldly image.

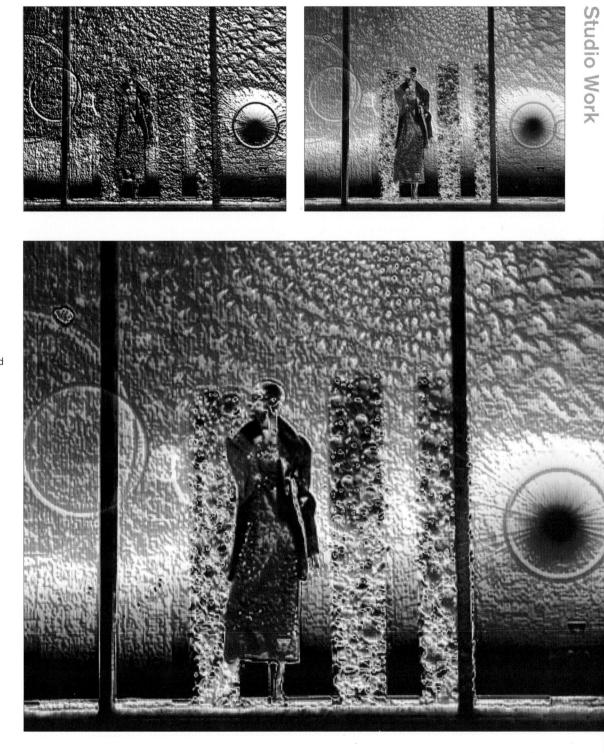

COMPOSITING IMAGES IN REALISTIC BACKGROUNDS

Air by Todd Pierson

Air uses a number of subtle compositing techniques to turn an everyday image into an extraordinary one. The apparently straightforward composition of the elements that make up the picture belies the tremendous amount of hard work that has gone into producing the image.

Originating The Concept

The whole idea behind my work with kids is to place them in amusing situations that are really impossible but seem real. The concept for this first image originated from attending birthday parties my daughters are occasionally invited to. The idea was to create a scene that looked normal except that the girls are in shock because the cake is blowing off of the table.

Shooting The Cake

Next, I shot the real cake in the same set and pulled it apart, shooting it in stages. Shooting as many as 23 shots gave me a nice selection from which to choose. Then each chunk of cake needed to be shot, along with crumbs, forks, and cups in different positions. A total of 65 shots were taken of the cake parts.

Combining The Elements In Photoshop

In Adobe Photoshop, all of the elements were outlined and their edges softened. To simulate motion, I also added a layer underneath the cake parts that was blurred using Photoshop's *Motion Blur* filter.

Creating The Props

The first thing I had to do was have a bakery make two layered cakes with a round piece of thin plywood between the layers, with a dowel rod attached to the board standing straight up out of the cake. This allowed me to separate the cake and suspend it over the table.

Shooting The Children

The next step was to shoot the models. A different cake was placed where the real cake would go. This cake had real candles on it so that the children had something to focus upon.

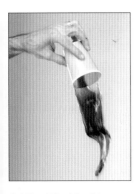

Adding The Liquid

For the liquid spilling from the cup, I used shots I had already taken of the liquid spilling, and then worked with the *Distort* tools in Adobe Photoshop along with the *Liquify* tool to make the liquid the right shape. In this way, the liquid was stripped into the flying cup.

AddingThe Circles On The Wall

After adding the floor and finessing all of the parts that were stripped in, I added the circles to the wall as an interior decorative touch. To do this I created white circles, reducing the *Opacity* and placing them on the wall. The working image had 33 layers in total and took about 13 hours of Photoshop imaging time.

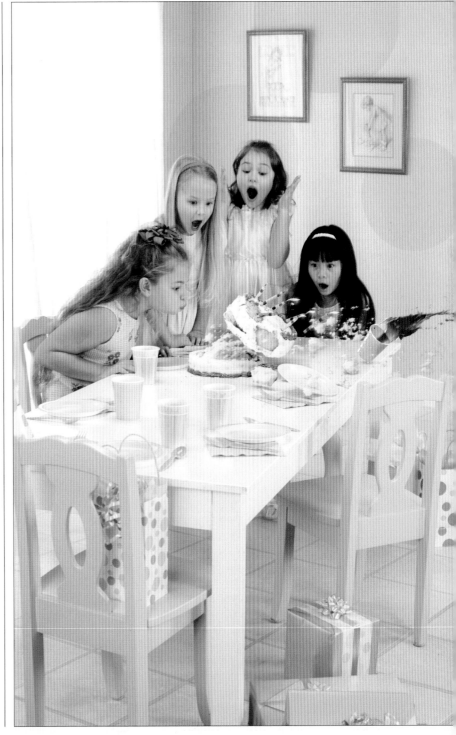

glossary

GLOSSARY

Adjustment layer

A specialized layer that can be handled as a conventional layer but designed to enact effects upon all those layers below it in the image "stack." Effects that can be applied via an adjustment layer include changes in *Levels*, *Brightness/Contrast*, *Color Balance*, and even *Posterization*. These changes do not actually affect the underlying pixels. If the adjustment layer is removed the image will revert to its previous appearance. Conversely, an adjustment layer's adjustments can be permanently embedded in the image (or in the underlying layers) by selecting an appropriate command (such as *Merge Down*).

Alpha channel

A specific channel in which information on the transparency of a pixel is kept. In image files, alpha channels can be stored as a separate channel additional to the standard three RGB or four CMYK channels. Image masks are stored in alpha channels.

Blend mode

In Photoshop, individual layers can be blended with those underneath using blend modes. Examples of these modes are: *Normal*, *Behind*, *Clear*, *Dissolve*, *Multiply*, *Screen*, *Soft Light*, *Hard Light*, *Color Dodge*, *Color Burn*, *Darken*, *Lighten*, *Difference*, *Exclusion*, *Overlay*, *Saturation*, *Color*, and *Luminosity*. Blend modes enact changes upon the original pixels in an image (sometimes called the base layer) by means of an applied blend color (or "paint" layer). This produces a resultant color based both on the original color and the nature of the blend.

Blur filter

The conventional *Blur* effect filter, designed to detect noise around color transitions and remove it. It does this by detecting pixels close to boundaries and averaging their values, effectively eliminating noise and random color variations. *Blur More* is identical but applies the effect more strongly. Somewhat crude, the *Blur* filter is now joined in many image-editing filter sets with more controllable filters such as the *Gaussian Blur* and *Smart Blur* filters.

Brightness

The relative lightness or darkness of the color, usually measured as a percentage from 0% (black) all the way up to 100% (white).

Capture

The action of "getting" an image, by taking a digital photograph and transferring it to a computer, or scanning an image and saving it as a file on the hard disk.

Channels

A conventional RGB color image is usually composed of three separate single-color images, one each for red, green, and blue, called channels. Each color channel contains a monochrome representation of the parts of the image that include that color. In the case of the RGB image channels containing the red, green, and blue colors, images are combined to produce a full-color image, but each of these individual channels can be manipulated in much the same way as a complete image. Channels can be merged or split using the *Merge Channels* or *Split Channels* commands.

Clipping

Limiting an image or piece of art to within the bounds of a particular area.

Clipping group

A stack of image layers that produce a resultant image or effect that is a net composite of the constituents. For example, where the base layer is a selection shape (say, an ellipse), the next layer a transparent texture (such as craquelure) and the top layer a pattern, the clipping group would produce a textured pattern in the shape of an ellipse.

Color

The visual interpretation of the various wavelengths of reflected or refracted light.

Color cast

A bias in a color image which can be either intentionally introduced or the undesirable consequence of a lighting problem. Intentional color casts tend to be introduced to enhance an effect (such as accentuating the reds and oranges of a sunset, or applying a sepia tone to imply an aged photo) and can be done via an appropriate command in an image-editing application. Undesirable casts arise from a number of causes but are typically due to an imbalance between the lighting source and the response of the film (or that of the CCD in the case of a digital camera). Using daylight film under tungsten lighting causes an amber color cast while setting the color balance of a digital camera for indoor scenes can give a flat blue cast outdoors.

Color temperature

A measure of the composition of light. This is defined as the temperature—measured in degrees Kelvin—to which a black object would need to be heated to produce a particular color of light. The color temperature is based on a scale that sets zero as absolute darkness and increases with an object's—for example a light bulb filament's—brightness. A tungsten lamp, for example, has a color temperature of 2,900K, while the temperature of direct sunlight is around 5,000K and is considered the ideal viewing standard in the graphic arts.

Contrast

The degree of difference between adjacent tones in an image (or computer monitor) from the lightest to the darkest. "High contrast" describes an image with light highlights and dark shadows, but with few shades inbetween, while a "low contrast" image is one with even tones and few dark areas or highlights.

Crop

To trim or mask an image so that it fits a given area, or to discard unwanted portions of an image.

Definition

The overall quality—or clarity—of an image, determined by the combined subjective effect of graininess (resolution in a digital image) and sharpness.

Density

The darkness of tone or color in any image. In a transparency this refers to the amount of light which can pass through it, thus determining the darkness of shadows and the saturation of color. A printed highlight cannot be any lighter in color than the color of the paper it is printed on, while the shadows cannot be any darker than the quality and volume of ink that the printing process will allow.

Dots Per Inch (dpi)

A unit of measurement used to represent the resolution of devices such as printers and imagesetters. The closer the dots or pixels (the more there are to each inch) the better the quality. Modern inkjet printers have resolutions of up to 2,880dpi.

Drop shadow

Effect (available as a filter, plug-in or layer feature) that produces a shadow beneath a selection conforming to the selection outline. This shadow (depending on the filter) can be moved relative to the selection, given variable *Opacity* or even tilted. In the last case a drop shadow can be applied to a selection (say, a person) and that shadow will mimic a sunlight shadow.

Eyedropper tool

Conventionally used to select the foreground or background color from those colors in the image or in a selectable color swatch set. Eyedroppers can normally be accurate to one pixel or a larger area (such as a 3 x 3 pixel matrix) which is then averaged to give the selected color.

Feather

Command or option that blurs or softens the edges of selections. This helps blend these selections when they are pasted into different backgrounds, giving less of a "cut-out" effect.

Gaussian Blur filter

Blur filter that applies a weighted average (based on the bell-shaped curve of the Gaussian distribution) when identifying and softening boundaries. It also introduces low-frequency detail and a mild "mistiness" to the image which is ideal for covering (blending out) discrete image information, such as noise and artefacts. A useful tool for applying variable degrees of blur and a more controllable tool than conventional *Blur* filters. It can be accessed through the *Filter > Blur > Gaussian Blur* menu.

Gradient tool

Tool permitting the creation of a gradual blend between two or more colors within a selection. There are several different types of gradient fills offered, those of Photoshop are typical: *Linear*, *Radial*, *Angular*, *Diamond*, and *Reflected*. A selection of gradient presets are usually provided, but user-defined options can be used to create custom gradients.

Hard Light

Blend mode. Creates an effect similar to directing a bright light at the subject. Depending on the base color, the paint color will be multiplied or screened. The base color is lightened if the paint color is light, and darkened if the paint color is dark. Contrast tends to be emphasized and highlights exaggerated. Somewhat similar to *Overlay* but with a more pronounced effect.

High key

An image comprising predominantly light tones and often imparting an ethereal or romantic appearance.

Histogram

A graphic representation of the distribution of tonal values in an image, normally ranging from black at the left-hand vertex to white at the right. Analysis of the shape of the histogram (either by the user or automatic) can be used to evaluate criteria and establish whether there is enough detail to make corrections.

Image size

A description of the dimensions of an image. Depending on the type of image being measured, this can be in terms of linear dimensions, resolution, or digtal file size.

Lasso

The freehand selection tool indicated by a lasso icon in the Toolbar. There are many other variations on the basic *Lasso*, such as the *Magnetic Lasso* (that can identify the edges nearest to the selection path, aiding accurate selection of discrete objects) and the *Polygon Lasso* (that allows straight-edged selections to be made). In the case of the latter, to draw a straight line, the user places the cursor point at the end of the first line and clicks, then place the cursor at the end of the next line and clicks again.

Layers

Photoshop (and alternative programs) uses a method of producing composite images by "suspending" image elements on separate "overlays." It mimics the method used by a cartoon animator where an opaque background is overlaid with the transparent "cels" (layers) upon which pixels can be painted or copied. Once layers have been created they can be re-ordered, blended and have their *Opacity* altered. The power of using layers is that effects or manipulations can be applied to individual layers (or groups of layers) independent of the others. When changes need to be made to the image only the relevant layer need be worked upon.

Layer effects/layer styles

A series of effects, such as *Drop Shadow*, *Inner Glow*, *Emboss*, and *Bevel*, which can be enacted on the contents of a layer.

GLOSSARY

Layer mask

A mask that can be applied to the elements of an image in a particular layer. The *Layer Mask* can be modified to create different effects but such changes do not alter the pixels of that layer. As with adjustment layers (of which this is a close relation), a *Layer Mask* can be applied to the "host" layer (to make the changes permanent) or removed, along with any other changes.

Lens Flare filter

A *Render* filter that introduces (controllable) lens flare into images that previously had none. *Lens Flare* can be set to simulate a variety of lenses (by, for example, creating multiple flares for multi-element zooms).

Lighting Effects filter

Powerful set of rendering filter effects that can be used to alter or introduce new lighting effects into an image. Most of these include an extensive range of tools to achieve credible effects. For example, the Photoshop implementation uses four sets of light properties, three light types and 17 styles to produce endless variations of lighting effects. "Bump Maps" (texture grayscale files) can be linked to the image to create contour-line three-dimensional effects.

Linear Gradient

Option of most *Gradient* tools. Shades uniformly along a line drawn across the selection. The start point is colored in the first color (or foreground color, in a foreground to background gradient) and the end point in the last color (or background). A gentle gradient is achieved by drawing a long line over the selection (which can extend beyond the selection at either extreme); a harsher gradient will result from drawing a short line within the selection.

Liquify

Tool found in Photoshop 6 and above. An image distortion filter or filter set that allows a series of tools to be used to alter the characteristics and linearity of an image. Distorting tools include *Twist*, *Bloat*, and *Pucker*, the last giving a pinched, pincushion effect. Reconstruction modes are provided to undo or alter the effect of the distorting tools.

Low key

A photographic image comprising predominantly dark tones either as a result of lighting, processing or image editing.

Mask

In the printing industry a mask was a material used to protect parts of an image or page, photograph, illustration, or layout. Image-editing applications feature a digital equivalent that enables users to apply a mask to selected parts of an image. Such masks are often stored in an alpha channel.

Midtones/middletones

The range of tonal values in an image anywhere between the darkest shadows and lightest highlights. Usually refers to the central band of a histogram.

Motion Blur filter

One of the *Blur* filters, *Motion Blur* creates a linear blur (implying movement) at any angle. The degree of blur can be altered between arbitrary levels that introduce mild through to excessive blurs. The filter works most effectively when applied to an inverted selection: a selection is made of an object (say, a car, a runner or a train), the selection is inverted (to select the surroundings) and the filter applied to the inverse selection.

Multiply

Blend mode. A useful mode when you want to create or enhance shadow effects, *Multiply* uses the paint pixel values to multiply those of the base. The resultant color is always darker than the original except when white is the paint color. Using a light paint imparts a gentler, but similar, effect to using darker colors.

Opacity

The degree of transparency that each layer of an image has in relation to the layer beneath. Layer opacities can be adjusted using an *Opacity* control in the *Layers* palette.

Overlay

Blend mode. Retains black and white in their original forms but darkens dark areas and lightens light areas. The base color is mixed with the blend color but retains the luminosity values of the original image.

Path

A line, curve, or shape drawn using the *Pen* tool. Paths typically comprise anchor points linked by curved (or straight) line segments. The anchor points can be repositioned to alter a path if required. Each anchor features a direction line (Bézier line) and (normally) a pair of direction points. These can be pulled and moved to smoothly reshape the curve. Closed paths can easily be converted into selections and vice versa.

Pen tool

Tool used to create paths. The basic *Pen* tool is used to draw around an intended selection, adding anchor points that are connected to make the path. You can add as many or as few anchor points as required to draw the path; simple, basic shapes will require few anchor points, while more complex selections will need more. Closed paths are completed by clicking on the original starting point. Open paths (for example, a straight line) are completed by clicking in the *Pen* tool icon in the *Toolbar*. Also comes in magnetic and freeform varieties.

Perspective

Command used principally to aid the correction of perspective effects in images, but also for the introduction of such effects for creative effect. The most common use is to remove converging verticals in buildings when the original image was taken with a conventional lens (relatively) close up.

Polar Coordinates filter

Distort filter that converts an image's coordinates from conventional rectangular x–y axis to polar, and vice versa. The *Rectangular-to-Polar* conversion produces cylindrical anamorphoses–images that make no obvious logical sense until a mirrored cylinder is placed over the centre, when the image is displayed in conventional form again.

Quick mask

Provides a quick method of creating a mask around a selection. The mask can be drawn and precisely defined by using any of the painting tools or the eraser respectively.

Radial gradient

Option of most *Gradient* tools. Shades along a radius line in a circular manner. The start point of the line is the "origin" and is colored in the first, or start, color, while the end point defines the circumference and is colored with the end color.

Reflected gradient

Option of most *Gradient* tools. Produces a symmetrical pattern of linear gradients to either side of the start point. The effect is one of a "ridge" or "furrow."

Resolution

The degree of quality, definition, or clarity with which an image is reproduced or displayed, for example in a photograph, or via a scanner, monitor screen, printer, or other output device. The more pixels in an image, the sharper that image will be and the greater the detail. As the resolution gets higher, the likelihood of jaggies is also reduced.

Rubber Stamp tool

Sometimes called the cloning tool (on account of its action), the *Rubber Stamp* tool is often considered by newcomers to be the fundamental tool, for the removal of unwanted image elements. Later Photoshop versions feature two *Rubber Stamp* tools, the basic tool, and the *Pattern Stamp*. The basic tool is normally used as a brush (and shares the common *Brushes* palette for brush type selection) but "paints" with image elements drawn from another part of the image, or a separate image.

Screen

Blend mode. Calculates the inverse of the blend and multiplies this with the base pixel values. The resultant color is always lighter than the original with the darkest parts of the base removed to give a bleached effect. There is no bleaching only if the blend color is black. This mode has been likened to printing a positive image from two negatives sandwiched together.

Soft Light

Blend mode. A more gentle, but similar, effect to *Overlay*. A light paint or layer color lightens the base color, a dark one darkens the base color. Luminosity values in the base are preserved. If the blend paint or layer is lighter than 50% gray, the image is lightened in the same manner as would result from photographic dodging. Blends darker than 50% produce a burned effect.

Specular highlight

An intense highlight usually resulting from reflection of a light source from a convex section reflector. Specular highlights are plentiful on photographs of cars, for example, where curved brightwork produces such highlights. Also used for the lightest highlighted area in a photograph, usually reproduced as unprinted white paper.

Unsharp Mask filter

One of the most potent *Sharpen* filters, *Unsharp Mask* can sharpen edges whose definition has been softened by scanning, resampling or resizing. Differing adjacent pixels are identified and the contrast between them increased. The *Unsharp Mask* uses three control parameters: *Amount*, *Radius*, and *Threshold*. *Amount* determines the amount of contrast added to boundary (edge) pixels. *Radius* describes the number of pixels adjacent to that boundary that are affected by the sharpening and *Threshold* sets a minimum value for pixel contrast below which the filter will have no effect. Once mastered it is a powerful filter and can achieve more subtle, but more effective, results than any other sharpening filter.

White balance

"White" light is rarely pure white and tends to have unequal levels of red, green, or blue, resulting in a color cast. This color cast may not be visible to the human eye but can become very pronounced when a scene is recorded digitally. Almost all video cameras and many digital cameras feature a "white balance" setting that enables these to be neutralized, either by reference to a neutral white surface or against presets (precalibrated settings for tungsten lighting, overcast sky, fluorescent lighting, etc.).

White point

Point on a histogram denoting where those pixels that define white are. Though nominally at the extreme end of the histogram, the white point should normally be moved to the position of the first "white" pixels in the histogram.

INDEX

index

acknowledgments

ACKNOWLEDGMENTS

Thanks to the following artists for their participation in this book:

Laurence Acland
Canadian Shield, Siren
www.acland-photo.com

Richard Ainslie
Handle With Care, Birdswirl
www.mcsteed.co.uk

Bob Bennett
Grinding Teeth and Land,
Battery View
www.bobbennettphoto.net

Vincent Chong
Metempsychosis, Suffering
www.vincentchong-art.co.uk

Stephen Hardy
My Friend The Cyborg
www.shardygallery.freeola.com

Barry Jackson
Fallen Angels, Manikins,
These Boots, Russian Doll,
Jack in the Head
www.etherealme.com

Randy Luckey
10 Men At the Museum Looking
At Framed Objects, Everyone
Stares, Lisa's Eyes
www.1220.org

Paul Maple
Unavoidable Involvement, Return
to Nature
http://paulmaple.co.uk/gallery/

Todd Pierson
Beaming, Sofa, Alligator, Air
www.piersonstudios.com

Thea Rapp
Original Sin, Mask, Phoenix
www.thearapp.com

Jerry Ritchie
Flowers
http://rfaponline.com/

Federico Santi
Waiting for the Transport
www.drawrm.com/rico1.htm

Gregory Stewart
Cradle of Man, Dawn, Mary
www.gregorystewart.com

Colin Thomas
Ruby Yelling, J.G. Ballard,
Peach Girl, Jigsaw
www.colinthomas.com

Susan Thomson
Shinzen Garden
www.sx70.com